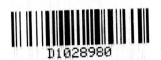

REYNAL'S WORLD HISTORY OF GREAT SCULPTURE

GREAT BAROQUE
AND ROCOCO SCULPTURE

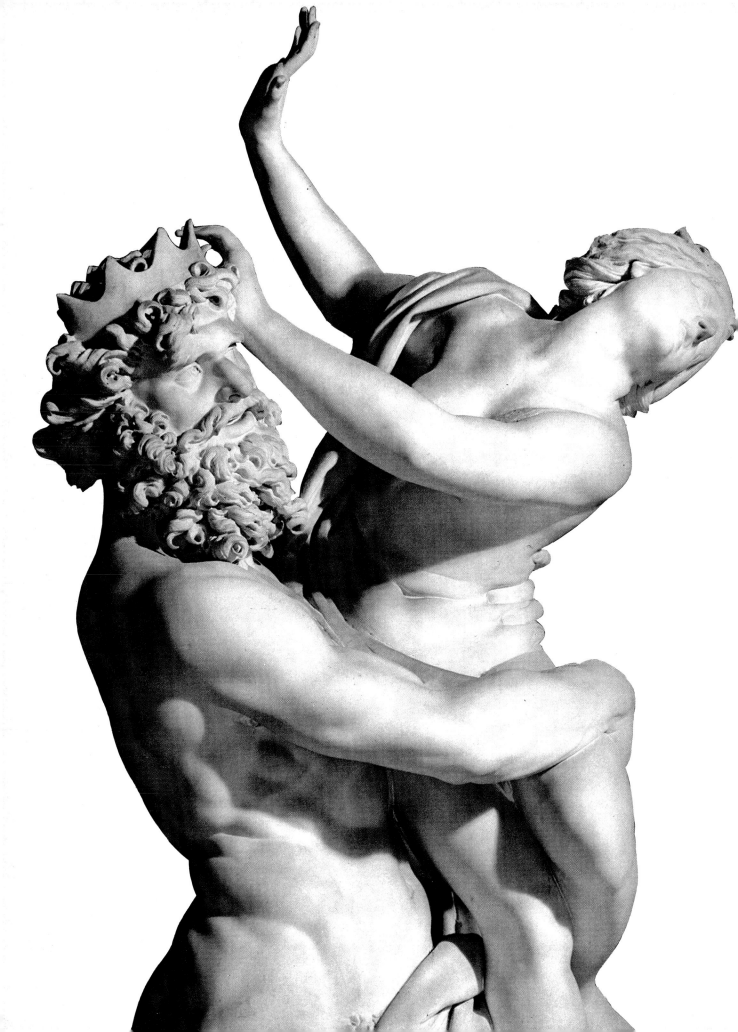

REYNAL'S WORLD HISTORY OF GREAT SCULPTURE

GREAT BAROQUE
AND
ROCOCO SCULPTURE

BY MAURIZIO FAGIOLO DELL'ARCO

TRANSLATED BY ENID KIRCHBERGER

REYNAL AND COMPANY
in association with
WILLIAM MORROW AND COMPANY, INC.
1978

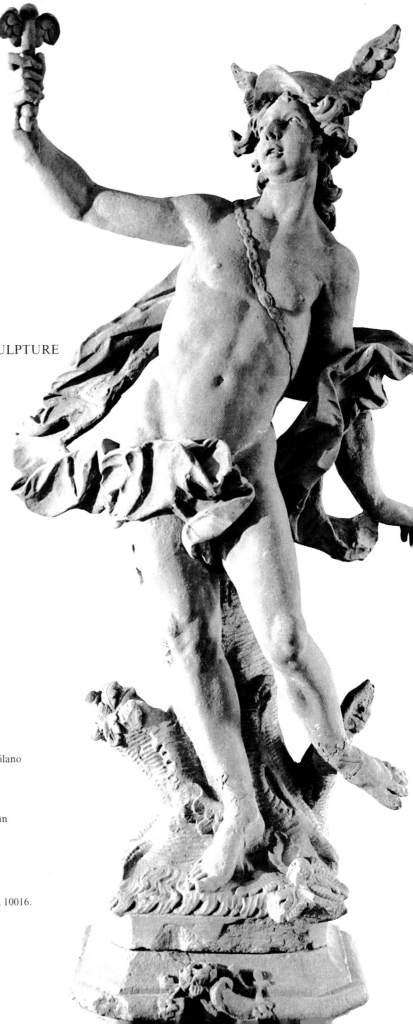

Here at right: Adam Ferdinand Dietz,
Mercury, *about 1763.*
Marble; originally located in the
castle of Veitschöchheim.
Würzburg, Mainfränkisches Museum

On page 2: Gian Lorenzo Bernini
The Rape of Proserpina *(detail)*
1621–1622. Marble. Rome, Galleria Borghese
(see illustration page 90)

On page 6: Gian Lorenzo Bernini
The Cardinal Scipione Borghese
(detail), 1632.
Marble; second version.
Rome, Galleria Borghese
(see illustration page 104)

REYNAL'S WORLD HISTORY OF GREAT SCULPTURE

Editorial Director
LORENZO CAMUSSO
Academic Consultant
MIA CINOTTI

GREAT SCULPTURE OF BAROQUE AND ROCOCO

Text
MAURIZIO FAGIOLO DELL'ARCO
Translated by
HALINA TUNIKOWSKA
List of works
GEMMA VERCHI
Notes
VITALIANO TIBERIA
Picture research
NICOLETTA POLTRI TANUCCI
Layout
GIOVANNI MELADA
Editorial assistant
MICHELE BUZZI
Editorial secretary
ADA JORIO

Translation copyright © 1978 by Arnoldo Mondadori Editore, Milano
First published in the United States by Reynal and Company, Inc.
Originally published in Italian in 1978 by Arnoldo Mondadori
Editore, Milano under the title BAROCCO E ROCOCO
Copyright © 1978 by Mondadori-Shogakukan
Photographs copyright © 1978 by Shogakukan Ltd., Tokyo, Japan
Text copyright © 1978 by Mondadori-Shogakukan
All rights reserved. No part of this book may be reproduced or
utilized in any form or by any means, electronic or mechanical,
including photocopying, recording or by any information
storage and retrieval system, without permission in writing from
the Publisher. Inquiries should be addressed to William
Morrow and Company, Inc., 105 Madison Ave., New York, N.Y. 10016.
Library of Congress Catalog Card Number 78-56117
ISBN 0-688-61205-9
Printed and bound in Italy by Officine Grafiche di Arnoldo
Mondadori Editore, Verona

CONTENTS

THE WORLD AS STATUE OF GOD

Man is the epilogue of the World itself.
The World is the statue, the image, the living
temple of God,
in which he has expressed his gestures
and written his concepts;
he has adorned it with living statues,
simple in heaven,
but complex and weak on earth;
but they all lead to Him.

(Tommaso Campanella,
De sensu rerum et magia, 1604)

"Don't speak to me of anything that isn't great," said Giovanni Lorenzo Bernini, the greatest sculptor of his century, upon his arrival in Paris. The seventeenth century has been called the *Aureum saeculum*, the *Siglo de oro*, the *Grand siècle*, and so forth. Its style wavers between the grand manner and "good taste." In a world dominated by Roman Catholic ideology, it was only to be expected that the "message" of sculpture should go forth from Rome. The vast number of Roman sculptors dispersed throughout Europe is significant: Domenico Guidi in France, Giuseppe Peroni in Sweden, Francesco Fanelli in England, and so on. Significant too is the great number of works sent abroad by Roman sculptors: to England by Bernini and G. B. Foggini; to Malta, France, and Spain by Alessandro Algardi; to Malta by Guidi; to Spain by Francesco Fanelli.

Sculpture was undoubtedly the best field for the demonstration of virtuosity. And, indeed, Bernini's First Commandment was "If you want to know the extent of a man's ability, give him something difficult to do." Through the important works of restoration undertaken at the time, sculpture became well acquainted with the art of antiquity. (According to the sculptor Orfeo Boselli, author of the treatise *Osservazioni della scultura antica*, restoration was not "a mediocre art, as many people may think, but rather a venture so varied and sublime that it equals the greatest forms of art.") Sculpture became an international language, which, despite its differences and repetitions, could be understood from Rome to Minas Gerais.

Within the Baroque movement sculpture has a predominant place, one which stands out distinctly among the many complex forms of art. When, in 1626, Cardinal Ludovico Ludovisi set the first stone of the church of Sant'Ignazio, the procession solemnly walked along the area where all the arts employed in the building of the church were to be represented in painting and sculpture: the arts of building, architecture proper, painting, graphic art, minting, brickwork, music, stone-cutting, encaustic, goldwork, weaving, incense-making, and others. These were only the more general forms of art; that which today is known simply as "sculpture" was then divided into nine specialized techniques.

Statuary was considered to be separate from sculpture proper, just as *crustaria*—polychrome intarsia—was considered separate from *nigellaria* (the art of niello) and *celatura* (bas-relief); casting was considered separate from ironwork, and woodwork from modelling (this last being the "mother" of the three arts: statuary, sculpture, and chiselling, according to the ancients).

In Baroque philosophy sculpture has a fairly formal rhetorical role to play. Take, for instance, Tommaso Campanella's words: "Man is the epilogue of the World itself. The World is the statue, the image, the living temple of God, in which he has expressed his gestures and written his concepts; he has adorned it with living statues, simple in heaven, but complex and weak on earth; but they all lead to Him." And if God created the world through the three major arts (sculpture, the statue; painting, the image; and architecture, the living temple), Baroque Man chose to identify himself with sculpture particularly.

THE PROBLEMS OF BAROQUE

In order to understand the spirit of Baroque sculpture, one should first try to understand the motifs of the seventeenth century, which will give us a key enabling us to interpret the works: new science and the sense of the infinite, rhetoric, nature, metamorphosis, religion (or piety), classicism, a use of enchantment, and interchangeable techniques.

NEW SCIENCE AND THE SENSE OF THE INFINITE

Bernini's "dynamic" sculptures, Francesco Borromini's modelling of space, Pierre Puget's marbles, which appear both centrifugal and centripetal in conception: the whole of Baroque sculpture is the fruit of a new conception of the world. Rome had been affected by Copernicus's message, which had opposed to Ptolemy's philosophy (of a geocentric world in which man was the yardstick) a vision of the universe in which the earth was only one element, and in which, therefore, man had once more to turn to God and nature in his bewilderment. Giordano Bruno fought to uphold this severe vision of an infinitely immense universe and an infinitely tiny man; Tommaso Campanella adapted it to a sense of the mysterious in *De sensu rerum et magia*, saying that "the World is a great and perfect creature, the statue of God. . . ." The tragedy of Galileo, first protected, then condemned by the Roman Court, was a warning that the time of the Counterreformation was not yet over.

Nevertheless, one is conscious of the presence of this "new science" in the works of the sculptors, the painters, and the architects of the time. Structures show a departure from the rationality that had hitherto prevailed, and a sense of the cosmic; modelling shows an ever increasing tendency towards dynamism; painting explores *trompe l'oeil* decorative techniques in such a way that palaces and churches seem to double in size (e.g., Sant'Ignazio, painted by Fratel Pozzo); stage setting abolishes the gap there used to be between the stage and the public (Bernini's comedies, for instance, include fires and floods in which the spectators are involved). In short, the arts start to extend the limits of technique to conform with this new consciousness of the infinite. Giordano Bruno, the philosopher, though his persecution and death were a tragic start to the century, nevertheless became its prophet.

In sculpture works such as Bernini's *Chair of St. Peter* (see pages 124 and 125), or Narciso Tomé's *"Transparent" Altarpiece* in Toledo (pages 18, 59) absorb external space, integrating it, as sculptures within churches, with the sense of the infinite through the play of light which penetrates the human space, transforming it into something active and cosmic. Tomé's work is close to El Greco's mysticism in that his groups of figures would remain static were it not for the living action of light, which gives birth to a series of movements and stage settings that vary according to the hour of the day.

When Giovanni Lorenzo Bernini was called upon to create a monument to the first protector of the Church, he decided to place his statue of Constantine (see page 181) at the beginning of the Scala Regia in the Vatican. Its structure is based entirely on a double point of vision. As the spectator moves up the staircase, the statue seems to be moving upwards too, into the palace, or entering the church: the two focal points seem to put into doubt the geocentricity of Ptolemaic Man. Bernini had adopted the same philosophical vision when he designed the triumphal colonnade of St. Peter's, where no spectator was ever able to command a single view of the entire structure, for the piazza having been designed with two focal points, the spectator was obliged to move around it, becoming therefore an actor in the stage set of the infinite.

Borromini, on the other hand, usually worked out his designs in a more scientific manner: more than a piece of architecture, the colonnade he designed for the Palazzo Spada is a workshop model, in which visual space is illusory and relative to the various points of vision. It is like something seen through an Aristotelian telescope, a fact borne out by a hitherto unpublished drawing by Borromini in the Albertina (no. 335) in which a sunset or sunrise is seen through a *camera lucida*.

It was eventually Newton, with his *Optics, or a*

Treatise on the Reflexions, Inflexions and Colours of Light, who brought to an end the intuitive period of Baroque and opened the era of Rococo.

RHETORIC

In that century that explored the persuasive power of images, the study of Aristotle's *Poetics* no longer sufficed and his *Rhetoric* was rediscovered. Nevertheless, poetry and literature continued to prevail along with philosophy. Sayings such as Giambattista Marino's "The poet's aim is wonder" became a kind of leitmotiv, as were Gabriello Chiabrera's "Poetry must cause eyebrows to be raised" and Bernini's "Talent and design are the magic means through which sight may be deceived." There were also Góngora's somber, solemn verse, Shakespeare's "play within the play," and Pascal's and Racine's austerity.

Subtlety became a means of rhetorical communication, and by the middle of the century Emanuele Tesauro could write: "Because of this mute things can speak, lifeless ones can live again, dead ones can rise again: Tombs, Marbles, Statues are given voice, spirit and movement and may discourse with intelligent men." Sculpture was looked upon as a language, a metamorphosis between man, God, and sculpture, a living interpretation of the plastic phenomenon in its relation with man.

During the whole of that century in Europe, rhetoric was a language commonly shared. It expressed itself through "rhetorical figures," that is, linguistic transpositions of mental concepts. In fact the whole of the art of this period can be viewed through this kind of Aristotelian telescope. The most widely used of these rhetorical figures were hyperbole, antithesis, anastrophe, metonymy, ellipsis, and, above all, metaphor, "the most subtle of all figures," according to Tesauro.

The first characteristic of the metaphor was its power to lead the intellect from one concept to another, as in stages in a journey. Aristotle defined it as a process which "transfers to an object a name that is proper to another object; this transfer may be from type to species, from species to type, from species to species, or through some analogy." The Baroque writer Baltasar Gracián describes it as "a mobile word which quickly identifies an object by means of another." To the notion of *mobility*, in this new dynamic period, is therefore added that of *speed*. Baroque sculpture is almost always based on this rhetorical figure: the bees from the fountain on the Piazza Barberini, for instance, spew forth water instead of honey; in the loggias of St. Peter's which support Michelangelo's cupola are four huge statues of saints—metaphorically the "pillars" of the Church. In Algardi's *Sleep* (Rome, Galleria Borghese) the touchstone from which the statue is carved becomes a symbol of technical difficulty but also a metaphor of sleep as a dark matter—in Tesauro's words, one had to "find similarity in dissimilar things."

Another key figure of Baroque rhetoric is hyperbole, which consists in exaggerating a concept. An example of this is Giovanni Lorenzo Bernini's baldachin over St. Peter's tomb, a real manifesto of Baroque. The twisted columns supporting a dynamic structure which, if static, would be absurd, were criticized in Bernini's time. "He said," commented his rival Borromini, "that baldachins are not supported by the columns but by trussing, and that in any case he wanted to show that it was supported by the Angels; and he added that it was a fanciful dream." These columns—which also become an allegory, for Bernini adorned them with laurel shoots (emblem of the poet pope and the Barberini family) instead of vine shoots—are in reality a hyperbole. Bernini did not "invent" them but, having seen their shape in the ancient vine-adorned columns which formed Constantine's *bower* in the apse of the basilica, he then used

them in the upper part of the Relics Loggias and the Sacrament Chapel. The hyperbole resides in the disproportionate enlargement of the form, in the richness of the gilded bronze, in the profusion of details, in the feeling of utter energy that emerges from the work. In short, this immensely magnified work, placed practically in the center of the transept of the church—itself the center of the Christian world—aspires to the austere greatness of Michelangelo's cupola (page 186).

Ellipsis, another figure of Baroque rhetoric, consists in the omission (and so the implication) of a word or a proposition. The most obvious aspect of Bernini's *David* (Rome, Galleria Borghese) is not so much the use of space or the Michelangelo-like opposition of forms which are at the limit between sculpture and architecture, but, rather, the omission of Goliath (see pages 92, 93). The fact that the giant is missing indicates that the young Biblical hero's opponent exists conceptually, but only in human space (for almost all other sculptors include Goliath's head or body in their work).

Metonymy is the substitution of the name of an attribute for that of the thing meant; in this case the substitution takes place between the whole and its components (i.e., the microcosm and the macrocosm). Synecdoche is evident in many Spanish works of sculpture, such as Juan Martínez Montañés's *Child Jesus* in Seville cathedral (page 170), in which the small figure is invested with the implication of the "mystical body" and the whole religious mysticism of the Spanish people. Antithesis is, on the other hand, the contrast between components: light and shade, flatness and curve, concave and convex. An example of this can be found in Algardi's *Donna Olimpia Pamphili* (page 102), in which there is a contrast between the face and the mantle and hood which frame the face in a "cosmic" sense—alternating human and inanimate forms, a sense of fullness and void, reality and unreality.

Oxymoron, yet another figure of Baroque rhetoric, is the conjunction of seeming contradictions. It is often used in Baroque as something akin to allegory and metaphor. An example of this is Bernini's *Bust of the Sun King* at Versailles: originally it rested on two nonhomogeneous elements—a globe and a trophy of arms which also had a hyperbolic function on a technical plane, since their juxtaposition was hardly "sculptural." Anastrophe, too, is based on contradiction, for it consists in the inversion of a normal syntactic construction. An example of this is Bernini's *Fountain of the Rivers* (see pages 37 and 107–111). There the obelisk is placed where one would normally expect the gush of the fountain; similarly, at the base, instead of a water-filled basin, one finds an exotic solar symbol, crowned by the papal dove, on a base of perforated rocks.

NATURE AND METAMORPHOSIS

A new and important feature of the seventeenth century is its concern with nature, and therefore with the elements and their transformation. Usually this is a dynamic vision, characterized by variability and metamorphosis. After a first concern with the subject matter of natural elements, Baroque art started to borrow from nature its own organic rhythms until it reached a deliberate attempt at "the natural" (even though Bernini says, through one of the characters in his comedy, that "where there is naturalness, there is artifice"). The universe was analytically broken up into its four elements until it could look upon itself in its primal wonder. As it was said in the description of a feast in 1637, the choreography was deliberately a "prodigious but regulated chaos."

The masterpiece of Bernini's youth is the group of *Apollo and Daphne* (Rome, Galleria Borghese), in which feelings are expressed in an almost geometric kind of ballet; it is a deliberate allegory of

metamorphosis (see pages 36, 37). The work contains the various elements of Bernini's cultural personality. First, the illustration of literature: the sculptor chooses a classical text and translates it into modern terminology. Then, the allegory: in this case the theme is the punishment of violence, as a poem of Maffeo Barberini (the future Pope Urban VIII) explains. Here the moral is understood in a medieval sense, for Barberini says that "the lover intent on pursuing the fleeting joys of love ends up with a handful of leaves or bitter berries." Marino, too, the genius of poetic metamorphosis who several times wrote about the myth of Apollo and Daphne, had to "moralize" in every canto of his sensual poem *Adone*. The hidden significance of this emerges only after a careful examination of the work: the episode of Daphne's transformation into the laurel tree sacred to Apollo can also be taken as poetry and, therefore, as an allusion to Maffeo Barberini (besides, the laurel is part of the Barberini coat of arms). The same allusion appears also in other works that Bernini made for the Barberinis in his youth: the *Abduction of Proserpina* (pages 2, 90, 91), *St. Bibiana*, and the baldachin of St. Peter's, which eventually became the personal monument of the poet-pope.

The subject matter of Apollo and Daphne was treated several times during the seventeenth century (for example in Matthias Rauchmiller's superb ivory carving), and also in literature (as far back as 1594, when Rinuccini first broached the subject with his drama *Dafne*). The real, original reference remained, however, Ovid's poem. The theme of transformation and metamorphosis is also a link with another characteristic of the period: theatricality. Though the text may fall into the field of the commedia dell'arte (a form of art in which Bernini himself was to dabble), the canvas and the form remain. In the great spectacle which starts from Rome, static stage setting vanishes and is replaced by set changing in full view of the spectator!

Characteristic of the time are its great ephemeral feasts, with their supercomplex machinery spewing forth fire and water. An example is Bernini's *Minerva's Elephant*. Fifteen years before erecting the monument to the glory of Alexander VII, the "Sun Pope," Bernini had experimented with a spectacle of fireworks in honour of the birth of the Spanish Infanta in 1651, in which he had used a construction eight meters high, from which an elephant blew streams of fire through its trunk; this symbolized fortitude. Many sculptures of the mature Bernini were derived from a work he made late in 1621, the catafalque of Paul V in Santa Maria Maggiore: his *Veritas* is a prototype of *Truth* (Rome, Galleria Borghese), his *Misericordia* a prototype of *Charity*, from the tomb of Urban VIII in St. Peter's, and so on. The catafalque of Paul V (for which the young sculptor was allotted a mere forty days to sculpt sixteen large figures and twenty angels) was used by Bernini, seven years after he had embarked in his artistic career, as a source of publicity for his work. Later, even the baldachin of St. Peter's, which had to be made in a hurry for the pope's Jubilee, was at first made of ephemeral materials such as stucco, wood, and cloth. Metamorphosis, therefore, was not confined to natural elements only, but also affected artistic techniques.

The Ovidian theme of transformation is present in many sculptures of that time: one of the favourite subject matters was the *Abduction of Proserpina*, of which we find a version in Versailles (François Girardon's grandiose vision of the theme), and another in Francesco Schiaffino's fluid group in Genoa; both versions were modelled on Bernini's. The myth of Proserpina was particularly popular with artists at that time because it represented the eternal renewal of nature. It is rarer to find the same subject matter in architecture. Examples of metamorphosis in architecture may be found in the details of modelling that Borromini always sculpted

with his own hands: under the large cornice of St. Ives's cupola in the Sapienza may be seen a classical frieze traditionally composed of ovolos alternating with palmettes—at least this is what an inattentive visitor would see. The attentive spectator, on the other hand, might spot Borromini's subtle use of metamorphosis, for the palmettes are transformed into contracted wings, the ovolos into grim bald heads. And in fact the key to this is linked with the theme of knowledge (the church of La Sapienza is the Roman University church), for the transformation of these architectural details evokes a series of cherubs which have always been the symbol of lucid intelligence.

The real triumph of nature and its metamorphoses occurred in the Rococo period (the decoration of certain Piedmontese villas, for instance, the sculptures at Caserta, where the great cascade ends with the transformation of Actaeon, or Giacomo Serpotta's androgynous figures), but it is already present in the Baroque vision. One has only to remember that the Arcadian Academy was founded (by members of the circle of Queen Christina of Sweden) in Rome in 1690, within the span of the Baroque era. The intellectuals of the time were obviously aiming at a structure in which to evolve their ideas, a structure no longer historical, like that of the ancient academies, but a strictly natural one.

ASPECTS OF RELIGION

In the seventeenth century religion sometimes seemed to have more to do with the theater than with faith, and from "propagandist" Rome to absolutist France ("one king, one Faith, one law"), from mystical Spain to the Roman Catholic centers of central Europe (such as Bavaria), the religious problem is reflected in the language of sculpture.

At the beginning of the century, in the context of a Rome which remained faithful to a "primitive form of Christianity," it was possible for an artist to create a purely religious piece of sculpture, such as Stefano Maderno's *St. Cecilia* (pages 80–81); linked with Bosio's research in the catacombs, this piece is an exception in the growing climate of "society" religion. One of the first acts of the new papal policy was the founding of the *Propaganda Fide*, in 1622, a center of missionary coordination linked to such orders as that of the Jesuits. This corresponded also to an important moment in the history of the Baroque movement, for it marked the establishment of religion as a universal mission.

Other important moments were the strengthening of the Inquisition (especially in Spain), the confirmation of the legislation adopted at the Council of Trent, the open strife with French Jansenism which was to last for the rest of the century, the Jesuits as soldier-priests, as Voltaire saw them. In this context, and at the center of the whirlpool, Bernini's sense of religion, as expressed in his art, was at first opulent and visionary (*St. Theresa*, for instance; see pages 33, 112–115); towards the end, however, it became mystical to the point of morbidity and given to expressions of sanctimony (*Fonseca Bust*, page 180). Borromini's religion, on the other hand, was ardent and tormented, and faithful to the Biblical vision to the point of making a philosophy of it.

The Jansenist vision of the world, rigorous to the point of tragedy, ended with the destruction of the abbey of Port-Royal by Louis XIV, in 1664. French culture was given its double face by Descartes and Pascal: logical, orderly, yet refined in its sense of the spiritual. According to the Jansenist vision, the world was a tragedy in which the sole spectator was God—which shows that we are still evolving in the theatrical sphere. The sculptors had to express the official face of religion: Girardon's *Tomb of Richelieu*, for instance (page 130) is all vitality; Antoine Coysevox's *Tomb of Mazarin* is all movement; Puget's religious statues strike attitudes

reminiscent of mythological heroes (pages 42, 129).

In Spain economic crisis reinforced religion in a popular sense; profane sculpture practically vanished and was replaced by a steady stream of processional statues. El Greco started to apply his genius to the decoration of altarpieces. Sculpture, which was almost always made in polychrome wood (Montañés, Alonso Cano, Pedro de Mena), concentrated on single characters, with a medieval cultural background but a popular tone.

CLASSICISM

The basic problem, not just of Baroque, but of the whole of Italian art is, paradoxically, the alternation of various types of classicism. The seventeenth century inherited from the ancient world two forms of art: art as imitation and art as idea (expressed in painting, for instance, by Caravaggio and the Carracci). A sculptor such as Bernini seems to encompass both viewpoints: in his youth his most famous groups are reminiscent of Hellenistic sculpture; later, too, when he went to France, he discoursed at length on classicism with the Sieur de Chanteloup. An important aspect of this reference to classical art was the extensive and persistent process of restoration of ancient works of sculpture: Nicolas Cordier and Pietro Bernini, Algardi and Giovanni Lorenzo Bernini, Boselli (author of a treatise on the subject), and Giulio Cartari all worked on the restoration of ancient works of sculpture. Many palaces and villas were decorated with classical bas-reliefs which mingled unselfconsciously with modern sculptures: the Villa Borghese, for instance, or the Villa Doria Pamphili, for which a team headed by Algardi proposed almost a whole façade recently excavated.

If Bernini favoured Hellenistic art as a model, Algardi preferred the more severe form of classicism, and François Duquesnoy the more languid style of Praxiteles (page 97). The *putti* entangled in the draperies in his little tombs at Santa Maria dell'Anima have a waxlike transparency and an extraordinary luminous grace. In his reliefs (e.g., the *Filomarino Altarpiece* in Naples) he depicted playing *putti* in an almost painterly manner reminiscent of the style of his friend Poussin, the new "prophet" of classicism in Rome. This seventeenth-century Apelles, whose most classical work was done for the Barberini family (the *Death of Germanicus*, now no longer in Italy), started as a painter and worked in St. Peter's (*The Martyrdom of St. Erasmus*). As for Algardi, his training as an architect led him to a more structured style in sculpture: and so this style was perhaps less influenced by the more severe form of classicism than by a vision of ancient sculpture tempered by Roman interpretation.

The restoration of ancient works obviously influenced "modern" modelling: Bernini's Apollo in the group of *Apollo and Daphne* is reminiscent of the *Apollo Belvedere*; Algardi's *St. Philip*, with his oratorial pose, is reminiscent of Demosthenes; Duquesnoy's *St. Susanna*, which remained a model until the end of the eighteenth century, is a mere transposition of a draped antique statue. Even in architecture (e.g., Borromini's) the effect of restoration was to make artists discover new elements in ancient art. Borromini's classicism was not derived from a set of rules (even if today we are aware that he was influenced by Bramante, Alberti, and Palladio), but was rather more sensitive to the more exceptional examples of classical art (tombs with articulated structures, reliefs on Montano's temples, the exotic sculptures of Hadrian's villa at Tivoli).

The basic theories of this modern classicism were first formulated in Rome by Giovanni Pietro Bellori, but its practice was to be found mostly in Louis XIV's France (even as a dialectic element in a dynamic and illusionistic language). In a lecture by Bellori in 1664 (*L'idea del pittore, dello scultore e*

dell'architetto, scelta dalle bellezze naturali, super-iore alla natura, later published as a preface to his *Vite*, 1672), Bellori himself emerges as a mediator between Rome and France: his friendship with Poussin, for instance, was well known, and he dedicated his book to Colbert. It was on Colbert's initiative (but also upon the advice of Bernini, who had himself just returned from his sojourn in Paris) that the Académie de Rome, in the Villa Medici, was founded in 1666. There, French artists could learn the Roman manner.

There is evidence of classicism also in Protestant England, in northern and even central Europe (e.g., Georg Raphael Donner's austere sculpture in Austria). Quite logically one of its problems became a preoccupation with the ancient world. Bellori's vague theory of art as something "superior to nature" was to be enlarged upon towards the end of the period we are dealing with here by Carlo Lodoli's rationalist beliefs, Francesco Milizia's disciplined censure, and J. J. Winckelmann's return to "the Idea."

THE MIRABILE COMPOSTO

The various components of art lose their individual importance as means of communication before their rapport with the spectator, who becomes the "goal" of Baroque art. An unprejudiced inter-exchange of techniques (defined by Bernini with the theatrical expression of *mirabile composto*) can then take place, which results in sculpture being absorbed in the context of "rhetoric" and "pro-paganda." The use of artifice triumphed and became the natural taste of the century. "It is a matter of establishing an easy and unbelaboured style, and hiding any difficulties as far as possible," said the Florentine Roberto di Ridolfi; the Venetian Marco Boschini, on the other hand, said that "artifice was joined to Nature"; Bernini, finally, asserted that "where there is naturalness, there is artifice."

Art as artifice had its appointed place: the spectacle. First and foremost, the great *feste*—feasts, balls, or spectacles—to which the great sculptors all contributed. The very ephemeral character of these "happenings" meant that they could explore new techniques, search for new effects (of light, for instance), or even test the public for its reaction to public works which were actually made years later. There was also the field of theater proper, in which stage sets bore the fruit of discoveries made by sculptors and architects on dynamism, metamorphosis, and enchantment ("The stage is a moving and talking picture," says an eighteenth-century theoretician). To faith in the absolute value of perspective space there succeeded a fanatical belief in relative space, in which the public played a fundamental role and which allowed for endless and numberless perspectives and a constant trans-formation of the sets within sight of the public. The machinery and effects were the brainchildren of the great sculptors of the time: Bernini, Giacomo Torelli, the Burnacinis (who were also active in this field in Vienna), the Vigaranis (who also worked in Paris) and the Jesuit, Andrea dal Pozzo.

Art as artifice and theatricality prevailed throughout the seventeenth century, and in this the supreme master was Bernini. Even today, the *Ecstasy of St. Theresa* (pages 33, 112–115) is analyzed in an incomplete perspective: its mystical content, its sensuality, its liquid modelling, the balanced relation of the figures, and so on. But the view remains a narrow one, unless one understands that the figure of the saint is not only the focal point but also the nucleus reflecting all the space which Bernini has created around it. Without an analysis of the complex play of architecture, sculpture, painting, inlay, and even light, the group itself has little value. The surroundings unfold before our eyes like a stage set: an empty space in a church becomes a set, a stage, a hyphen between life and art, the functional context of different inventions.

15

From above and from the right, from the left and from the back, and even from below, the enclosed space begins to pulsate and record the presence of life and the world beyond. The kind of spectator that Bernini wished for does not remain passive and inert before the spectacle, but takes part in it: he is not the pious man who prays outside the chapel, but the active man who enters it and experiences its message. He must go forward and backward to make out the credibility of the side shelves where the dead lean from, who have just come out of their coffins; he must go very close to the altar to look at the "*sancta ex machina*," but also to understand where the light is coming from; he must notice that clouds are hanging above, superimposed over the painted scenes and bas-reliefs; he must tread with surprise over the two skeletons inlaid in the marble floor. The work of sculpture itself is merely incidental: what is important is the arrangement of space around it, which was the fruit of the "new science" of "trying and trying anew."

This global vision prevailed in the whole of Roman Baroque (a good example of this being the Church of Gesù e Maria, which is entirely built around the figures of the dead represented alive and facing the altar from their biers), in Spanish Naples (e.g., the representation of Virtue and Death in the Sansevero Chapel), in Florence under the Grand Dukes of Tuscany (e.g., the Corsini Chapel at Santa Maria del Carmine), and also in Spain and central Europe (the magnificent *"Transparent" Altarpiece* by Narciso Tomé in Toledo—pages 58–59—or the spectacular German altars made by the Asam brothers—pages 52–53), and even in colonial Brazil. There certainly is a method behind this madness, as Shakespeare might have said, and a schizoid interpretation of the world ("*La vida es sueño*"—"Life is a dream"—says Calderón de la Barca). By the time Descartes and Bacon established the search for a method that prescinded the peculiarity of individual branches of learning (*Novum Organon*, 1620; *Discours de la méthode*, 1637), we are in the thick of the system of exchange between the different techniques and recomposing with new elements. These are arbitrary in appearance only, and eventually they find their way into the streams of the "new science."

TYPOLOGY

In order to appreciate the complexity of Baroque art, which is made up of several elements and phenomena, each of which is part of a harmonious whole, we propose to analyze these according to types. This deliberate breaking up of the whole will highlight the various components which make up the spectacular universality of the "*mirabile composto.*"

THE PORTRAIT

Seventeenth-century busts reflect not only the new "dynamic" technique but also, as in the sixteenth century, the dignity and power of the sitters. At the beginning of the seventeenth century, the classical theoretician Giovanni Battista Agucchi asserted, "One should not try to imagine what Alexander's or Caesar's face was like, but what the face of a king or some powerful captain should be." It was Giovanni Lorenzo Bernini who established, with his triumphal bust of Louis XIV, the European model of the fusion between official portraiture and the new manner of depicting a sitter.

At the beginning of the century the Roman sculptors Maderno, Cordier, and Pietro Bernini gave their sitters frozen faces. The bust sculpted by Pietro Bernini (*Antonio Coppola*, Rome, San Giovanni dei Fiorentini, also attributed to the young Giovanni Lorenzo Bernini), is typical of this style: the figure is represented like an ancient bust,

complete with toga, and seems borrowed from some antique bas-relief; but the sculptor's energy is concentrated on the face itself. Cheeks abnormally sunken, the mouth drawn in a final rictus, hollowed eye sockets: all these details remind one of a death mask. The portrait is still, as indeed it was in the art of antiquity, a depiction of suffering (and therefore of death), rather than a psychological interpretation of a person.

It was, once again, Giovanni Lorenzo Bernini who, in the 1630s, was to establish a new type of portrait, a vital and dynamic image; he was at the same time to establish new types of statues, groups; a new kind of architecture, fountain, altarpiece, and even a new approach to death in art. His *Scipione Borghese* (Rome, Galleria Borghese; see pages 6, 104) expresses for the first time some sense of communication, a dialogue with the surrounding world. The cardinal is shown moving his head and opening his lips as if about to answer a question. The image depicted requires the presence of a spectator, for here again, Baroque sculpture is not self-contained but something that is open to interpretation and to a dialogue with a hypothetical interlocutor. The portrait, fixing the character of the sitter, is therefore open to confrontation, and there is only a step from the representation of a social type (the rich, good-natured patron) to a theatrical interpretation. Scipione Borghese is caught in the act of speaking, but this would have little meaning were it not for the presence of the ideal spectator, i.e., the sculptor himself, gazing at his model with the chisel in his hand, and eventually the public itself.

Algardi's attitude, on the other hand, is more dialectical: he presents his portraits as an objective look at the present. His *Innocent X* (page 118), often compared to Bernini's merciless portrait of the same character (which is itself comparable to Velázquez's), is a rather idealized and static interpretation. The sculptor here is not interested in a psychological interpretation of his sitter's character, but rather in the dogmatic security of both his spiritual and his temporal power ("*L'Etat c'est moi*"). The two different attitudes of Bernini and Algardi were fairly quickly diffused elsewhere in Europe, and they engendered a double attitude to the sitter: on one hand the sitter as reflection of authority, and on the other as worldly and theatrical interlocutor.

When Coysevox made his *Bust of Louis XIV* (Versailles, Château), it was naturally as a rival to the one Giovanni Lorenzo Bernini had made in 1665. Perhaps Coysevox did not fully understand the meaning with which Bernini had invested certain details (the billowing cloak, for instance, was an allusion to Hercules on top of the mountain of Virtue), perhaps he did not fully grasp the dynamic "framing" of the work (Bernini conceived the work "from below upwards"); nevertheless he understood the decorative value of the curly hair and the lacework, and altogether he approached the work with a fairly vital vision which was in opposition to the French official backing of classicism. What escaped him altogether, however, was the important allegorical value of Bernini's portrait: one has only to notice how he depicts the sun on the pedestal, whereas Bernini (who originally wanted to use a globe for the pedestal) represented the king as the very image of the sun. Coysevox has recourse to the use of symbols, whereas Bernini (to whom the king, viewed "from below upwards," must indeed have appeared as the sun) had used the Baroque figure of allegory.

If Bernini's vision was twisted out of all proportion in the Rococo period, there nevertheless remained a real link with it; an example of this is Jean Antoine Houdon's *Voltaire* (Paris, Bibliothèque Nationale; page 143), in which the ironical and skeptical character of the philosopher is caught by a merciless chisel that emphasizes the thin, almost skeletal face, with its scornful smile and

bright eyes. What Houdon wanted to show there was that man's face bears the imprint of his own death.

THE STATUE AND THE GROUP

At first a self-contained entity, the Baroque statue became steadily ever more complex, until, at the height of the period, it had reached a point where, even if it were not part of a group, it nevertheless imposed itself as a group (partly, of course, through the usual Baroque participation of the onlooker).

Giovanni Lorenzo Bernini's first attempts in the field of statuary were almost inevitably influenced by the Tuscans and the Mannerists (*Aeneas and Anchises*, *The Abduction of Proserpina*; Rome, Galleria Borghese; see pages 83 and 2, 90–91). Yet a dynamic element was already in evidence in these early works. The first group expresses the different ages of man through an undulating movement, almost a spiral or a twisted column of human forms. In the other group the sculptor tries to resolve the spatial relationship of two figures, with the three-headed monster Cerberus as observer of the three-dimensional operation. The Tuscan Francesco Mochi was also undoubtedly influenced by sixteenth-century Mannerism, but there is more than an intimation of Baroque in such works as his figures of saints in San Bernardo alle Terme or in his incredible *Annunciation* (Orvieto, Museo del Duomo, pages 88–89). In these large billowing statues there remains a naïve spatial arrangement which makes the angel and the Virgin (even though they are treated with energy and a certain ardour) not so much a group as a juxtaposition of two figures in the old-fashioned sense. Even if many art historians consider Mochi to be pre-Baroque, this interpretation should be reconsidered in the light of his conscious choice of a paratactic vision in contrast with Bernini's grandiose and syntactic vision.

The first great instance of the new conception of statues (i.e., as groups in a stage setting) dates from the time when Bernini was working on the baldachin of St. Peter's: the four loggias supporting Michelangelo's dome, with their gigantic marble statues sculpted by Andrea Bolgi, Duquesnoy, Mochi, and Bernini, under Bernini's direction. The transept of St. Peter's thus became a round theater in which the action revolved around the baldachin. In the foreground was the saint reciting his monologue; and in the background—i.e., above—was an allusive representation of the Passion of Christ through the four relics of saints placed on the large pilasters supporting the dome and representing metaphorically the pillars of the Church. This "contrapuntal" theatrical conception is reminiscent of the Elizabethan double or upper stage and the Spanish *corral*; it is also typical of Baroque conception. In this instance the two planes are still divided, but soon the symbol is to vanish in order to make place for the allegory. The deliberate use of the "double" motif is evident in the gesture of Bernini's *Longinus*, as in Mochi's windblown *Veronica* (page 101): Longinus's gesture is cruciform because he had pierced the crucifix with his spear; St. Veronica is wind-tossed in reference to the breath of mysticism which is to invest her kerchief. An exchange takes place in the church between all these statues which introduces into the space allotted to them the organic metamorphosis of nature.

Puget's *Milo of Crotona*, de Mena's *Penitent Magdalen*, and Balthasar Permoser's *Flora* are, respectively, in the Louvre, in the museum at Valladolid, and in the Zwinger at Dresden. Puget's *Milo* (page 128) is in effect a plastic group: the figure of the athlete being devoured by the lion expresses a new sense of space. It is natural that Girardon, on a visit to Genoa, should have expressed disappointment at not finding in Puget's works "natural beauty and a fine display of

draperies" but rather "*a striving for effect.*" There is no longer evidence of the tortuous structure of the Roman sculptures of Bernini's time but instead a complicated criss-crossing of vectorial lines that bear the weight both within and without and join centripetal and centrifugal force into formal synthesis. De Mena's *Magdalen* (page 172) and Permoser's *Flora* are extremely different from each other, even if their colour is similar: the former is like a dry trunk, though the dramatic gesture and the mass of hair invest it with some dynamic force; the latter is a bucolic staging of nature. On one hand mysticism and on the other Arcady.

One last element to be included among statues transformed into groups is the great ensembles of statues in the basilicas (San Giovanni, St. Peter's) which for a century now had enabled young artists to confront their own works with those of the old masters. One should mention also works of sculpture on the exteriors of churches, such as the group of ninety-six saints in the colonnade of St. Peter's. They are something like a huge workshop and are part of the cloth of Baroque Rome, despite Winckelmann's ironical comment: "Most of the last great statues in St. Peter's, Rome, are nothing but huge pieces of marble that, when still untouched, cost 500 *scudi* each. If you've seen one, you've seen them all."

THE MONUMENT

Monuments have always been connected with history, partly because they are usually placed in the center of a city as social examples. The classical idea of a "monument" permeates in a curious way that fantasy work, the monument to Carlo Barberini on the Capitol, in Rome: the body consists of the antique figure of a Praetorian guard wearing an intricately carved cuirass; the limbs were restored by Algardi, and the head is a portrait by Bernini. The present has recourse to the past, but from the combination of the two a new language is born: the modelling is based on the antique; the gesture indicating command and power betrays an orthodox classicist; but the psychological approach to the almost priestly head belongs to the Baroque era.

There is another instance of a confrontation between Algardi and Bernini on the Capitol—the two monumental statues of Urban VIII and Innocent X (page 118). Bernini's marble work and Algardi's bronze are the reflection of a mentality which consists in believing that people are living in a golden age, whereas in fact they are in the midst of an economic, political, and religious crisis: it is therefore logical, in that century that saw politics become art (artifice), to see art becoming a political statement. Here, the figures of the two Roman popes are in fact placed on the holy spot of laicity (and indeed there is written proof that the statue of Urban VIII was placed in position in the middle of the night), on that hill on which Cola di Rienzo had hoped never again to see a pope.

Another type of monument is found in the equestrian statues, although these are linked to the tradition of Donatello and Verrocchio. Among the most spectacular are Mochi's two Farnese monuments in Piacenza (page 95), Pietro Tacca's kings in Madrid, Bernini's Louis XIV at Versailles (page 126), and many others, including Andreas Schlüter's monument to the Great Elector in Berlin. In these triumphal representations of power, history and nature are united.

Pietro Tacca's two monuments in Madrid (Philip III in the Plaza Mayor and Philip IV in the Plaza de Oriente) show two possible developments of the type: the first is static, the second violently dynamic. The statue of Philip III is interesting because of its potential dynamism, which had been prescribed by the sitter ("The horse should be seen to be galloping, but should not lift its feet too far from the ground; it should rather appear to be

curveting"); the monument of Philip IV is more remarkable, for it shows the horse and rider rearing impressively in a way which would not have pleased the sitters a few years earlier.

Mochi's two monuments in Piacenza (Alessandro and Ranuccio Farnese) are the two dynamic focal points in a piazza which is hardly elliptical. The monuments are modelled after the antique statue of Marcus Aurelius in Rome, and this adds nobility to a family which had only fairly recently risen to power; the *putti* on the base of the monuments (which go from pathos to drama) give the key as to how the monuments should be interpreted: they in fact express the thought that, historically speaking, life oscillates constantly between war and peace.

After Giovanni Lorenzo Bernini finished the windblown bust of Louis XIV, he worked on the equestrian monument to the French king (page 126). In the statue of the sovereign the greatest importance is given to the bust, which is no longer a truncated one, with an allusion to death, but a living and powerful one. The windblown draperies separate the rider from his horse, and the horse itself is rearing, like the horse in the ancient statue of Alexander the Great. In the original design the horse was to be standing on a rocky base, like Hercules on the mountain of Virtue. It is interesting to note here that the third project for the Louvre was also to have a rocky base. As ever, with Bernini, the arts have no limits when he wants to express a clear political concept such as power.

THE RELIEF

One of the most ancient forms of sculpture finds new life in the Baroque period, not only because it is a form in which virtuosity can be displayed at a great advantage but also because it implies a system of exchange between different techniques: The figures emerging from the flat background or the flattened areas alternate in a technique which is no longer sculptural but pictorial, just as in other cases architecture becomes sculptural decoration, a piece of furniture becomes architectural, a fountain also, a painting becomes illusion through the use of *trompe l'oeil* (and therefore architecture), or simply tapestry.

By the middle of the century Algardi had established the type in his gigantic relief *Leo the Great and Attila* in St. Peter's. This rigorously classical sculptor was at ease in a medium that derived so much from ancient technique, and this relief is one of the works in which his virtuosity is best expressed. He invested the rigid white background with a multitude of actions and "feelings" that are all linked together through the figures of the train-bearer, the imperious pope, the barbarian, the apostles standing out against a stormy sky.

One of the most important reliefs from the point of view of the departure of the relief as a flat phenomenon is the marble bas-relief, the *Virgin of the Assumption*, by Puget (Berlin, Staatliche Museen; page 131). Here the bier is placed diagonally and the masses whirl about in a three-dimensional scheme; angels, large and small, give the scale of proportions within this centripetal and centrifugal structure. Also important are Montañés's *Retable of St. Michael*, in Jerez de la Frontera, a coloured *tableau-vivant* of neomedieval style; and Sebastian Walther's *Annunciation*, in Dresden, which displays the apparent dynamism of a sixteenth-century structure.

In many cases the relief takes enormous proportions which transform its surroundings. In the elliptical space of Sant'Agnese, in the chapel at Monte di Pietà, or in the Corsini Chapel in Florence, sculptors vie with one another in imparting a life of its own to their huge illusionistic spaces, while at the same time preserving the

stereometrical and structural quality of the architectural space.

GARDEN SCULPTURE AND THE FOUNTAIN

It is important here to explain how the concept of nature was understood in the seventeenth century. Campanella was probably the first to suggest a description of the new feeling for nature: "The world is all sense, life, soul and body, the image of the Almighty, fashioned to glorify Him with power, wisdom and love." Bruno, too, placed nature at the foundation of the concept of the infinite.

An example of garden sculpture is Bernini's *Neptune and a Triton* (pages 34, 35 and 85), once in the garden of the Villa Montalto and now at the Victoria and Albert Museum, in London. The motif is Florentine and Mannerist in taste, but as usual Bernini imparts his dynamic force to the trident, to the wind swelling up the cloth, to the frowning face. It is important to point out that it was indeed Bernini who was responsible for taking this type of sculpture from the garden to the city, transposing it from a natural environment to a social environment. This type of sculpture is conceived around the notion of water, which becomes, through its fluidity and its character as an element of nature, one of the most important symbolical forms of Baroque.

In the *Triton* fountain, for instance, the sculpture is intimately related to the water factor: the water gushes forth from the triton itself through the shell on which it blows (the idea behind it being that sound is transformed into water, just as in the nearby *Fountain of the Bees* the idea is that the water is transformed into symbolic honey); originally the water used to flow down on the shells and then further down in the basin adorned with dolphins, constituting thereby a sculptural element in its own right. The lily shape of the basin is an allusion to the French coat-of-arms—for the Barberini family, for whom the fountain was made, were pursuing a pro-French policy at the time. It may be said that Bernini even used water in his allusions (page 39).

Naples and Florence also are cities of fountains (they also happened to be Giovanni Lorenzo Bernini's father's home cities). In the Piazza dell'Annunziata and in the Mercato Nuovo, Pietro Tacca brought garden elements into a town square. In one he placed a wild boar, which is really quite out of place in its surroundings (it was certainly placed there for "effect"); in the other he put two fountains conceived as *capricci*, or fantasies on an urban scale. These fountains consist of two fantastic creatures backing each other, while the basins are like organic swellings; Tacca's most inventive feature is probably that at the center of the two shells.

In mid-century Giovanni Lorenzo Bernini achieved his masterpiece among all his monumental fountains with the fountain in the Piazza Navona (pages 38, 107, 111). In the center of the "court" of the reigning pope, Bernini placed a four-faced arch made of rocks, with figures symbolizing the four continents, an obelisk, animals, and palms. The general structure was borrowed from the spectacle in honour of the pope's coronation, which included machinery representing Noah's Ark on Mount Ararat and the four continents; this fact itself points out to the ephemeral nature of Bernini's work. The dove featured on the fountain is an allusion to the Pamphili family, but it is also the personification of the Holy.Spirit and, in addition, the dove which announced to Noah the end of the Flood. Nature is triumphantly represented with all its elements: earth, on the mountain; wind, blowing on the palm tree; water. An inscription on the north side of the fountain says, "Innocent X laid the stone adorned with hieroglyphics over these rivers which flow below and offer their water to those who are thirsty, pleasure to those who are walking, and an opportunity for those who wish to meditate."

Bernini also proposed a further interchange between nature and the city in two palaces built respectively for the pope's family and for the king of France: at Montecitorio he designed window sills and pillars adorned with rocks; for the Louvre he proposed that the palace should be placed upon a rock and surrounded by a moat, like some gigantic allegorical sculpture, in which the rock (brute earthly force) supports the structural force of Reason. And it was his pondering upon the life-filled rocks of the *Fountain of the Rivers* (with their peonies and horse, reeds, armadillo, prickly pear, snake, lemon trees, lion, and so forth) that led him to design the Trevi fountain, which is probably the most schematic example in Europe of the intercourse between palace and nature.

The synthesis between nature and the city was realized in mid-century by an artist fed on Roman Baroque but far from belonging to the Rococo movement. The Royal Palace at Caserta, built by the Bourbons as an alternative to their palace at Naples, is halfway between nature and the city, just as its function as the seat of power makes it an intermediary between nature and history, country and city, Rococo and enlightenment.

THE ALTARPIECE

Placed deep in a church or a chapel, the altar is the devout spectator's natural focal point; which in turn makes the altarpiece in many cases the equivalent of the god from a machine on a theater stage. In time the altarpiece became a global phenomenon incorporating sculpture, painting, and architecture.

In early Baroque examples, such as Maderno's great *Altarpiece of St. Cecilia* (pages 80–81), the structure is still a little rigid. Even the saint's white figure placed beneath the altar is not truly a Baroque innovation but rather the equivalent of a portrait in death. In fact the sculptor did not intend it to be an innovation but was content to fix into marble the image of the martyred saint in the very position in which her body was found when it was discovered in the course of excavations.

The altarpiece begins to take into account the surrounding space in Bernini's work for the Raimondi Chapel (Rome, San Pietro in Montorio). The dead before their open graves and the saint painted on the ceiling are preceded by a vision of the saint in ecstasy, supported by angels above the altar, or rather behind the altar, for the work of sculpture is placed as if behind a proscenium and illumined by spotlights from the wings; the whole thing is in fact one of the first examples of "theater within theater." But the real triumph of both religion and sculpture can be found in the world-famous *Chair of St. Peter* (pages 124–125) in the apse of St. Peter's. The much revered relic, adorned with decorations, is supported by the four gigantic figures of the doctors of the Church, whilst the oval window lets through the light which materializes in bronze rays and stucco clouds and gives life to *putti* of various sizes. The light in Michelangelo's apse gives birth to the drama every day (and as if by miracle the chair appears to levitate), with fireworks, crackers, and Catherine wheels, making it into one of those ephemeral feasts on which Bernini worked every year (in the catalogue of his works he describes them as "innumerable").

Bernini's art influenced the whole of Europe; we should, however, mention another splendid variant in Rome—Antonio Gherardi's Chapel of St. Cecilia, in San Carlo ai Catinari, painted, sculpted, and built at the end of the century. The saint on the altarpiece is surrounded by relief decorations which reach the double cupola, a wonderful source of light, where angels are shown playing their instruments. An angel on the entrance arch is writing on a shell "*Cantantibus organis Caecilia Virgo Dom.*" The sculpture (and the saint) triumph every time we

are gazing at the scene at the magic moment when the music stops.

The artists who established the type of altarpiece for Baroque Europe were Bernini and Fratel Pozzo (*St. Ignatius*, in the church of the Gesù; *St. Luigi Gonzaga* at Sant'Ignazio). This type of altarpiece was conceived almost as a decoration made of ephemeral material for use in the Forty Hours' Devotion. Apart from the central part, which is a sculpture in its own right, every detail of the architectural ensemble also becomes sculpture because the elements are all divided and then integrated again into a composition in which twisted columns, gold decorations, statues, broken arches, twisted pediments, and high bases intermingle. The elements are decomposed and recomposed again in a masterful manner, but Fratel Pozzo pushes his desire for a dramatic stage set too far and overdoes the use of different materials and techniques in such a way that here the Baroque language already heralds Rococo.

THE TOMB

It would be an error to think that death in the Baroque period was considered as a grim fact or in a pessimistic light: for the true Christian, death is nothing but the beginning of real life and is therefore something to celebrate. This is borne out by the innumerable catafalques that during the entire century were the center of elaborate feasts. In Giulio Rospigliosi's *Sant'Alessio*, 1631 (one of the first melodramas), the author, who was none other than the future Clement IX, extolled death in verses reminiscent of Metastasio's, with words such as "pleasant," "sweet," "source of delight," and "comfort."

Most of the sculptors of the time, from Maderno to Pietro Bernini, from Mochi to Cordier, worked on the funeral monuments of Sixtus V and Paul V in the chapels at Santa Maria Maggiore. Their works were integrated into a rigid architectural structure which stifled any personal features. This type of tomb thus became a cold curtain-like step between life and death and between the various styles of the sculptors who worked on it. In these chapels the past and the future confronted each other, whilst a hundred meters from the Pauline Chapel the young Bernini was already making his first attempts at the métier of sculptor in the courtyard of his house.

It was once more Bernini who was to establish the new type of tomb, together with a new concept of death, in his *Tomb of Urban VIII*, in St. Peter's. The figure of the pope, in bronze, sits at the summit of a kind of melancholy pyramid; he lifts his hand before two marble figures of Justice and Charity. The real key of the group, however, is in the center of the composition: Death, which was blocked up in a first project, now becomes an apparition. It is not really part of the structure, but is revealed as a powerful and active presence, holding a large book on which it is writing the dead pope's name (another name can be seen on a preceding page). It is more an apparition than a skeleton and it is not a frightening figure, for it is represented as a necessary complement to human life.

Bernini went on to design new forms of funeral monuments, simpler yet at the same time more inventive. His *Tomb of Suor Maria Raggi* (Santa Maria sopra Minerva), for instance, consists only of a medallion supported by angels but resting on a cloth that is also a curtain (like the curtain separating Life from Death in the tomb of Alexander VII); the funeral inscription itself is, with typical Baroque subtlety, transformed into a canonization bull. In Bernini's comedy *I Due Covielli* the last scene ends with one of the twin characters pointing out that the real spectacle is not onstage but rather offstage, consisting in the crowd of people coming out of the theater; and indeed at this point the backcloth is raised, showing the spectators leaving the theater in their coaches. But

here there was a spectacular theatrical effect—the sudden appearance of a large number of footmen dressed in mourning and holding black torches, and, on a skeletally thin horse, Death, also dressed in black and brandishing a sickle. Then the Coviello character comes back on the stage, explaining that Death "ends and cuts off the thread of all comedies" and ordering the final curtain to be dropped in order not to embitter the public. This was not meant as a solemn *memento mori*, but as just another moment in the commedia dell'arte and the comedy of life.

Borromini's interpretation of the tomb (and of death) is colder and substitutes the symbol for the allegory. The first chapel on the right in San Girolamo della Carità—the funerary chapel of the Spada family—is practically a room transported from a palace to a church: the marble panelling displays medallions of the dead which look like oval portraits; the Virgin on the altarpiece is a large painting hanging from a disk, and higher up, also presented as paintings, are St. Bonaventura and St. Francis. On either side of the altar two *trompe l'oeil* urns display two inscriptions which give the key to the chapel: the fact that two ancestors of the Spada family had once given a tunic to St. Francis of Assisi. This explains the balustrade (sculpted by Giorgetti) which features two angels holding a cloth; it explains the floor decorated with a carpet of inlaid roses (a reference to the rose bush on which St. Francis had rolled down). Borromini's conception of space excludes the "live" presence of Death; he prefers an intricate use of symbols that, behind the appearance of Life (the make-believe of a real room, with paintings and a table—the altar) conceal the reality of Death.

Nevertheless, it was Bernini's vision which prevailed in Italy and the rest of Europe. In Filippo Parodi's *Morosini Monument* (Venice, San Nicolò dei Tolentini) the allegory is contained in the fluid cloths and clothes, which represent the passage from life to death. Rauchmiller's *Tomb of Bishop von Metternich* (Trier, Liebfrauenkirche) features the confrontation between an old prelate and a dancing *putto*. The monument *Cardinal de Richelieu*, by Girardon (Paris, Sorbonne; page 130), shows the cardinal alive and hopeful with his sarcophagus represented as an ordinary bed, complete with bedsheet and mattress.

In the middle of the eighteenth century a more synthetic vision of Death is evident in Naples, which is the logical result of its Spanish culture. The Sansevero Chapel (pages 50, 151) displays a series of Virtues (among them the Genoese Francesco Queirolo's splendid *Allegory of Disenchantment*) that are used as an introduction to Giuseppe Sammartino's *Dead Christ*. Here the "transformation" of materials reaches absurdity: marble becomes wax in the grim draperies of the shroud, which is reminiscent of Bernini's curtain between Life and Death. Baroque subtlety is all in the design of this tomb as a great plastic and live complex revolving not around the effigy of Raimondo di Sangro, Prince of Sansevero, but around the figure of the dead Christ, who, though dead, represents the resurrection, though in the process of putrefying, represents eternal life.

THE PROBLEMS OF ROCOCO

The best way to penetrate the complex imagery of a century is perhaps *not* to analyze the meaning of the word which describes it (the word "Rococo," like "Baroque," is a later appellation, and a derogatory one at that), but rather to try to understand the image that the intellectuals of the time had of themselves. This image is reflected in three attitudes: Voltaire's unconditional adherence to the new "taste"; Charles Nicolas Cochin's ironical vision; and Stendhal's severe epitaph: "These

profane times are quite to my taste./I love luxury and even a certain soft voluptuousness./All pleasures and every kind of art./Cleanliness, taste, ornament:/All men worthy of that name feel this way/.../Superfluousness is a very necessary thing. ..." There are several significant points in this poem of 1736 (*Le Mondain*), which is certainly suffused with pre-Enlightenment irony. The most significant points are the following: a reaction against specialization in favour of more eclectic tastes ("every kind," "ornament"); a heralding of Baudelaire's sensual style ("pleasures," "luxury," "soft voluptuousness") which announces Baudelaire's "*luxe, calme et volupté*"; the consciousness (perhaps also political) that this is a "profane" moment in time; the arrogant assertion that his is an objective statement ("all men"); the discovery, certainly through an Oriental influence, of new values, such as "superfluousness."

Cochin, speaking of Nicolas Pineau's sculpture, says, "He suddenly freed himself of this rule which they had imposed upon themselves, to relate all the details in their works to one another. He divided them, cut them in a thousand pieces, and so that those who love coherence should not notice these divisions, he added apparent links between them, by means of a flower, which had itself no connection with anything else, or through some other equally ingenious device; he renounced forever the ruler and the compass. ..." This describes Rococo at its apex: a lack of adherence to any rule which might make the artistic language acceptable; the disintegration of formal structures; fragmentation taken to its extreme point; the triumph of artifice with its justification as "ingenious device"; the forsaking of normal instruments of precision ("the ruler and the compass"); the systematic recourse to excessive and redundant detail.

"If I may be allowed a base word," wrote Stendhal in his *Promenades dans Rome* (1828), "I'd say that Bernini was the father of that bad taste that people in studios describe with the somewhat vulgar term Rococo." This statement contains two significant points: first that the origin of Rococo should be directly attributed to Bernini, with all its allusions to "degeneration"; and second the open polemic of the time (in which the prevailing taste favoured graceful, simple lines) against a period which seemed to have generated only "bad taste" and "vulgarity."

But here perhaps some form of verification imposes itself. Let us examine both a manual of Rococo taste and a general work on sculpture to see whether the German attitude (namely that the new type of sculpture—i.e., Rococo—is all *Grillenwerk*, that is, bizarre fantasy) is correct and whether Mertens's statement of 1770 on sculpture is true; Mertens had said, "For a while people have been favouring scrolls and flourishes, with the result that a great number of statues seem to be suffering from belly-ache or seem to be about to start dancing the minuet, instead of allowing us a glimpse into a soul burdened with heavy thoughts."

In 1734 was published a book entitled *Livre d'ornements inventés par J. O. Meissonnier*, an extraordinary encyclopedia of the superornate, the bizarre, the grotesque, so much so in fact that the plates in the book became famous as "bits of fantasy or caprice." The review of the book in the *Mercure de France* describes it in the following terms: "There are Fountains, Cascades, Ruins, Rockeries, Shells, Pieces of Architecture which produce a bizarre, singular and picturesque effect through their witty and extraordinary forms in which often the contents have nothing to do with one another without for that matter making the whole duller or less agreeable." So Meissonnier, the "*Architecte Dessinateur de la Chambre et Cabinet du Roi*," was simply reducing his inventions to a smaller, "chamber" scale, changing into sculpture the most traditional elements of architecture, including the use of water. The reviewer's con-

clusion is conciliative: the relationship between the whole and its components is abolished, the rules of metonymy are disregarded, and yet there is coherence and harmony. Fantasy triumphs.

In 1722 Lucas Hildebrandt's Palace of Belvedere was opened in Vienna. In it the large entrance hall, which is both a functional area and a symbolic space expressive of power, is typical of the new taste. It includes four gigantic pillars supported by Herculean telamones bowed down under the weight of the arches (page 157) on which are carved trophies of war and peace and an elegantly and intricately ornate ceiling. It is a relief to pass from the excessive sight of the telamones to the subtle and almost transparent relief on the ceiling, from overstated sculpture to shallow relief, to contorted figures on a monumental scale to lacework.

The term "Rococo" is derogatory in origin (as are, for instance, the terms "Baroque," "Gothic," Impressionism," etc.). It comes from *rocaille*, which also refers to the ambiguous image of rocks and rockeries. From the very start, therefore, the idea of *nature* was implicit in Rococo. Here are two definitions which may be useful. The first is matter-of-fact: "Rococo is a vulgar term describing a type of ornament, style and drawing belonging to the school which prevailed in the reign of Louis XV and the beginning of the reign of Louis XVI." (*Dictionnaire de l'Académie Française*, 1842.) The second is more philosophical: "All beings are contained within one another, and so all species, everything is in perpetual motion.... Every animal is more or less a human being; every mineral is more or less a plant; every plant is more or less an animal. There is nothing separate in nature" (Denis Diderot).

This movement, which seems to take Baroque inventions to their extreme point, above all in central Europe, demanded a complete freedom of composition and developed a certain elegance and an open interest for exoticism, refuting all the classical norms which were still prevailing in the Baroque period.

This period too has been the object of positivist interpretations. Gottfried Semper suggests that it came about through the use of new materials that eventually conditioned its forms. He actually links the origins of the style with the European "discovery" of porcelain (originating with Johann Friedrich Böttger at Meissen in the first decade of the century). Historically speaking, there then was a series of extravagant interpretations which have in fact gone on to the present day. One of these asserts that the Rococo phenomenon is exclusively French—a theory which is easily belied by a look at a photographic anthology of European sculpture.

There are many sides to this complex period (scientific theories, political upheavals, the cult of Reason and Unreason, social problems of the court versus the emerging bourgeoisie). It might be useful to remember that as far back as 1699 Louis XIV had said to Jules Hardouin-Mansart, "We must have Youth working with us," and also, "There must be Children everywhere." In his critical thoughts on poetry and painting the abbot Jean Baptiste Du Bos wrote, in 1719, "A work may be poor without trespassing against rules and regulations, just as a work which trespasses against these may be superb." We are faced here with a probabilist theory which already heralds the French Revolution.

Nevertheless, an essential facet of the period remains the new use of material. Mirrors, for instance, had already been used profusely in Roman drawing rooms such as that of the Palazzo Colonna, and in the palace at Versailles; but now they became inextricably linked with sculptural decoration. And indeed in those long *salons* and ballrooms sculptures would acquire through their reflection in mirrors a more complex sense of space.

An inscription on a project of Bernard Toro's (d. 1731) for the door of the Hôtel d'Artalan at Aix

says, "The sculptor carved the wood with such delicacy that the works he produced, namely table legs, clock cases and console tables, did not have to be adorned with gilt and indeed were so perfect that the addition of any varnish would spoil them; all these works were perfectly finished and he would put into them all his genius and the talent of his fingers." From now on there is interchange between sculpture and furniture-making: some of the great sculptors of the century can be found among the cabinetmakers to the point that today one refers to both sculpture and cabinetmaking in terms of "Louis XV" or "Regency" or "Louis XVI." One of the geniuses of the Louis XV style, Gilles-Marie Oppenord, designed a fountain shaped like a seat and would make projects for a church with the same ease that he had in designing a candelabrum.

In the Rococo period the chair became like a monument to seated man; furniture once again became organic in shape (full-bellied or anthropomorphic). Just as architecture could pass quite naturally from an external monumental phenomenon to interior decoration, so sculpture passed naturally into the field of furniture. The new "light" effect of interiors was realized by the use of a new material: wood. The complex wooden *boiseries* eventually ousted internal architecture just as eventually the use of small objects (porcelain ornaments, Oriental lacquer, mother-of-pearl objects, small bronzes, etc.,) replaced the monumental use of sculpture.

Another essential feature of Rococo is the idea of interchangeability and variability, which gave rise to a certain hybridism; "Whether it is real or artificial," wrote Diderot, "I love this transformation of marble into humus, of humus into the vegetable kingdom, of the vegetable kingdom into the animal kingdom and into flesh." What Diderot is expressing here is almost a pre-Romantic eroticism rather than a pagan feeling for nature. This hybridism soon began to manifest itself in sculpture: Coysevox made a portrait of the Duchesse de Bourgogne as Diana—no longer the Renaissance type of disguise but the conferring, through the use of myth, of a social and natural dignity. This also goes back to the foundation, in Rome, of the Arcadian Academy in the seventeenth century, and leads to the social phenomenon of the celebration of shepherds and shepherdesses as an example of the abolition of social classes, the embarkation for Cythera, the elegant parties. In the field of science at that time, Linnaeus and his followers researched into mutations and arrived at the theory of hybrids.

Another feature of Rococo is its predilection for the picturesque, which of course included exoticism in all its manifestations—the taste for the Chinese, for instance. Within this context, however, there was a strong vein of skepticism, which is another, very important feature of the century: Montesquieu's *Lettres persanes*, and Swift's *Gulliver's Travels* are two examples of the passage from West to East, from large to small.

Yet another feature is the theorization (in a fairly uninventive period) of discovery; thence the investigation of various subject matters through the new figure of the "Virtuoso," the skilled writer or artist. There are no new types of sculpture, but those of the preceding century are worked on until they are so excessive in every feature that they are unrecognizable. Painters renounce the painstaking search for the image and concentrate instead on whimsical and swift brushstrokes. Music has become a point of reference—a field in which there is not much invention but skillful and virtuoso interpretation. Indeed, one of the "symbolic forms" of this *siècle dansant* (as the Goncourt brothers dubbed the eighteenth century) was dancing and above all the minuet, which comprised bowing, meeting, parting, pirouettes, and so on.

Though the sculptors working in different centers of culture, from Europe to Latin America, used

different idioms, their basic language remained the same. A few examples, taken from cultures as different as the French, the German, the Italian, and the Spanish, show that despite the use of individual expressions the basic structure of Rococo was the same everywhere.

We have chosen two examples from France—an ensemble and a single work of sculpture. The former is the series of medallions made by the Adam brothers for the Chambre du Prince de Soubise; these are decorations of an intricate nature grafted onto Boffrand's architectural structure and complementing Boucher's tapestries. Here the work of sculpture loses its specific identity and becomes part of the furnishings, like tapestry, which by then had become a favourite new genre (it should be noted here that the royal manufacture of the Gobelins had reopened).

The statues by the Adam brothers at Versailles are also different from their counterpart of half a century before: they are no longer groups placed in the open to adorn nature, but compositions (such as *Neptune and Amphitrite*, page 133) that seem to be born from nature and become its personification in sculpture.

One of the leading sculptors of Rococo in Germany was the Bavarian Ignaz Günther, who was almost a theoretician of the serpentine form, which he used in skillful arabesques. His work has two salient characteristics: a conception which owes much to his study of the contorted style of the Mannerists, and a style which remains static in technique (it is extremely difficult to date his works). Also typical of Günther is his use of colour, perhaps with the illusion of adding to it. Günther's colour is always brilliant and too shrill, its vividness once more reminiscent of Mannerist sculpture. Another characteristic is that his works, which are almost always of a religious nature and destined to be placed in churches, have a "social" tone. His cardinals (*St. Peter Damian*, in the Benedictine abbey of Rott am Inn) are exhausted courtiers; his queens (*St. Helena*, former abbey of Neustift) are ladies wearing sumptuous, low-necked gowns (see page 159); his groups (*The Annunciation*, former capitular church at Weyarn) are mannered and ballet-like (pages 56 and 57); his larger works (*Main Altarpiece*, former abbey church of Mallersdorf) recall Bernini's *Chair of St. Peter*, but comprise characters out of a court theater.

In Spain too Rococo was based on the Italian example (Juvarra in Madrid) whilst sculpture was only partly affected by the exuberance of the Churrigueresque style. In Portugal sculpture remained rather closer to Baroque, even in its overseas dominions, such as Brazil, for instance, where Aleijadinho's sculpture flourished.

The statues placed like a religious procession on the stairway of the Bom Jesus church look as if they are there to point out the way. This aspect of his work, which others may qualify as naïve, denotes instead an authentically popular style (page 174).

In Italy Giacomo Serpotta's situation is rather characteristic. Though active in a faraway province, he was nevertheless in direct contact with Bernini's style (he sometimes imitates elements of *The Ecstasy of St. Theresa*, or uses twisted columns or cloths borne by angels), but also with more marginal artists such as Caffà or Duquesnoy (evident in his *putti* caught in drapery). Serpotta's case, however, is peculiar from a chronological point of view: the highly Rococo *Oratory of Santa Zita*, for instance, dates back to the turn of the seventeenth century (page 147). Some elements are still typically Baroque (the theatricality, the sense of the profane and of the ephemeral), but their significance changes in the new vision of art. Serpotta's oratories are like little court theaters or decorated private rooms.

On the back wall of the *Oratory of Santa Zita* the scenes are linked together by means of a vast cloth supported by countless *putti*, with a central scene

representing the ships of the Battle of Lepanto sailing in the wind. There is evidence of a new taste for the antique in its most Hellenistic phase (the extraordinary figures of ephebi, *Fortitude* represented by an androgynous creature). In early documents he is mentioned as "stuccoworker," but later becomes "sculptor" and finally "architect." It is his painstaking craftsmanship, akin to that of Caravaggio or Van Dyck (paintings by whom could be seen in his Oratories) that places his work in a Rococo light.

The Rococo period was not just one of exaggeration, abundant use of gold, richness of the curved line, sensuousness, fantasy, tormented shapes and ecstatic expressions, "superfluousness" of knickknacks, and so on. It was also a period which saw the ripening of the consciousness of the Age of Enlightenment. And it is logical that a search for rigour and rationality should be established in opposition to a period of irrationality and excesses. What happened in literature and philosophy is well known. In sculpture a witness to this passage from Unreason to Reason was Giovanni Battista Piranesi. He was part of the Enlightenment, yet still attached to the "dark ages"; he drew Rococo *capricci* and immediately afterwards his erudite topographical maps; he liked to imagine the greatness of antiquity and compare it with the smallness of modern man; he rediscovered the classical roots of the modern world yet at the same time denounced its disintegration; he oscillated between the picturesque and the sublime, history and dehistorization. In sculpture we have an extraordinary example of this subtle dialectic of Piranesi's—the *Main Altarpiece* of the church of Santa Maria del Priorato. Each detail of this monumental work was carefully elaborated by the architect as he imparted life to his chiselled branches. But it is in the altarpiece itself that Piranesi's two sides come face to face (in a manner of speaking) with each other and, while putting an end to the past, open up the future. From the front the altarpiece is full of elaborate details—garlands and rockery, putti and saints striking post-Berninian attitudes. From the back, however, it is broken up into the stereometric blocks which compose it: a cylinder for its base, a trapeze for support, and finally a sphere. It is the structure itself which is important, for it is the backcloth to the austerity of the art of the imminent Revolution.

These, therefore, are the two faces of a medal: on one side ecstatic nature and on the other the Goddess of Reason.

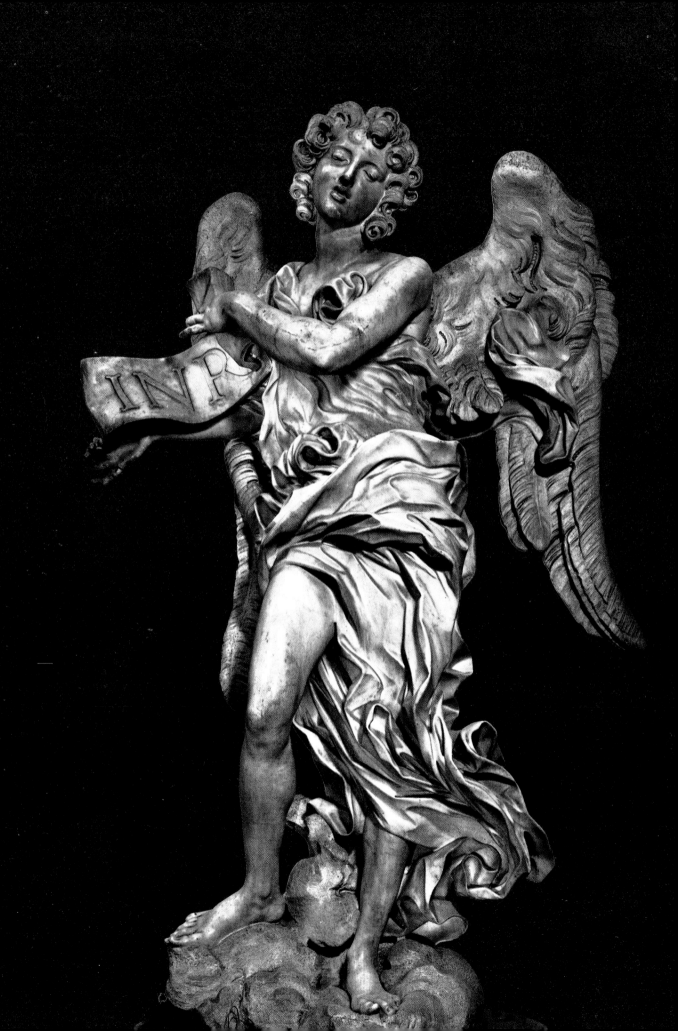

MATERIAL
AND COLOUR

I saw, standing next to me, an angel in corporeal form,
a beautiful angel with such fire in his face that he
looked like one of those angels from the highest choirs
who seem to burn with love. He held in his hand a long
golden arrow the point of which was on fire. I felt as if
he were stabbing me in the heart with it, ramming it
down into my very vitals: and when he removed it I felt
that he had left me burning with an immense love of
God.

(St. Theresa of Avila, *Life*, 1580, Chapter XXIX: Ecstasy)

The function of the colour illustrations reproduced from page 33 to page 64 (see list below, with references to the page of the caption) is purely introductory. These illustrations show that the world of sculpture is not only a three-dimensional world but also a world of colour, for works of sculpture are made of materials of various colours and placed in natural or artificial surroundings which add other colours. Within the structure of this book, however, a more didactic function is fulfilled by the pages of illustrations and captions found from page 80 to page 174. There the reader will find a chronologically arranged sequence of illustrations and notes giving concise information on the works reproduced in colour and black and white.

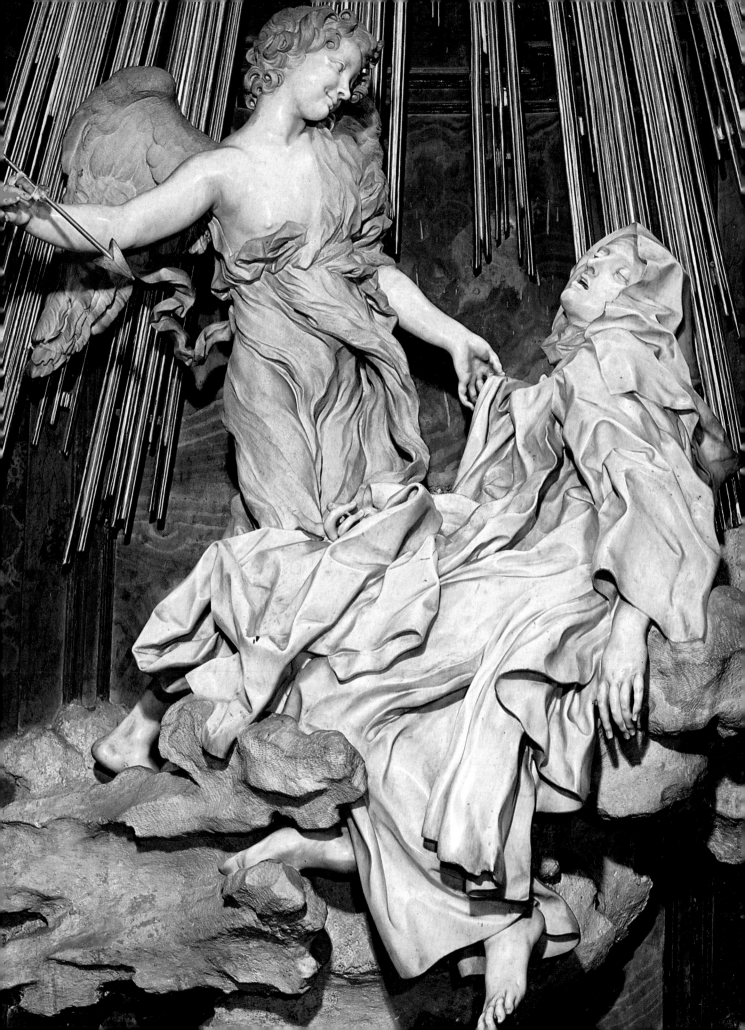

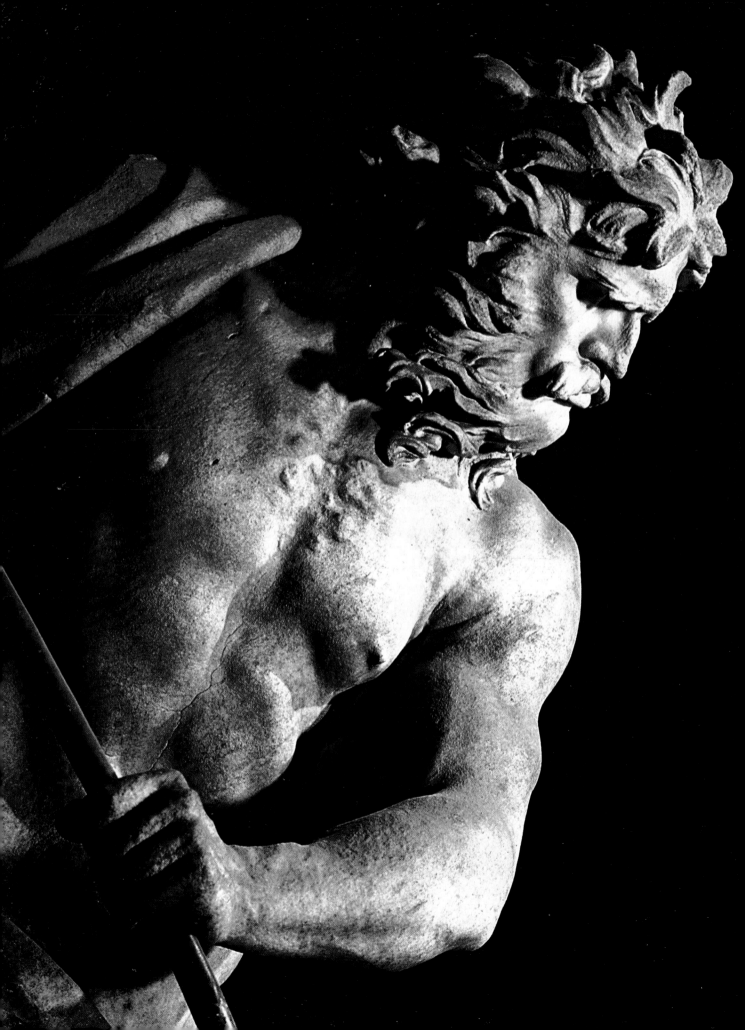

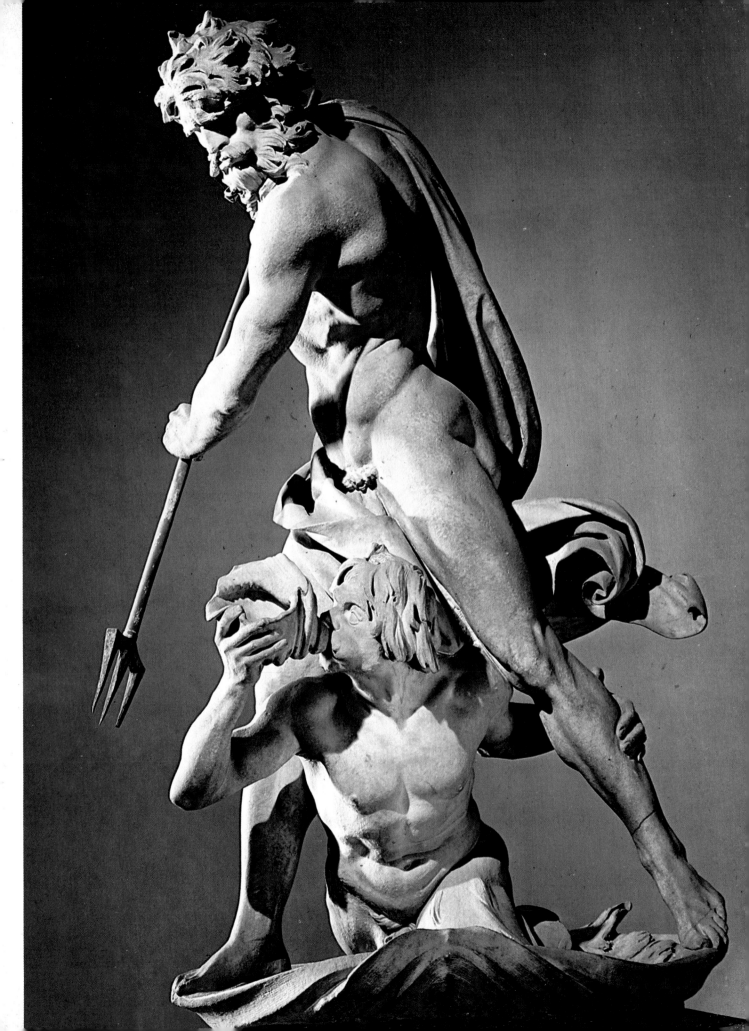

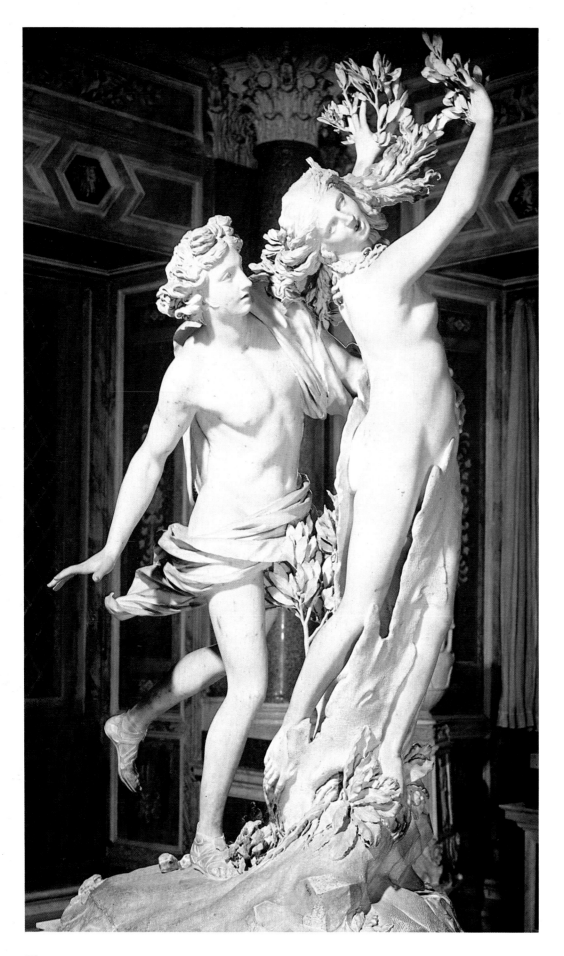

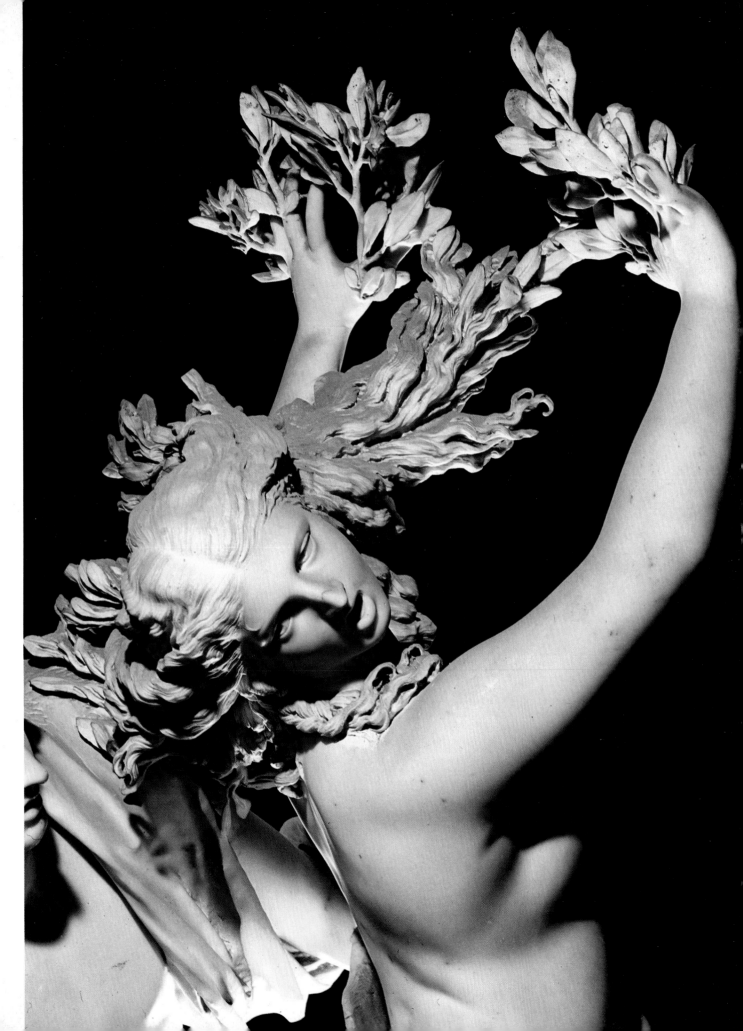

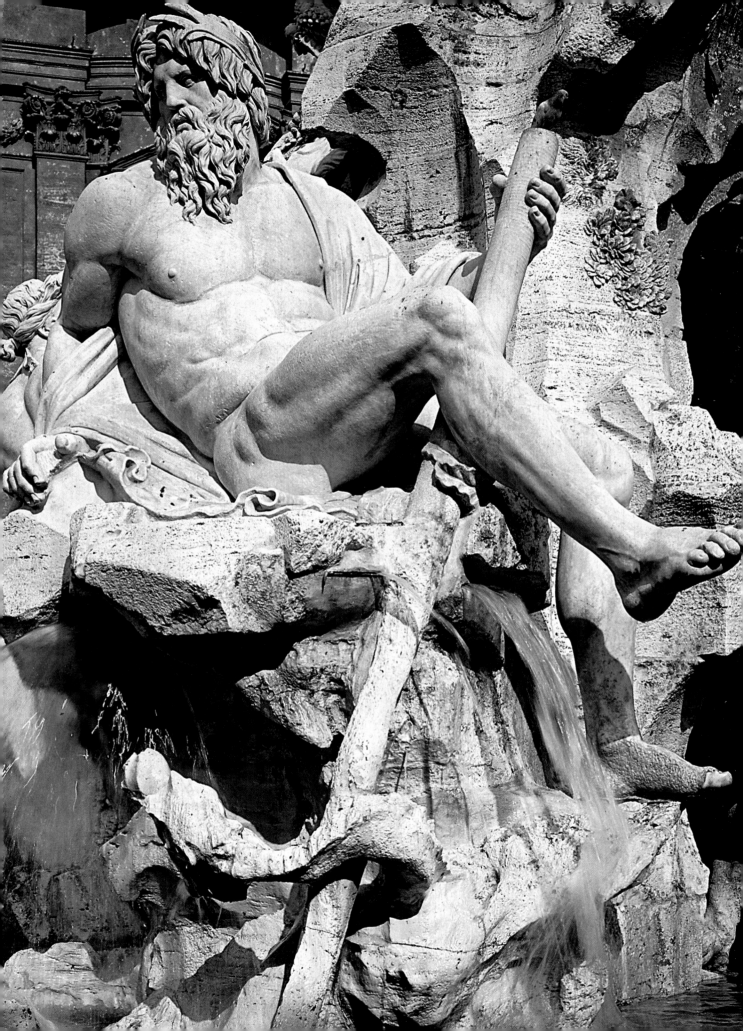

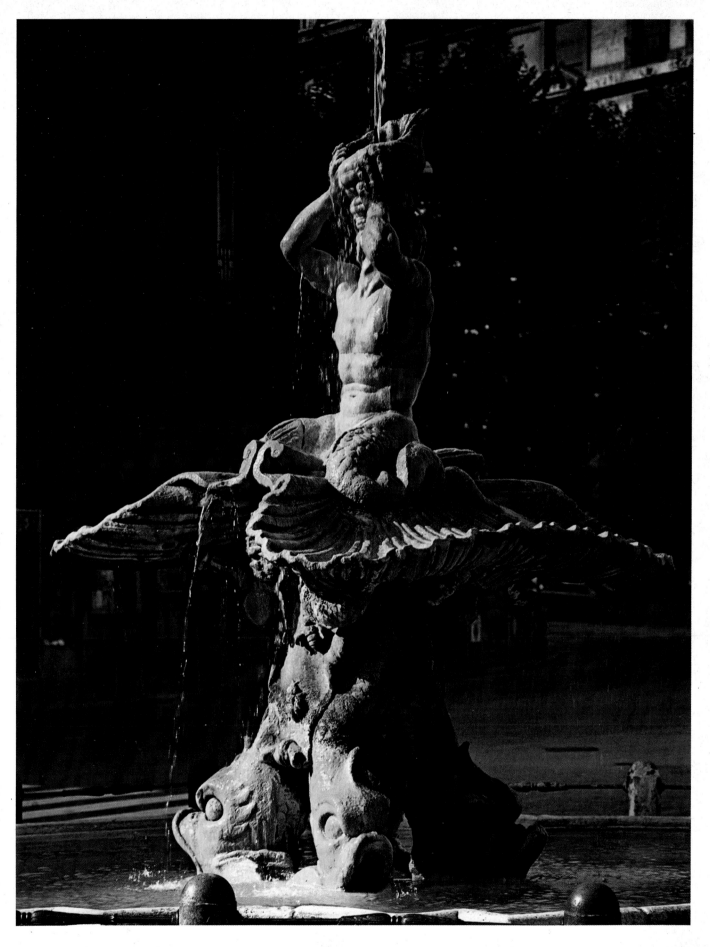

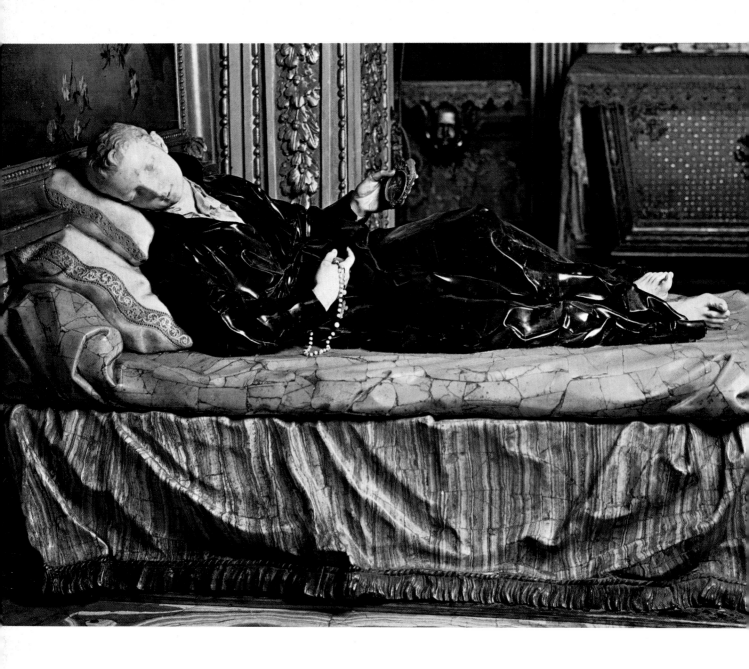

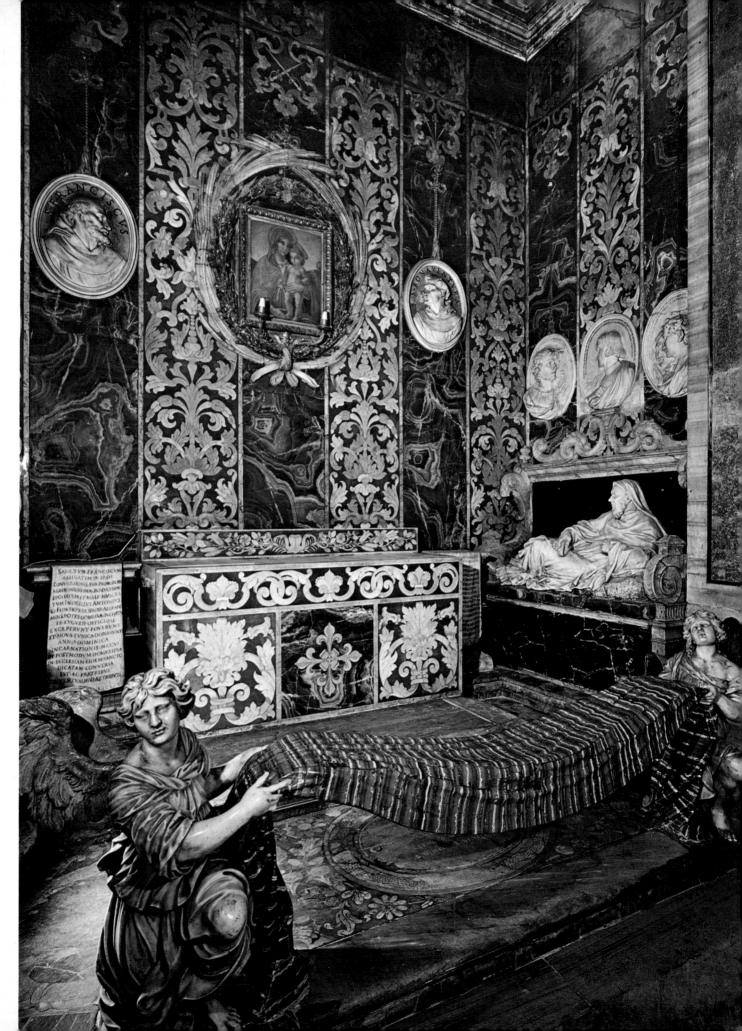

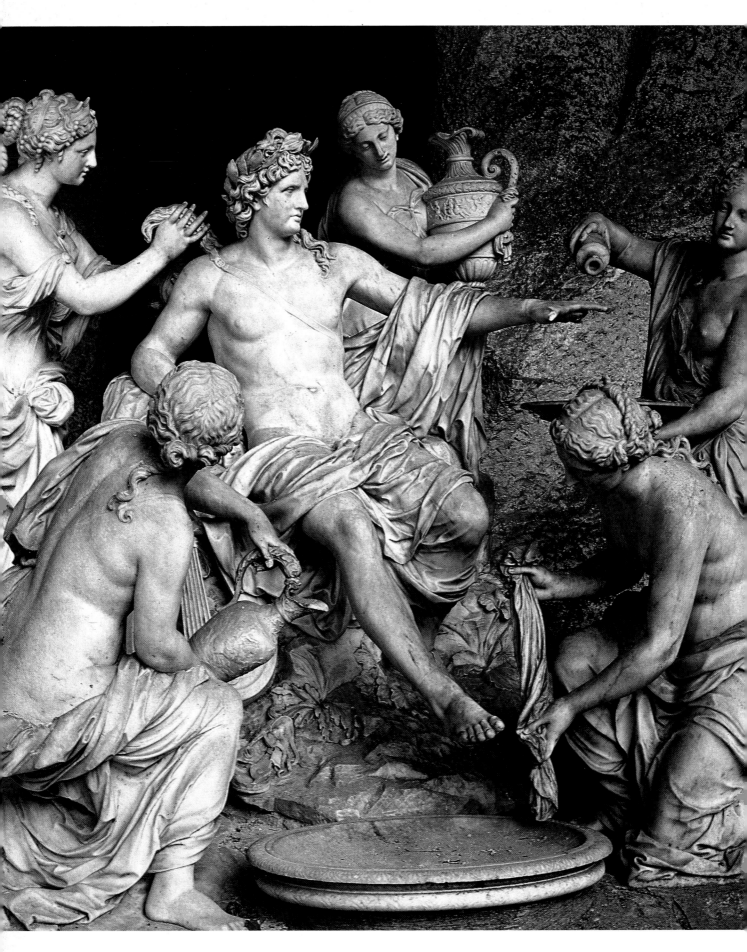

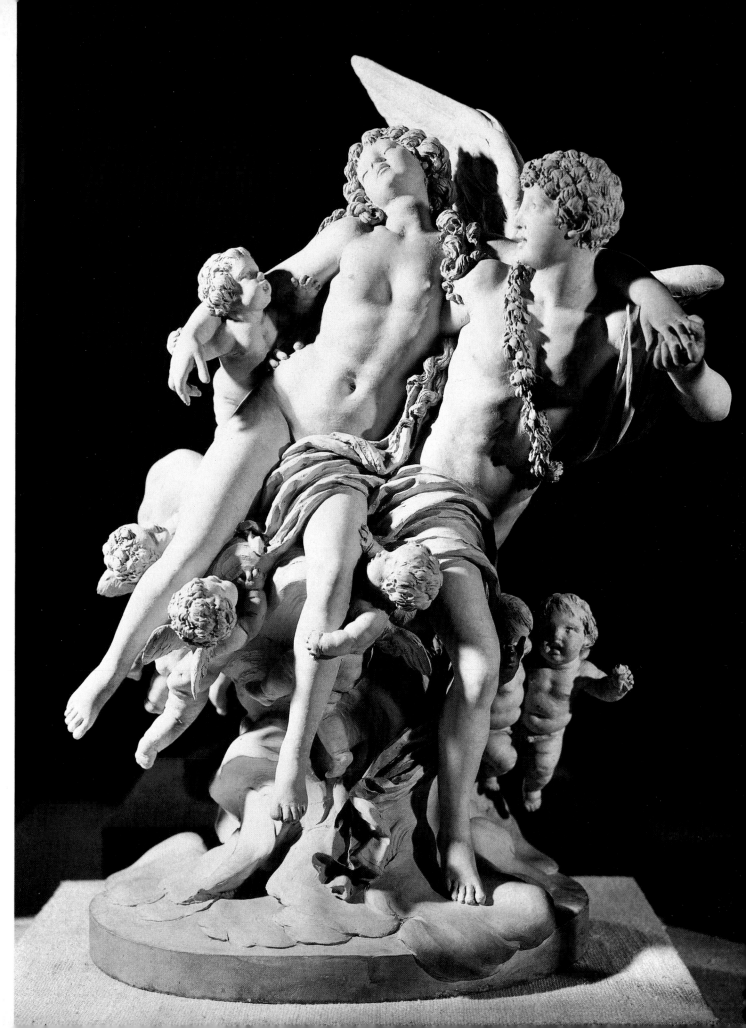

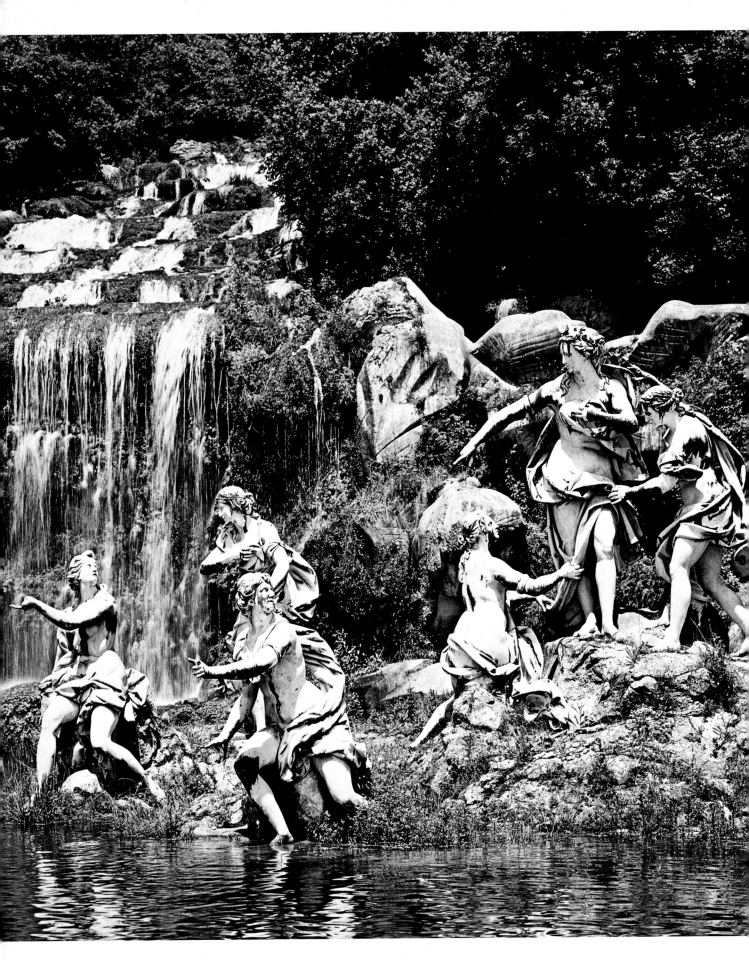

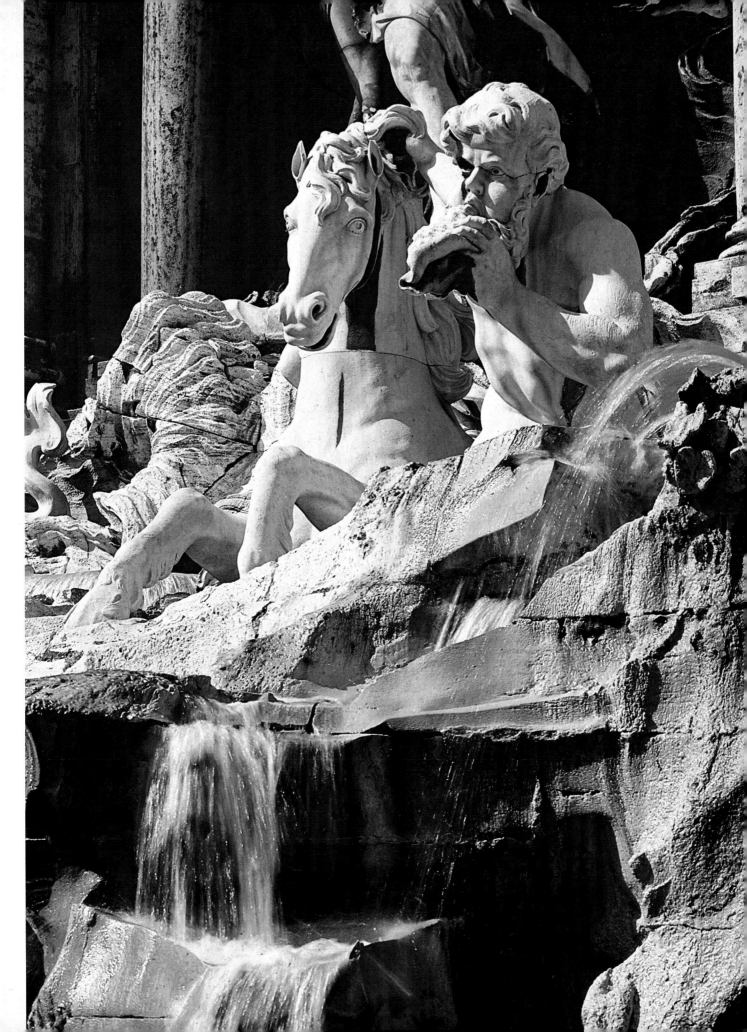

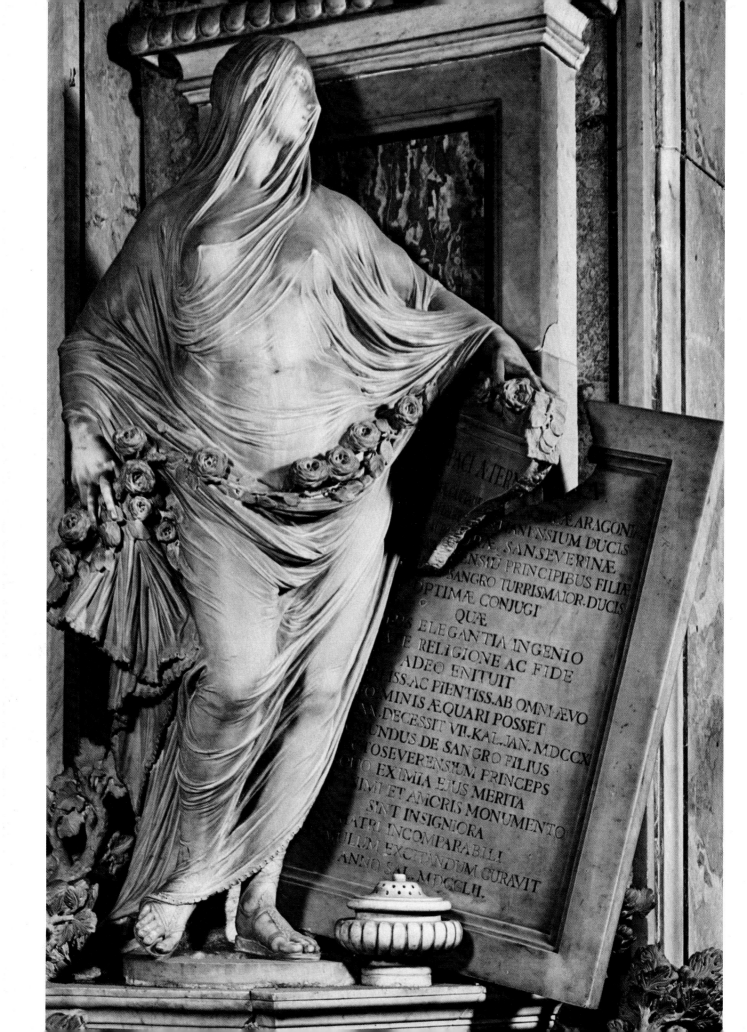

FORTITVDO

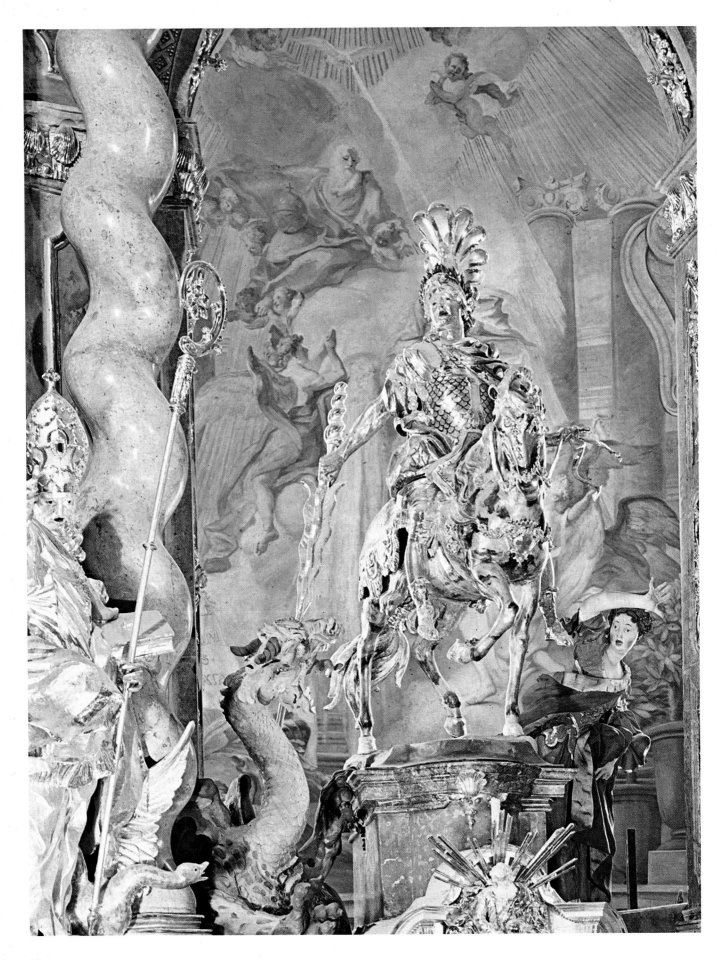

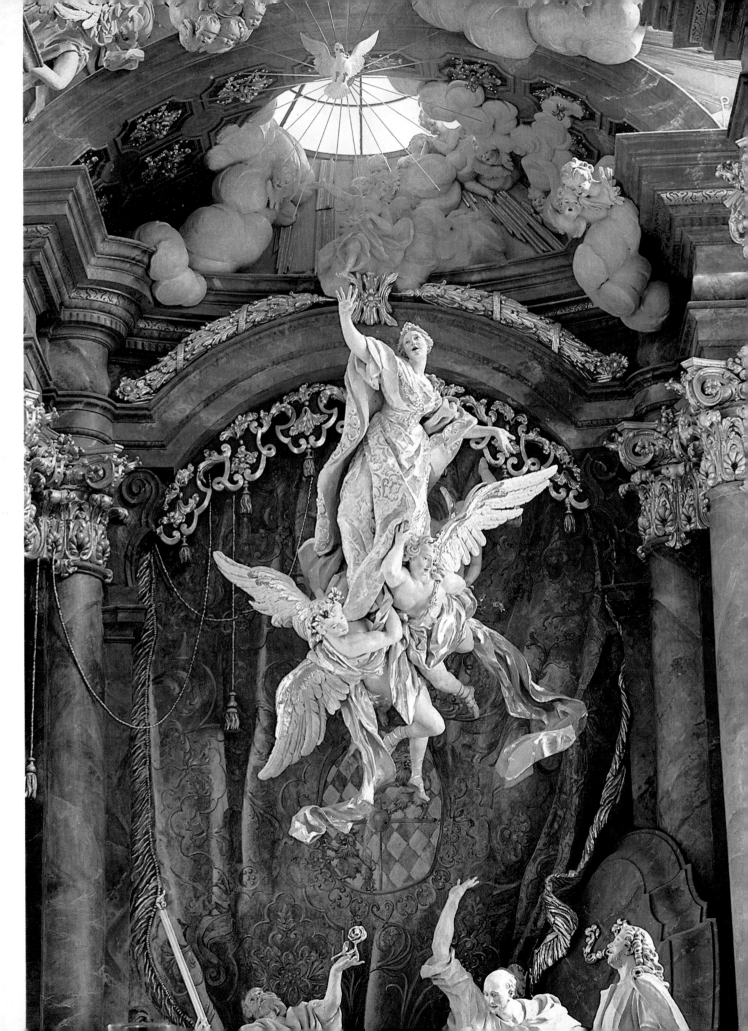

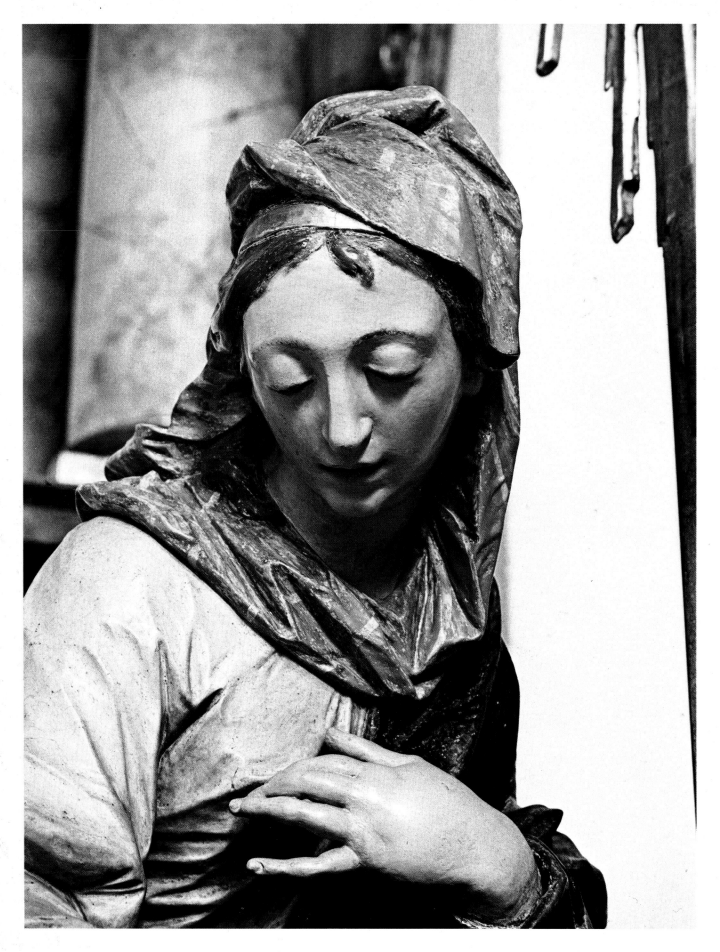

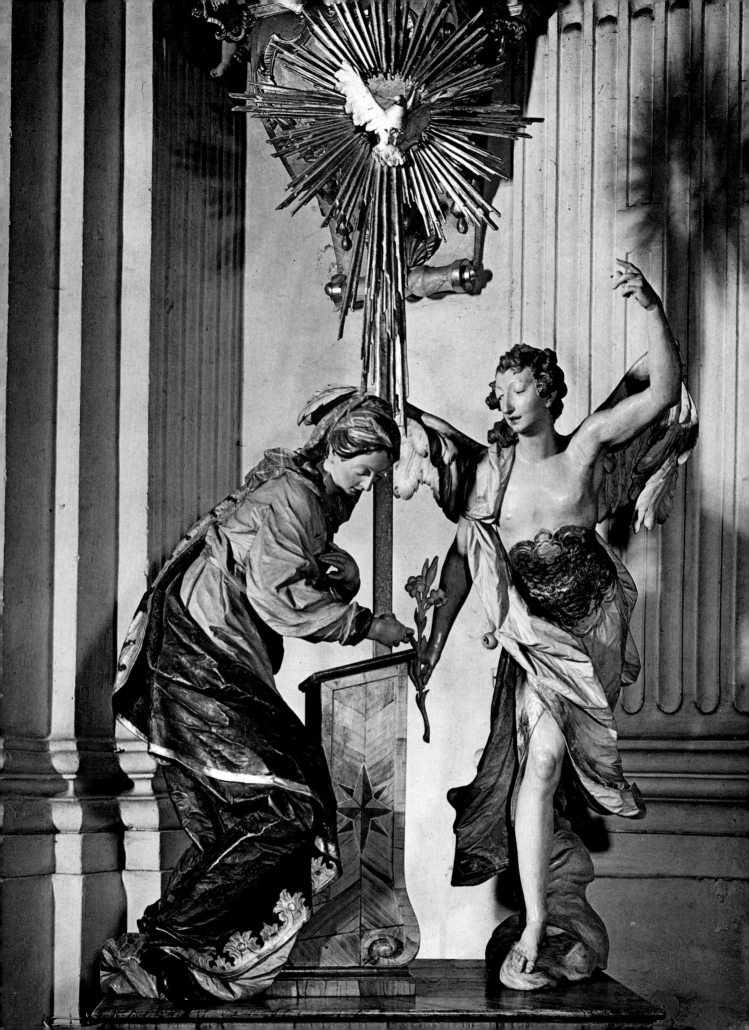

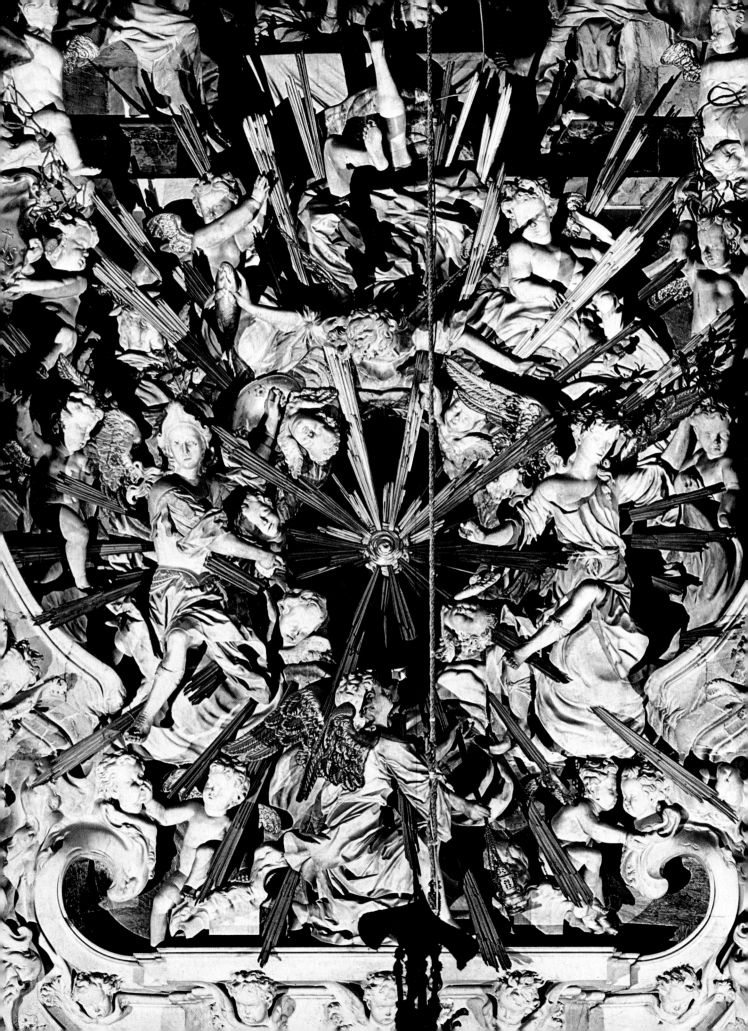

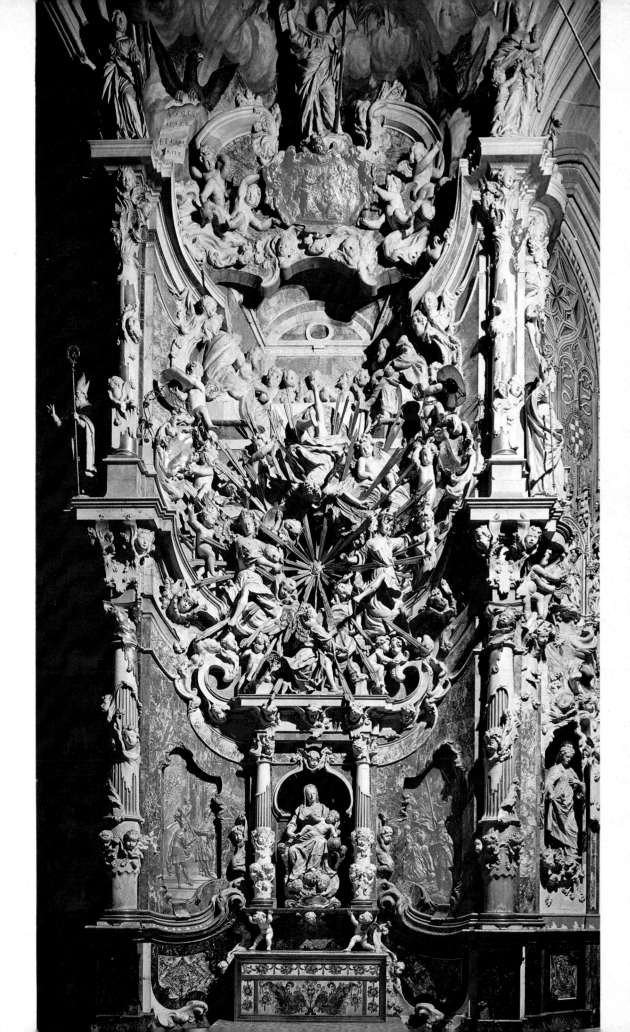

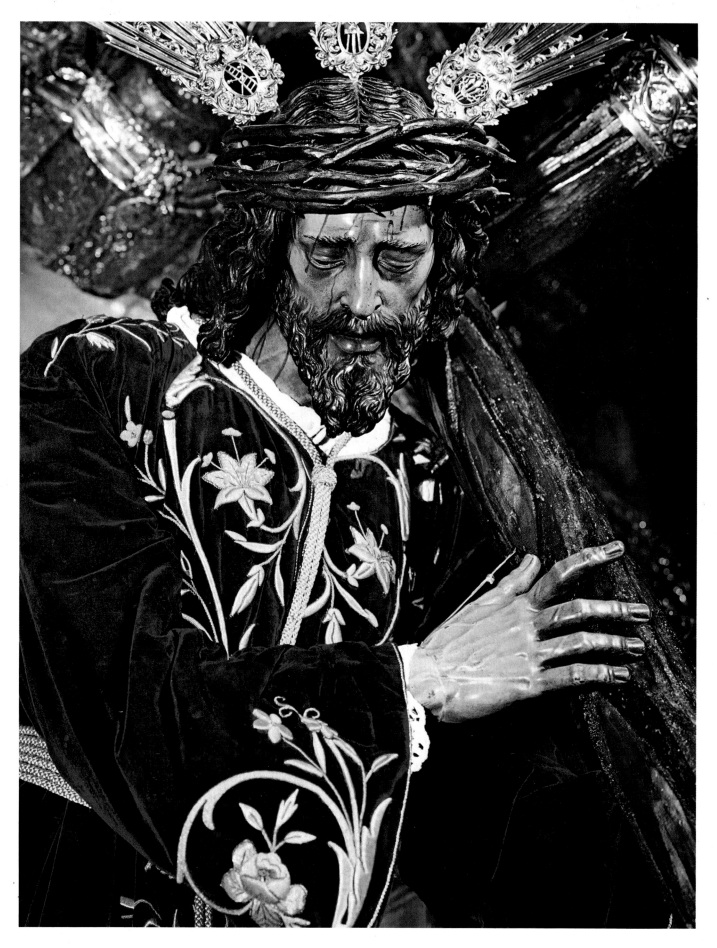

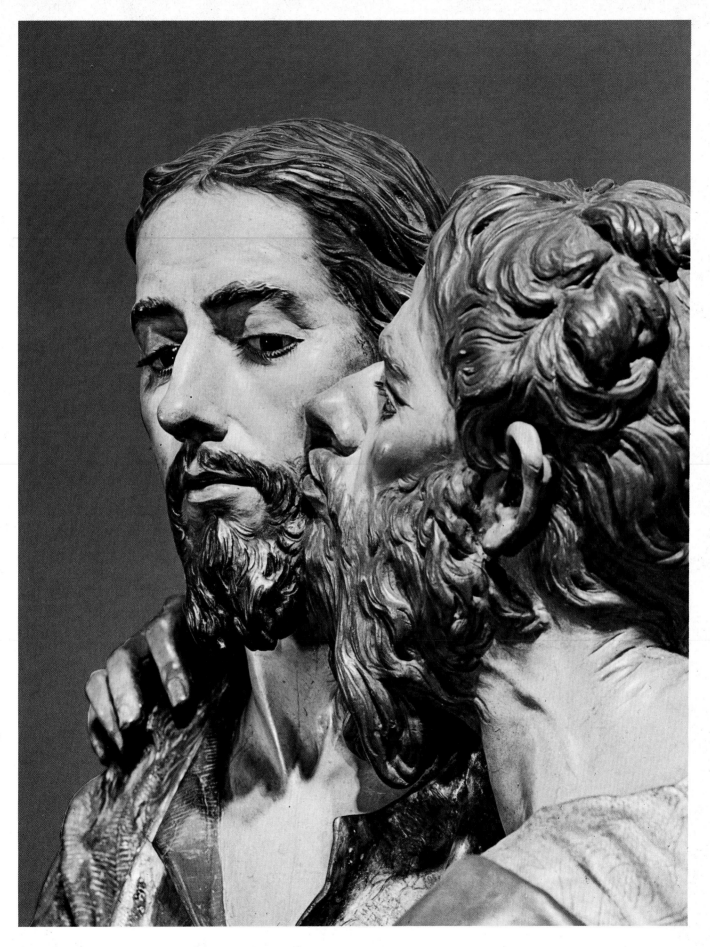

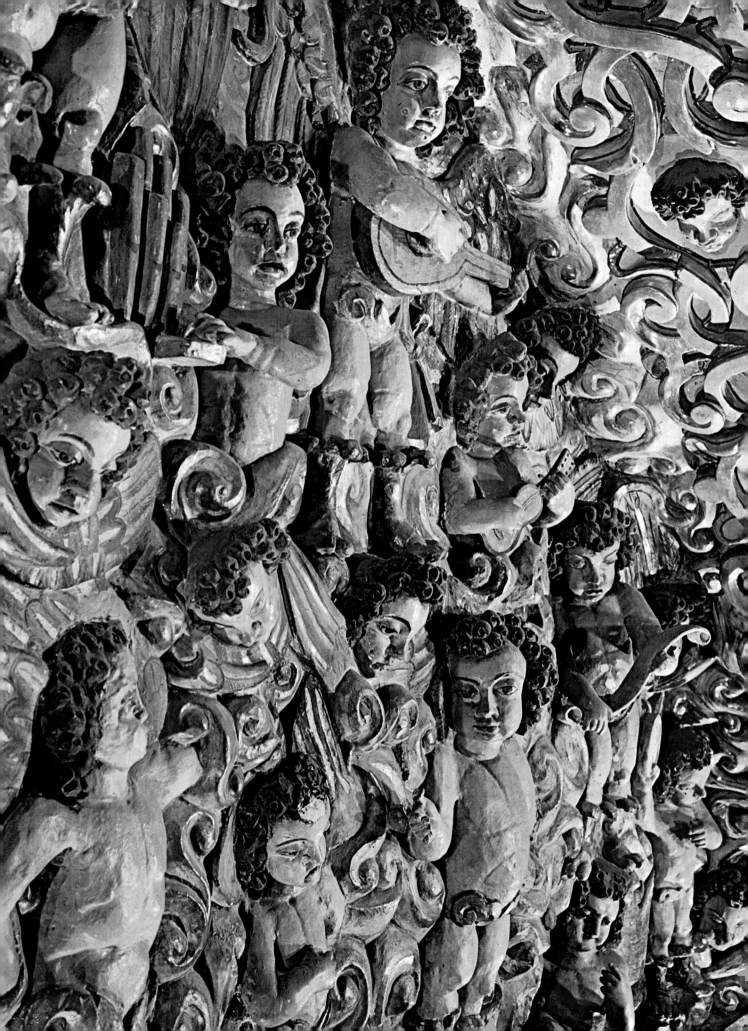

Every art within a specific society achieves its products according to ideal norms and practical rules which make up the entire wealth of intuition and experience reached by artists through their own fantasy and the demands of their patrons. The sculptor at work constitutes the secret and significant moment of a public action, a personal contribution to society and history.

Title-page vignette of Caravaggio's biography in the abbot Giovanni Pietro Bellori's Vite de' Pittori, Scultori et Architetti moderni *(1672). It shows the figure of Praxis, the artist's practical activity.*

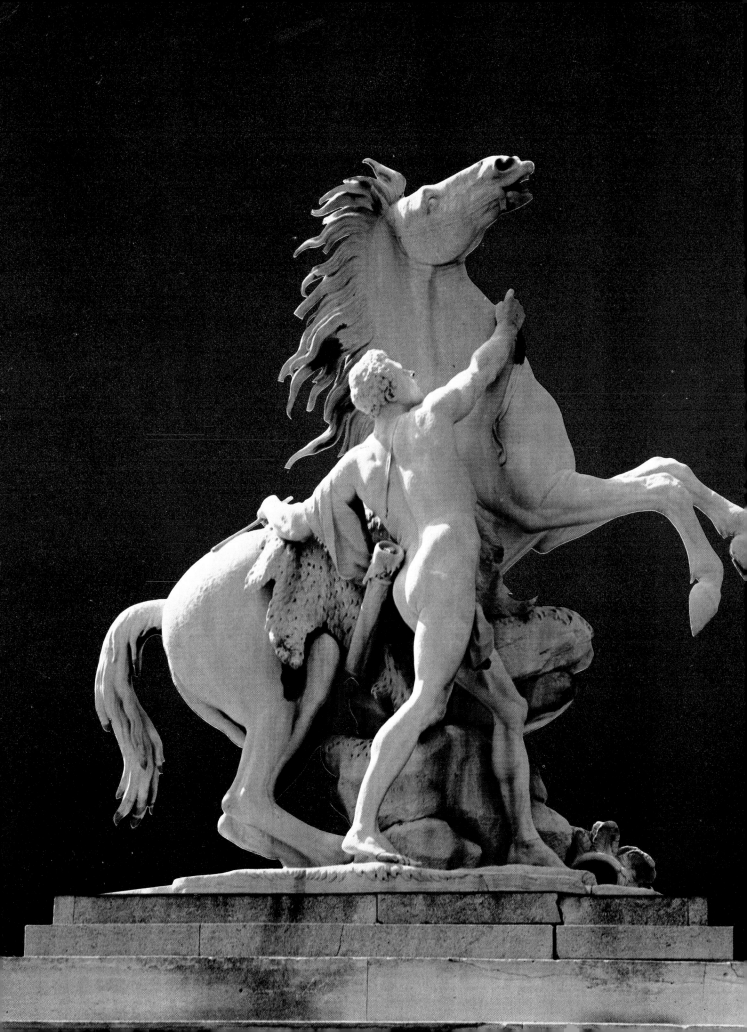

THE MASTERS OF ARTIFICE

Talent and design make up the magic art
through which the eye may be enchanted.
Where there is naturalness,
there is artifice.

(Giovanni Lorenzo Bernini, *Fontana di Trevi*,
Comedy, 1643–1644)

ART, CULTURE, AND SOCIETY: ROME

The origins of the Baroque phenomenon remain a mystery unless one considers the social environment in which it took place. There is, however, a risk that this mystery may deepen upon investigation. For at the beginning of the seventeenth century Rome (and hence its art in all its forms—sculpture, painting, architecture, town-planning) was in a period of economic regression. Rome was not a nation, but had remained a symbol. It numbered only one hundred thousand inhabitants, of which about ten per cent belonged to the Church. Yet it still was considered the center of the world, and above all of the world of art. Bernini's workshop welcomed French, Flemish, and German artists; Nicolas Poussin and Claude Lorrain came to settle in Rome; Peter Paul Rubens's visit was still fresh in people's minds, and Velázquez sojourned twice in the city (in 1629 and 1649).

It was a time of economic crisis. The papal families were in the habit of enriching themselves at the expense of others, and famines succeeded epidemics. The papal treasury awaited anxiously the coming of the Jubilee every twenty-five years, for it brought to Rome seven hundred thousand pilgrims, seven times the population of Rome.

It was a time of political crisis. Urban VIII was in opposition to Richelieu's absolutism in France; he also had to take part in the Thirty Years' War and see his own state invaded by the enemy. His successors had to face the continuation of the war against the Ottoman Empire. Alexander VII submitted to the French.

It was also a time of religious crisis. Ecclesiastical reforms followed one another. The Inquisition grew ever more powerful. Galileo himself was tried before it. Under Urban VIII the Jansenists rebelled against central power; they were condemned first by a decree of the Inquisition, then by a Papal bull (1643), but continued to resist. As if in compensation, Alexander VII celebrated with great pomp the conversion of Queen Christina of Sweden.

In this context art did not figure as adornment but rather was used as a means of propaganda, both religious and political. The colonnade of St. Peter's Square, for instance, is not only the apotheosis of Roman Catholicism but also an assertion of power. Girders like those of the Pantheon, smelted on the order of Urban VIII, were used for the baldachin built over St. Peter's tomb, but also to build canons for the Castel Sant'Angelo. Bernini became a unique instrument of foreign policy. He sculpted the bust of Richelieu in the thick of the struggle between French absolutism and the pope; he also sculpted the portrait of Charles I of England, who was inimical to the pope. He sojourned in France for a long time. The encouragement given to the arts at that particular time was above all politically motivated; patrons were no longer moved by purely aesthetic motives. We must point out, however, that an artist of Bernini's caliber can never be the passive illustrator of his patrons' wishes, but always manages to invest his works with his own individuality. He found an aesthetic structure for every one of his patrons' demands. What proved to be a great help to him in this delicate balancing act was his own experience of the theater. One may say that Bernini was the stage director of Baroque.

In the early seventeenth century society, despite the political, religious, and economic crises, felt that a new golden age was upon it. On one hand we have Giordano Bruno's death at the stake, Tommaso Campanella's emprisonment, Galileo's abjuration; on the other Borromini's tormented search truly in the spirit of Giordano Bruno, Pietro da Cortona's "sense of things and magic" worthy of Campanella, and Giovanni Lorenzo Bernini's Copernican conception of the colonnade of St. Peter's.

Bernini was truly the key figure of the seventeenth century. He lived for about seventy years under the successive reigns of eight popes. His life was a balancing act between great ambition and poverty, adulation and criticism, the sublime and the grotesque. He was stubbornly attached to Rome, and only an express order from the pope could overcome his reluctance to leave it and go to France. Unlike Borromini, who, like Campanella, believed that the fruit of invention could only come after a certain time, Bernini, in France, asserted that he thought it likely that after his death his fame would "decrease and perhaps even die altogether."

As usual it is not a center of culture that establishes a new artistic language but, rather, a bunch of artists who dictate the new manner in vogue in a specific city. Caravaggio was perhaps the first European artist, though it was he who established the School of Rome; Italian and foreign artists alike flocked to see him, as if on a pilgrimage. Rubens visited Rome twice in the first decade of the century and showed, in his work at Santa Maria in Vallicella, how Caravaggio's dark, rigorous style opened the way to the luminous sense of space of Baroque.

The nobleman Cassiano Dal Pozzo, an avid collector of eclectic tastes and an amateur archeologist, gathered around him an impressive group of artists. He filled twenty-three volumes with drawings after antique works of art, signed by Pietro da Cortona, Pietro Testa, Nicolas Poussin, etc. Bernini himself was among his protégés. It was Cassiano Dal Pozzo who encouraged Poussin to become interested in archeology, and his collections included at least fifty paintings by that artist (among them the *Seven Sacraments*). Poussin became an active member of the Roman scene. Bernini painted his portrait (now at Hovingham) and gave him his support to obtain a commission for a large altarpiece at St. Peter's; he often praised his work in public. Poussin was to remain in Rome

(with a short interval spent in Paris) until his death. He had first arrived there in 1624, three years before another honorary member of the Roman scene, Claude Lorrain. Then, as now, the artists' quarter was the area around the Via del Babuino. Poussin lived near Duquesnoy, Dughet near Claude Lorrain; Sacchi had his studio next door to Algardi's. There was a close community of artists from the Netherlands, with Duquesnoy as their leader. He was soon adopted by the Barberini family, became a close friend of Poussin's, and studied and later collaborated with Bernini.

Sculptors were on the whole organized in workshops, and Bernini managed his a little like an industrious factory. For instance Morelli, Naldini, Baratta, Fancelli, Francesco and Domenico Mari, and G. M. Rossi all worked on the statues of St. Peter's colonnade. To speed up the work Bernini suggested, in a letter to the pope, that Erole Ferrata, Antonio Raggi, Melchiore Caffà, Girolamo Lucenti, and Orfeo Boselli should also join the team. The fact that both Bernini and Algardi sometimes used the same artists in their workshops makes it sometimes difficult to distinguish their respective studios, though Algardi's is usually considered to be more "classical" in spirit. Next to Bernini, Giovan Paolo Schor, known as "Paolo Tedesco," and Antonio Raggi were responsible for the establishment of a more graceful and decorative style which was the precursor of Rococo.

Meanwhile the presence of French artists in Rome was beginning to make its mark. The Académie de France had been established in the Palazzo Mancini in 1666. Working in the Jesuit churches were artists whose work already heralded the Rococo style—Pierre Legros, Jean Baptiste Théodon, and Pierre Etienne Monnot. Domenico Guidi, who later was an intermediary between Paris and Rome, attached himself to Algardi's circle. The Rococo phenomenon hardly affected Rome, for the sculptors working in the huge worksites of San

Giovanni in Laterano and St. Peter's (Camillo Rusconi, Pietro Bracci, Filippo della Valle, Giovanni Battista Maini, etc.) all had a rather severe style. Only Giuseppe Mazzuoli, at the turn of the century, and Michelangelo Slodtz were sensitive to the new manner. A greater feeling for Rococo could be found in decorative sculpture and furniture making. The church of the Maddalena, in Rome, is a Rococo world in itself: here each single part, from the façade to the organ, built like a huge and overornate musical sculpture, to the sacresty, conceived like a brilliant ballroom, adds to the whole harmonic decorative conception.

THE ITALIAN COURTS

"Italy," wrote Voltaire, "was the most flourishing country in Europe, if not the most powerful."

In fact the Italian courts went on living their separate autonomous existence, economically and politically speaking. Even Rome, the center of culture, no longer played the dominant role that she still imagined was hers.

In Florence, the Medici rule was drawing to an end (it in fact ended in 1743). The grand-ducal government was an authoritarian one, but the city revolved above all around its cultural activities. The hierarchical system pervaded art itself. The "First Sculptor of the Serenissima House" (from 1687 it was Giovanni Battista Foggini) had precedence over architects and painters. The Baroque spirit was introduced into Florence through Pietro da Cortona's and Ciro Ferri's decorative painting, and later through Luca Giordano. The first generation of Baroque sculptors was led by Pietro Tacca, with his somewhat diluted vision of Mannerist sculpture. Francesco Mochi and Pietro Bernini also were from Tuscany. The chief monument of Baroque in

Florence is the Corsini Chapel at Santa Maria del Carmine, which was built and decorated under the direction of Foggini, who was also its main sculptor. The cupola was painted by Luca Giordano and the German Permoser, and in the sculptural decorations Foggini displayed a remarkable virtuosity. Like Massimiliano Soldani, who worked in the first half of the eighteenth century, Foggini was also employed extensively by the English court.

Naples was partly dependent on Rome, and also on Spain. In architecture a new idiom was introduced by Domenico Fontana. Pietro Bernini was responsible for introducing, from Florence, the new manner in sculpture; and in painting Caravaggio's influence was evident and was to prevail for a whole century. One of the leading sculptors in Naples was Cosimo Fansaga, originally from Bergamo; also an architect, he was particularly talented in sculpture of a decorative nature—fountains, pulpits, altarpieces, and polychrome intarsia. His most significant works are the two great obelisks of San Gennaro and San Domenico, with their excessive decorations; they are reminiscent both of Roman obelisks and of the ephemeral machinery used in great feasts which were a frequent happening in the Neapolitan Baroque period. A familiarity with Bernini's work was established through Giuliano Finelli and Andrea Bolgi. The triumph of Baroque seemed to be the logical complement of an absolutist government.

In Sicily there flourished an active school of stuccoworkers and decorative sculptors whose achievements ranged from a lively provincial and popular style to the art of Giacomo Serpotta. One of the most successful subjects was that of the Nativity and Christmas crib figures, at which sculptors such as Celebrano, Vaccaro, Sammartino, and Bottiglieri tried their hand.

In Lombardy the cathedral worksites continued

to function in a conservative manner. A more lively style was provided by a family of stuccoworkers, the Carlonis, who also worked outside Lombardy. Among the Lombard eighteenth-century sculptors, Andrea Fantoni stands out; he worked exclusively in provincial towns and produced mostly pieces of furniture and furnishings. Algardi's sojourn in Bologna reinforced a certain austere tendency in Bolognese artists. There, in the eighteenth century, the artists that stand out are Mazza and above all Angelo Piò, a stuccoworker of spectacular talent. A link still existed between Genoa and Venice, though the former was, culturally speaking, on her way up, and the latter—apart from a remarkable flourishing of painting in the eighteenth century—on her way down. Genoa had the advantage of being geographically at the center of Italy. The city was rebuilt, the economy flourished through its Mediterranean trade, and the cultural scene was extremely active (both Rubens and Van Dyck sojourned and worked there). It was Pierre Puget who introduced Baroque sculpture to Genoa, though the Genoese school was subsequently headed by Filippo Parodi, who had been a pupil of Bernini's in Rome; Parodi was also a cabinetmaker who produced rather fantastic furniture in a pre-Rococo style. Among his pupils the Schiaffino family stand out; Francesco Queirolo—whose virtuoso style was later to manifest itself in Naples—worked for them. In the seventeenth century in Venice, the situation of both sculpture and painting was not a brilliant one. It is significant that what new ideas there were were all introduced by foreign artists: the Genoese Parodi, the Bolognese Mazza, the Frenchman Perrault and above all the Flemish Josse De Corte. At the turn of the century the classical-minded Corradini was active in Venice and, in furniture making, the Brustolon family, who greatly contributed to European Rococo.

The most autonomous of the Italian states, from a cultural point of view, was certainly Piedmont, where the Savoy dynasty gained steadily in power. Turin became a capital patterning itself on France in which culture played a predominant role (Tesauro having set the style for the decoration of palaces and castles). At the head of the arts was architecture, with Guarino Guarini's half-mathematical, half-structuralist style. At the beginning of the seventeenth century sculpture was mostly used in the Stations of the Sacri Monti (Varallo, Crea, Orta, Oropa); its style was coloured and popular in tone, similar in many ways to its Spanish counterpart. The "new style" was introduced in the Piedmontese cultural milieu by the stuccoworkers. Bernardo Vittone's architecture triumphed; he was a Newtonian theoretician of light and he also followed Leibniz in the infinitesimal calculations he applied to his works, which seem to have been chiselled by a sculptor's hand.

FRANCE

Paris obviously contested with Rome for European cultural supremacy. Both cities faced the same delicate political balancing act, though by the middle of the seventeenth century the Duc de Bouillon could proudly assert that Paris was the capital of the world. For thirty years France achieved pride of place in Europe, thanks to Richelieu and Mazarin, those masters of politics. Religious unity was pursued even with the use of arms, and there followed a remarkable expansion of the bourgeoisie to which the king had to subscribe in order to prevail over the ancient aristocracy.

The cultural scene was at first austerely classical. In the field of architecture there were Mansart and Lemercier, with their well-balanced and Italianate style. In philosophy Descartes's method and Pascal's science prevailed. In painting the leading

masters were Simon Vouet and the great Poussin; then came Philippe de Champaigne, with his synthesis of classicism, the Flemish vision, and love of the spiritual (one must remember that Philippe de Champaigne was the painter of the Port-Royal and the Jansenists). It was a time when the salons prevailed. In the field of the theater Corneille's heroic dramas were counterbalanced by the works of the Comédie-Italienne (Tiberio Fiorelli presented *Scaramouche* in Paris in 1640).

Sculptors, like other artists, kept their eyes turned towards Rome. Jacques Sarrazin, who established mid-century style, had been trained in Domenichino's classical environment. It was curious that, upon his return to Paris, his decoration of the Pavillon de l'Horloge at the Louvre (1641) should find a counterpart of sorts in the School of Fontainebleau. The brothers Anguier, also, played a role as intermediaries between Paris and Rome.

In Louis XIV's absolutist and centralized reign, political and cultural life revolved around the court and the city—at least until 1683, for it was after this date that the "provincial problem" arose, with the regional centers being deprived of authority. Once many of the provincial patrons disappeared, the king remained the only great patron. The economic policy imposed by the minister Colbert was based on trade (which led to colonial struggle with the British), but the minister also looked after cultural problems and saw the need for a centralized institution. The Royal Academy of Painting and Sculpture started assuming great importance on Colbert's orders in the same year (1663) in which Charles Le Brun was made President for life and Colbert Superintendent of Buildings. "I entrust you," said Louis XIV to the members of the Academy, "with the most precious thing in the world: my reputation." This was a clear indication that art was first of all a political instrument and, in this particular case, the instrument for spreading the king's personal renown. Among the various

policies implemented by Colbert was the reopening of the Gobelins' factory with a new official title, Royal Manufacturer of Furnishings to the Crown, and a new function to fulfill, that of providing every kind of decoration for the royal palaces.

The Louvre and Versailles—the royal palaces in town and in the country—made up the two faces of this political centralization of culture. Among the artists who competed to work on the Louvre were architects such as Pietro da Cortona, Carlo Rainaldi, Candiani, and Giovanni Lorenzo Bernini, who was summoned to Paris in 1665 to help produce a definitive plan. Versailles combined a town palace with extensive gardens, thereby forcing nature to submit itself to court etiquette. It was Colbert who insisted on the presence in Paris of the pope's foremost artist, Bernini. Bernini had formerly already refused Mazarin's invitation to France, though he had agreed to play the role of consultant whenever the French crown bought Italian works of art; he also sent to Paris suggestions for stage settings. When Colbert's invitation came, Bernini was seventy-seven years old and it was only upon the insistence of his friend Oliva, a general of the Jesuits, that he undertook the journey. Upon his arrival in France, he was greeted like a prince.

He spent his six months in France producing plans for the Bourbon Chapel and sculpting the king's marble bust and an altarpiece for the church of the Val-de-Grâce; he also taught the French the technique of "caricature," and three days before he left for Italy he was present at the ceremony at which the foundation stone for the Louvre was laid. Unfortunately his project was abandoned, partly through the machinations of French architects. French architecture was in fact based on extremely rational lines, and the prevailing architects of the time (Le Vau, Perrault, Mansart, and Le Nôtre) were always precariously poised between "good taste" and the grand manner. Classicism was a code

which was considered valid on a universal basis, especially in view of the political role of art.

The idea of art as ritual gave rise, quite naturally, to detailed theorization. François Blondel put together a rigid *Cours d'architecture*; André Félibien researched into the laws governing painting; Jean Racine elaborated the rule of the "Three Unities" in classical theater; Nicolas Boileau imprisoned poetry in the rigid set of rules of his *Art poétique*; Jean Baptiste Lully, the foremost musician of the Royal Academy, established other rules, for reformed music; Jacques Bénigne Bossuet, who wrote and delivered famous funeral orations for the most famous men and women of his time, established the rules governing such speeches in his *Instruction sur les états d'oraison*.

There were others who took up critical attitudes towards the court and expressed themselves in a dialectical tone: There were, for instance, Molière, with his relentless, acid commentary; La Rochefoucauld, with his skeptical pessimism; La Fontaine, whose clever or stupid animals were modelled on types commonly encountered at court. As far as official theater was concerned, the Comédie-Française was founded in 1677 and the Italian stage setters, with their elaborate machinery, were a great success.

The two official sculptors of the time were François Girardon and Antoine Coysevox. The former followed in the footsteps of Le Brun and the rules decreed by the Academy, and the latter was rather more influenced by Bernini's style. Both styles prevailed in the funerary sculptures made for the great ministers of the time: Girardon worked on Richelieu's tomb in the Sorbonne (page 130), and Coysevox on the monument to Colbert, in Saint-Eustache, and to Mazarin (now at the Louvre). Both styles can also be found at Versailles: Girardon's groups (such as *Apollo and the Nymphs*, in the Grotte de Théthis) counterbalance the Salon de la Guerre, in the decoration of which Coysevox participated (together with Mansart and Le Brun). Nevertheless, the best sculptor of the time was Pierre Puget, whose training, first with Bernini, then with Pietro da Cortona, and whose sojourn in Genoa, also make him one of the leading sculptors of European Baroque.

Usually the last few years of the Sun King's reign are considered to have been a period of decline. There was indeed a new "moral" tone to court life, which was certainly due to the pious new favourite, Madame de Maintenon; but in sculpture this coincided with the period in which Baroque, triumphant until then, gave way to a more graceful style that already heralded the coming of Rococo. The Academy was in a period of turmoil due to the strife between Dufresnoy and De Piles on the problems of the didactic function of the institution. The most lively sculptors of the time (Legros, Théodon, Monnot) took refuge in Rome. Louis XIV (who was painted by Rigaud in 1701, dressed in sumptuous brocades) challenged practically the whole of Europe. Louis XV's famous prediction, "When we are gone—the flood!" seemed close to fulfillment.

The Regency and, after that, Louis XV's reign witnessed a change of style in art, especially through the spectacular rise of cabinetmaking as a form of art. There were changes in the type of furniture in daily use: Louis XIV's *commode* replaced the traditional *bureau*, with its new, elongated form; this in turn acquired more harmonious proportions during the Regency; console tables were placed against walls like reliefs decorated with foliage and rockery motifs; painting was also used for decorative purposes, as in the Louis XV *boiseries*.

In music Jean Philippe Rameau expounded his theories in *Traité de l'harmonie réduite à ses principes naturels* (1722). The new rules were musicality and nature. In painting, Boucher's sophisticated world brought into court life the

fictional shepherds and shepherdesses so dear to Madame de Pompadour. But there were also Chardin's quiet contribution, which heralded bourgeois painting; Fragonard's almost pre-Romantic bucolic scenes; and Watteau's melancholy *fêtes galantes*.

There were few great sculptors, on the other hand: there was Nicolas Coustou, nephew and pupil of Coysevox, with his elaborate monuments (see page 138); Jean Baptiste Lemoyne, one of the most brilliant of Rococo sculptors, who came from a family of craftsmen; the Caffiéris, who went from sculpture to decoration and finally to cabinetmaking; Edme Bouchardon, who found inspiration in ancient sculpture (*Fountain of Neptune* at Versailles); and Jean Baptiste Pigalle, whose own way lay between Rococo and a neoclassical style (pages 141, 142).

It is significant that neoclassicism in all its manifestations should find inspiration in sculpture, which was after all the form of art which best suited the celebration of history: David's painting *The Swearing-in of the Horaces* is indeed conceived like a severe relief, just like Boullée's and Ledoux's architecture, with its spherical, triangular, and cylindrical forms.

CENTRAL EUROPE

In the seventeenth and eighteenth centuries, the various countries which vied with one another for pride of place within the Holy Roman Empire had a similar political and cultural climate. In art they were influenced first by Italian, then by French art, but within this context several distinct personalities emerged. A key to the philosophy of art between Baroque and Rococo may perhaps be found in the development of Leibniz's thought, from his early treatise *De arte combinatoria* to his theory of infinitesimal calculus, from his great synthesis of pre-established harmony (*Système nouveau de la nature et de la communication des substances*) to the cosmic and energetic theory of the *Monadology* and finally to the *Principes de la nature et de la grâce*.

The seventeenth century in central Europe was dominated by the Thirty Years' War (1618–1648). The struggle between Roman Catholics and Protestants was further complicated by a desire for a new balance and greater unity, which was thwarted by the Peace of Westphalia, which recognized the existence of three hundred and fifty autonomous states. The crisis grew ever more acute as the princes grew ever more arrogant (using art as a manifestation of power) until, towards the end of the seventeenth century, Prussia emerged as the supreme power and the economic and cultural center of central Europe. Frederick II persuaded a large number of states to join him in a north and central German league. He was a typical despot of the Age of Enlightenment, stabilizing the economy, founding the Berlin Academy of Science, establishing a civil code, and conceding freedom of the press and freedom of religion. The time for unity, however, was not yet at hand.

Art, of course, expressed itself differently according to the religion of the various countries. The dominating countries of Catholic faith were Austria and Bavaria; of Protestant faith, Prussia and Saxony. When, in 1683, John Sobieski halted the Ottoman march in Europe by defeating them in Vienna, a certain unity followed that was reflected in the architecture, the sculpture, and the painting of the time, with the development of a middle-European style that prevailed over the Italian influence in art.

It was a fruitful period for culture: several academies of Fine Arts were founded, with Donner and Moll teaching in Vienna and Schlüter in Berlin; music grew ever more important (with the activities of Bach and after him Mozart); Fratel Pozzo's

arrival in Vienna in 1703 was the start of a fashion for grandiose decorative painting typified by the works of Paul Troger and Franz Anton Maulbertsch; there was also a conception of the universality of all forms of art and its illusionistic function.

In the field of architecture several Italian architects, even minor ones, were welcome at various courts and given the highest honours. Andrea Spazza, Carlo Lurago, and Francesco Caratti worked in Prague and in Bohemia, paving the way for the great Dientzenhofer, who was to create a graceful style of his own (similar in many ways to the Italianized style of Fischer von Erlach) that transformed architecture into a modulated sequence of luminous plastic spaces based on the theory of infinitesimal calculus. Carlo Antonio Carlone, Filiberto Lucchese, and Domenico Martinelli, upholders of the monumental style, all worked in Vienna. In southern Germany there were Agostino Barelli working in Munich, Enrico Zuccalli in Schleissheim, and Antonio Petrini in Würzburg.

Three of the greatest architects of the time used sculpture extensively in their work. Fischer von Erlach, in his church of St. Carlo Borromeo in Vienna (1761), integrates sculptural elements in his façade decorated with two spiral columns relating the saint's life. In their church of St. John of Nepomuk in Munich, Cosmas Damian and Egid Quirin Asam strike a delicate balance between undulated moulding and decorative sculpture. The case of Schlüter (see pages 152–155) is typical of the close link of the activities of sculptors and architects. Oddly enough, his sculpture is much more dynamic and Rococo than his buildings.

There were relatively few sculptors with a style of their own, untouched by French or Italian influence, and proposing new techniques and a new typology.

The most positive aspect of the situation is probably to be found in the decoration of exteriors and interiors and in craftsmanship. Here unknown masters (or masters whose names are not significant any longer) have provided the background to a civilization which was remarkable above all for its architecture.

Nevertheless, several names emerge: in the first generation, Georg Petel, Matthias Rauchmiller, and Balthasar Permoser. Petel gave a new stature to ivory carving (e.g., *St. Sebastian*) which had been hitherto considered a minor technique. Rauchmiller was active in the middle of the century in Vienna. His subject matters (*The Abduction of the Sabine Women*, *Apollo and Daphne*) reveal the influence of Rubens and Bernini, and, according to Winckelmann, he "superseded the Greeks themselves in matters of gracefulness." He took part in the decoration of the Pestsäule in Vienna, collaborating with Ignaz Bendl and Paul Strudel in the project of the architect Fischer von Erlach and the stage designer Burnacini. Balthasar Permoser was trained in the style of Bernini. His pictorial quality and moderate pathos are fully expressed in the Corsini Chapel in Florence and in the work he did in Venice (he sojourned in Italy for fourteen years, from 1675 onwards, then went on to Dresden, returning to Italy for brief visits). He is one of the few middle-European sculptors who was profoundly influenced by Italian Baroque. He could switch without any difficulty from exquisite ivory carving to monumental sculpture. Many of the sculptures in the Zwinger in Dresden are by Permoser (see page 156); significantly conceived as a colossal piece of sculpture, the building remains the most typical of its period.

Four remarkable sculptors worked in Prussia, Bavaria, Franconia, and Austria in the first half of the eighteenth century: Andreas Schlüter, Egid Quirin Asam, Paul Egell, and G. R. Donner. Schlüter's *Dying Warrior* (Berlin, Arsenal, pages 152–153) and *Männlich Monument* (Berlin, St. Niklaus) show another side of this moderately

classical architect—his taste for both Hellenistic pathos and medieval macabre. In the tomb, he expresses his idea of life and death by means of a skeleton grasping a *putto*, carved in a fluid style, just like the cloth surrounding the medallion with a portrait of the dead man. Egid Quirin Asam, brother of a famous painter of *trompe l'oeil* (trained in Rome), is characterized by a virtuoso style in his sculpture which is close to architecture. This may be seen in the *Trinity Altarpiece* (Munich, St. John of Nepomuk), with its feeling for space, which owes much to the theater. In works such as the *Assumption of the Virgin* (Rohr, monastery; page 53), the tormented composition goes even beyond Franz Ignaz Günther's decorative delirium. A pupil of Permoser's at Dresden, Egell (see page 162) mingles Roman Baroque with a kind of neo-Renaissance style. The position of Georg Raphael Donner (see his classical statues of *Rivers*, page 163; also the magnificent angel in the Bratislava cathedral, with its Greek face and attitude) is in between Baroque classicism and the future "re-discovery" of the ancient world (Mengs, Winckelmann).

Ignaz Günther, with his coloured and dynamic sculpture, is perhaps one of the greatest representatives of Rococo. He started by studying the ancient statues in the Vienna Academy, but there is not much evidence of this early education in his tormented and contorted figures, which were well adapted to the new Bavarian absolutism. His saints wear the improbable costumes of the time; his altarpieces in country churches display a style of sculpture which is nearer to pure painting and courtly decoration; his madonnas and angels, with their painted cheeks and lips, seem like ballet figures (pages 55–57, 78, 158–160).

This "emotional" period comes to an end in an almost tragical way with Franz Xaver Messerschmidt, a sculptor who was much more important than is usually imagined. His schizo-phrenic nature is expressed in the many busts he sculpted on the subject matter of "states of mind" (Melancholy, Obstinacy, Irritability, Torment) and other, more complicated characteristics (the Hypocritical Slanderer, the Sorrowful Man with no emotional outlet), or abnormal situations (the Hanged Man, the Man Saved from Drowning). This was not caricature but, rather, an early attempt at recording the incredible variety of human facial expressions.

FROM EUROPE TO THE AMERICAS

In the Netherlands there was opposition between the Protestant North (the present Holland) and the Catholic south (more or less the area of present-day Belgium). In the north there prevailed an urban bourgeoisie, and in the south Spanish domination had imposed a courtly Catholic culture. Economically the country was flourishing. Amsterdam was the richest city in Europe. The Dutch cities were built according to the earliest forms of modern urban planning. In the field of art, however, sculpture and architecture were placed second after painting, which, mostly through the bias of economic reasons (the ever increasing phenomenon of private patrons), was given pride of place. Rubens's epic Catholic vision counterbalanced Rembrandt's Biblical one; the prolific Flemish painters imitated Vermeer's timeless light.

For economic reasons England in the seventeenth century became just an annex of the Netherlands. Rubens's and Van Dyck's presence was not enough to shake the Protestant torpor of a country that perhaps had not even had a proper Renaissance. Of all forms of art, it was the theater that took pride of place. In sculpture minor techniques such as porcelain (e.g., Chelsea) or cabinetmaking (Chippendale) prevailed. English

Page 78: Franz Ignaz Günther,
St. Catherine, post 1753. Polychrome wood.
Munich, St. Peter's.

culture was tinged with the empiricism of Bacon, Locke, Kepler, and Newton.

In Spain, absolutist monarchy used religion as its instrument. The Inquisition too (dubbed "Holy") became a political instrument. The economic situation was based on the riches of the colonies. However, as Spain was not able to channel properly the gold that came from those colonies, the early seventeenth century witnessed an inflation which led to a serious economic crisis in which eventually the whole of Europe was involved. Both the Spanish attitude to religion and this economic crisis were reflected in the country's culture. Lope de Vega's and Calderón de la Barca's conventional theater was counterbalanced by Cervantes's *Don Quixote*, which pinpointed the gulf that existed between the nobility and the real world and reflected the end of an era.

In the field of architecture, towards the end of the century, there prevailed the Churriguera family, which was responsible for the overly ornate style known as "Churrigueresque" (which was a predecessor, by a few centuries, of Gaudi's excessive style). The leading sculptors of the time were Juan Martínez Montañés, Alonso Cano, and Pedro de Mena, whose Baroque idiom was still tied to a certain Renaissance stiffness while at the same time continuing the popular tradition of a highly coloured sculpture. The most flourishing city was Seville, where the gold from the colonies arrived and from which local sculptures were sent to the Americas.

The colonization of Latin America went back to the mid-sixteenth century, with its economic exploitation, the violent invasions of the conquistadores, and the hardships arising from an imposed civilization. Spain and Portugal shared the Catholic religion and a structure in which politics consisted of a bureaucratic and religious centralization. The New World was invaded by a large number of religious orders which promptly founded monasteries and churches. By the beginning of the seventeenth century Latin America numbered seventy thousand churches and five hundred convents, and by the beginning of the nineteenth century von Humboldt (a friend of Goethe's) reckoned that in Mexico eighty percent of all cultivable land was in the hands of the church. Local art obviously reflected the use of religious subject matters as an instrument of colonial propaganda. Thus, the subject matters were those of pietistic Spain (asceticism, agony, ecstasy, triumph). The favourite material was wood, which was almost always highly coloured. In architecture the European idiom was somewhat deformed, for all its elements were taken out of their context and restructured differently. Sculpture remained faithful to the types and subject matters established by the conquistadors, with the addition of a larger dose of pathos due to popular taste. The last embers of European absolutism glowed in the colourful sculptures and rich materials of the New World, and art became accessible to (and indeed made by) all, which explains the fact that artists of the time are often anonymous.

ACKNOWLEDGMENTS
The author wishes to thank Cecilia Bernardini, Laura Cherubini, and Ester Coen for their help. This work is dedicated to the masters and friends who directed him towards this field of research: Giulio Carlo Argan, Rudolf Wittkower, Erwin Panofsky, Italo Faldi, Antonia Nava Cellini, and Hans Sedlmayr.

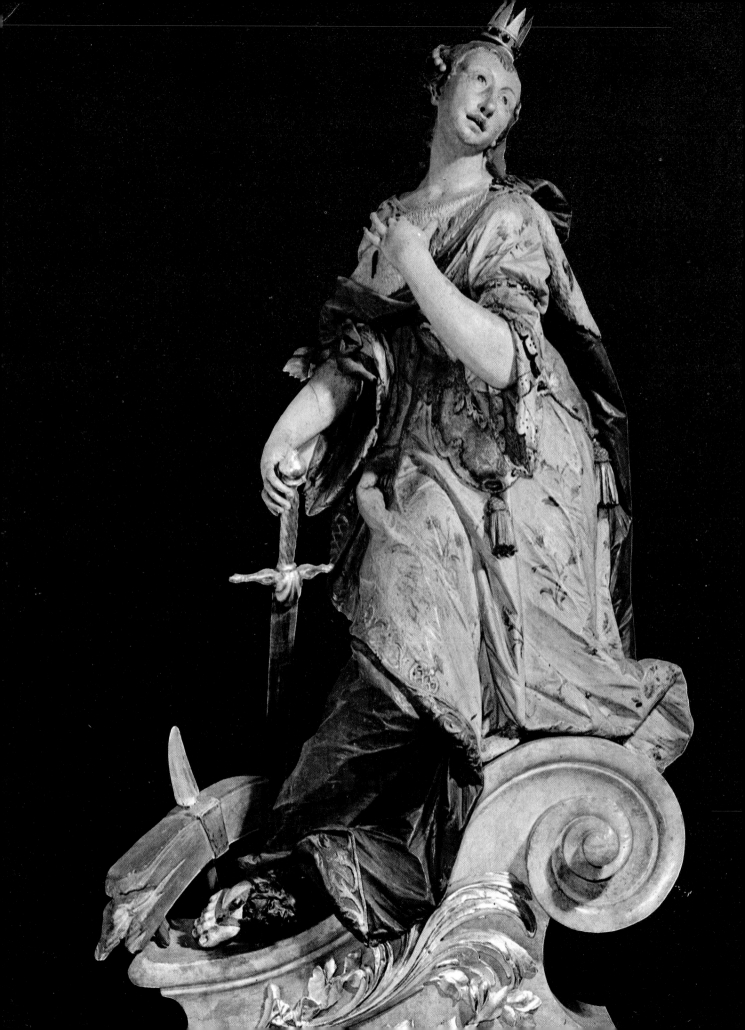

THE WORKS

To look at people with the eyes of
imagination, to smell and taste the infinite
sweetness of God, to celebrate ornaments and
buildings of the Church, to celebrate images
and venerate them for what they represent.

(St. Ignatius Loyola,
Spiritual Exercises, 1548)

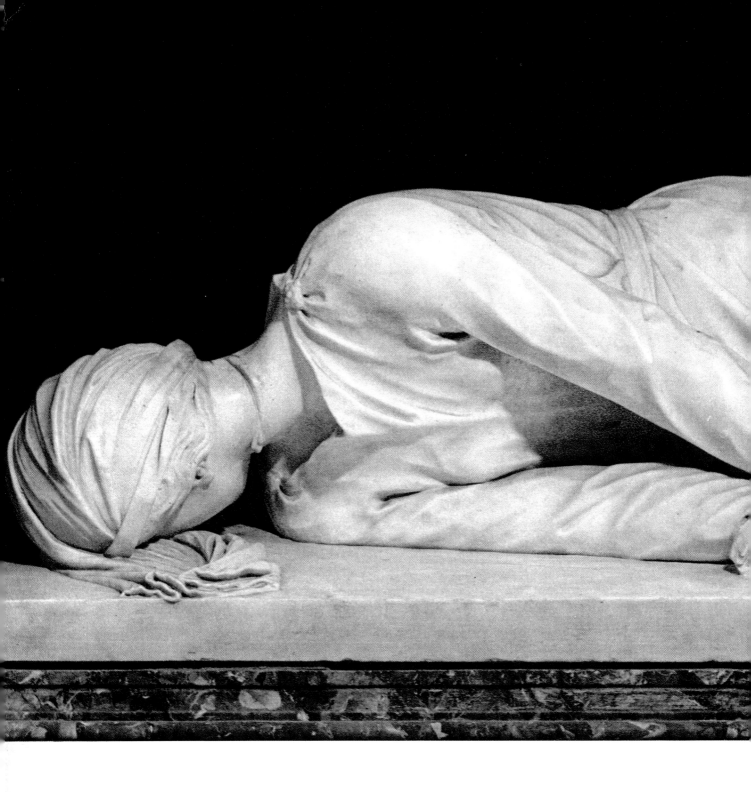

Above: Stefano Maderno (Bissone, near Pavia,
1576–Rome 1636), St. Cecilia, 1600.
Marble; length 40 in. Rome, Santa Cecilia.
The saint is shown dead, lying on the ground after her
martyrdom. She is wearing Roman dress and her head is
wrapped in the scarf in which the hair of those to be
beheaded was traditionally wrapped. Her neck shows the
mark of the executioner's sword. The work reproduces the
miraculously preserved position of the saint's body as it
was found when her tomb was opened and examined in
1599; it is said that Maderno was present at that event.

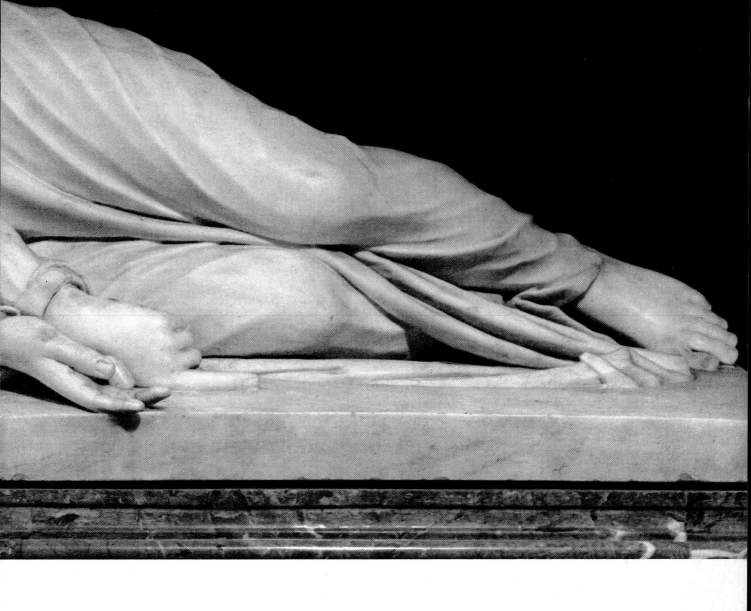

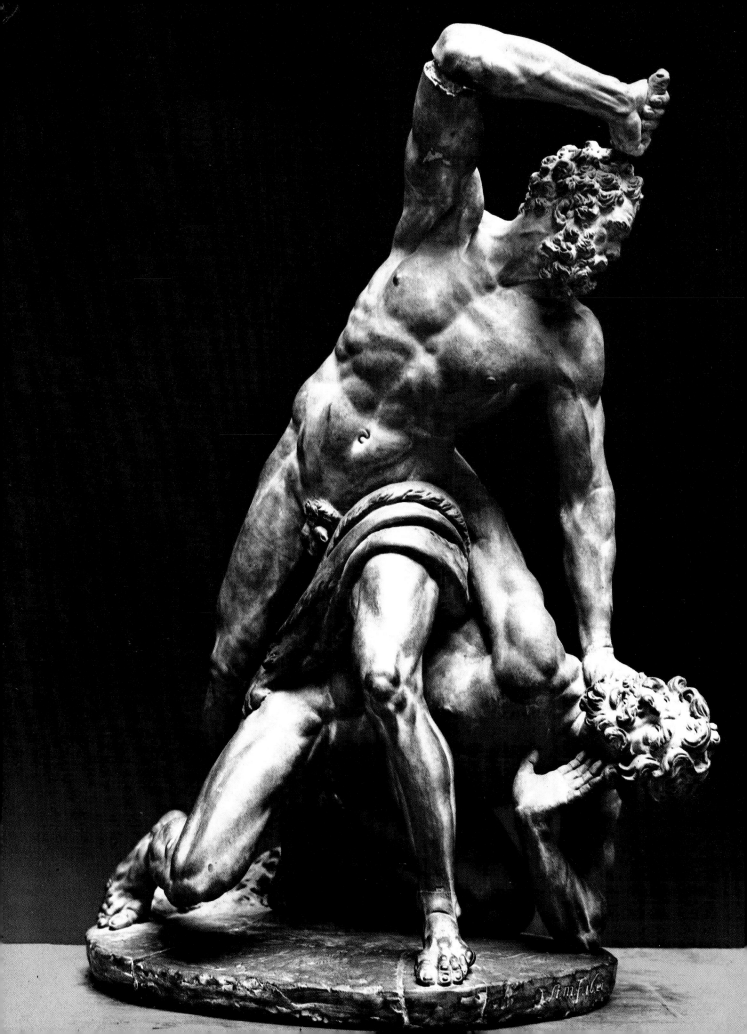

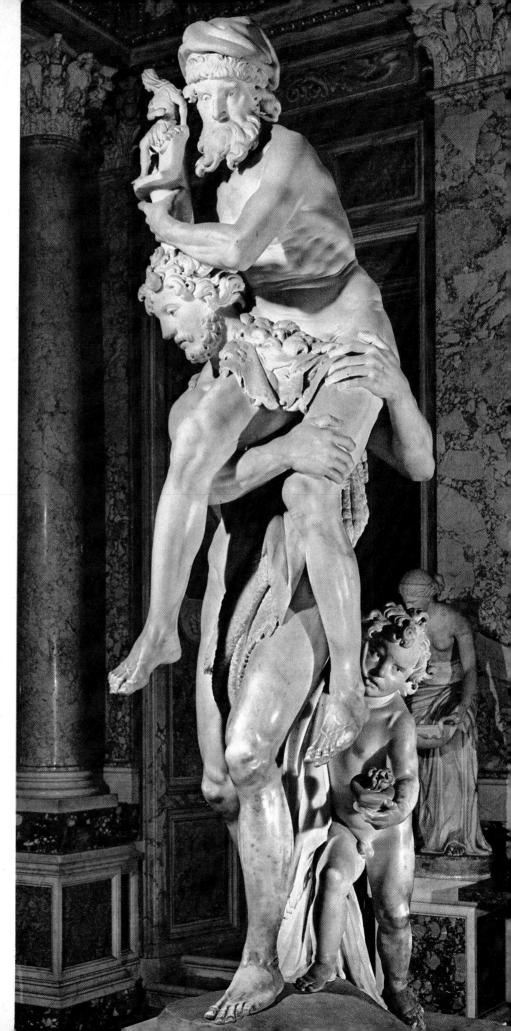

*Left: Stefano Maderno
(Bissone, near Pavia, 1576–Rome
1636),
Hercules and Cacus, 1610.
Terra cotta; height 22 in. Venice, Ca'
d'Oro.
This model represents one of the
labours of Hercules. A marble statue
was made from it and is now in the
Staatliche Kunstsammlungen, Dresden.*

*Right: Pietro Bernini
(Sesto Fiorentino 1562–Rome 1629),
and Giovanni Lorenzo Bernini
(Naples 1598–Rome 1680).
Aeneas, Anchises, and Ascanius,
1618–1619.
Marble; height 7 ft. 2 in. Rome,
Galleria Borghese.
The subject matter, inspired by the
Aeneid, represents Aeneas's flight from
burning Troy. He is shown carrying his
father, Anchises, who is himself
carrying the effigies of the penates
(household gods); Aeneas's young son,
Ascanius, is clinging to them. The
group, commissioned by Cardinal
Scipione Borghese, was inspired either
from a detail in Raphael's Fire at
Borgo (Rome, Vatican Palace), or
from Michelangelo's Risen Christ
(Rome, Santa Maria above Minerva),
for the figure of Aeneas. Giovanni
Lorenzo Bernini's hand is evident only
in the figure of Ascanius.*

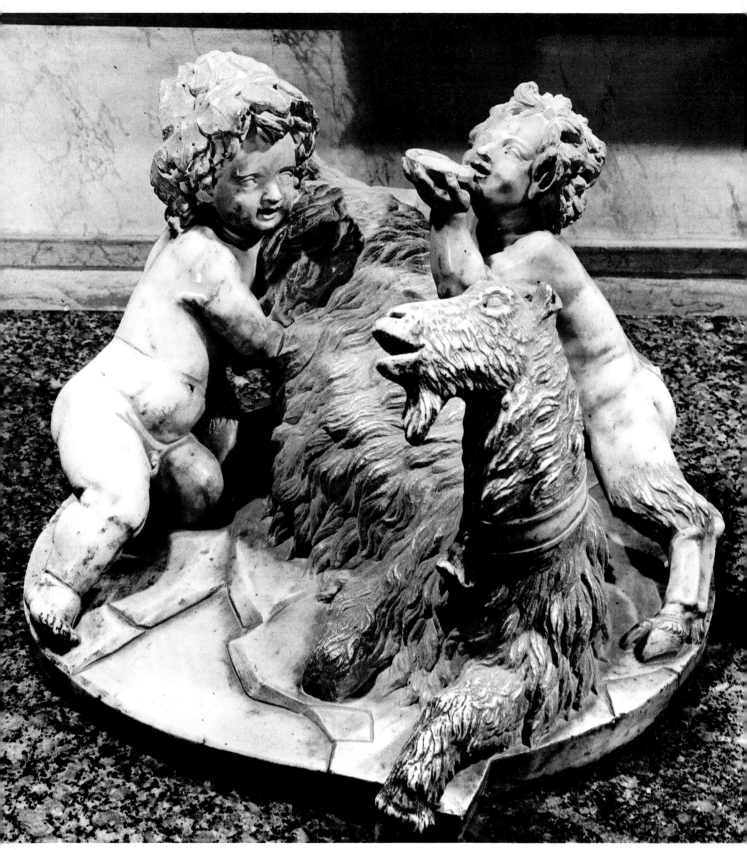

Above: Giovanni Lorenzo Bernini (Naples 1598–Rome 1680), Zeus Drinking the Milk of the Goat Amalthea, c. 1615. Marble; height 18 in. Rome, Galleria Borghese.
The subject matter, taken from Vergil, represents the infant Zeus watching the small satyr drinking the milk of the goat Amalthea. According to the legend Zeus was abandoned at birth by his mother on Mount Ida so that his father, Cronos, might not devour him.

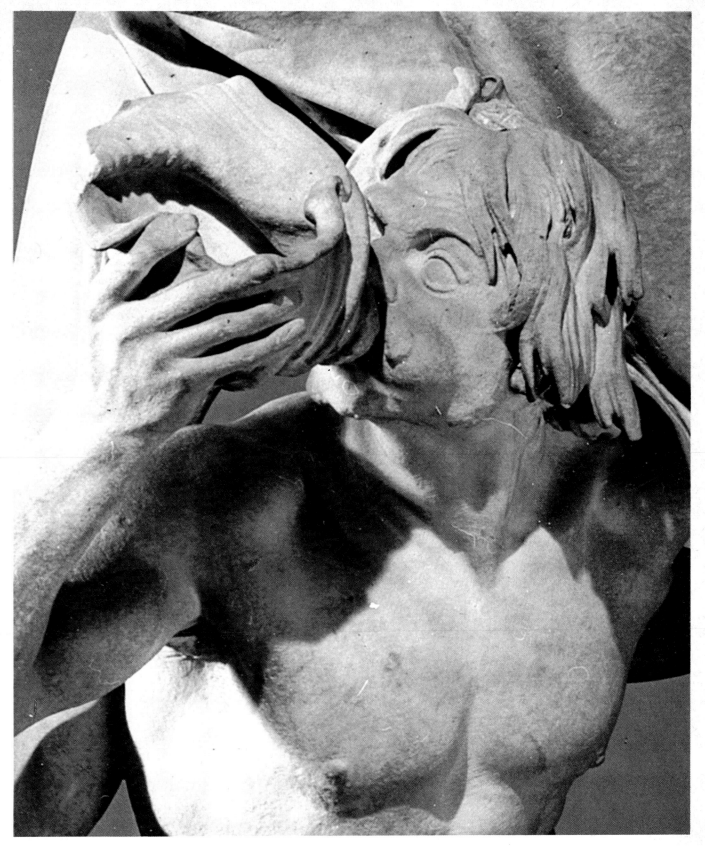

Above (detail) and pages 34 and 35 (detail and whole): Giovanni Lorenzo Bernini (Naples 1598–Rome 1680),
Neptune and a Triton, *1619–1621.*
Marble; height 5 ft. 11 in. London, Victoria and Albert Museum.
The subject matter, taken from the Aeneid, *represents Neptune rising from the sea in order to still a storm that was*
threatening Aeneas's fleet. The work originally adorned the fish pond at Villa Montalto, but was taken to England in 1786.

Above: Giovanni Lorenzo Bernini (Naples 1598–Rome 1680), Blessed Soul, *c. 1620.*
Marble; life size. Rome, Palazzo di Spagna.
This bust, the pendant of the Damned Soul *(see page 87), was made for the church of San Giacomo degli Apostoli, Rome.*
It represents a soul in heaven, with loose hair capped by a garland of flowers.

Above : Giovanni Lorenzo Bernini (Naples 1598–Rome 1680), Damned Soul, c. 1620.
Marble ; life size. Rome, Palazzo di Spagna.
This work, the pendant of the Blessed Soul *(see page 86), represents a damned soul, personified by a male head screaming in despair, with dishevelled hair and staring eyes. The work was partially inspired by certain studies of Michelangelo for the Sistine Chapel frescoes.*

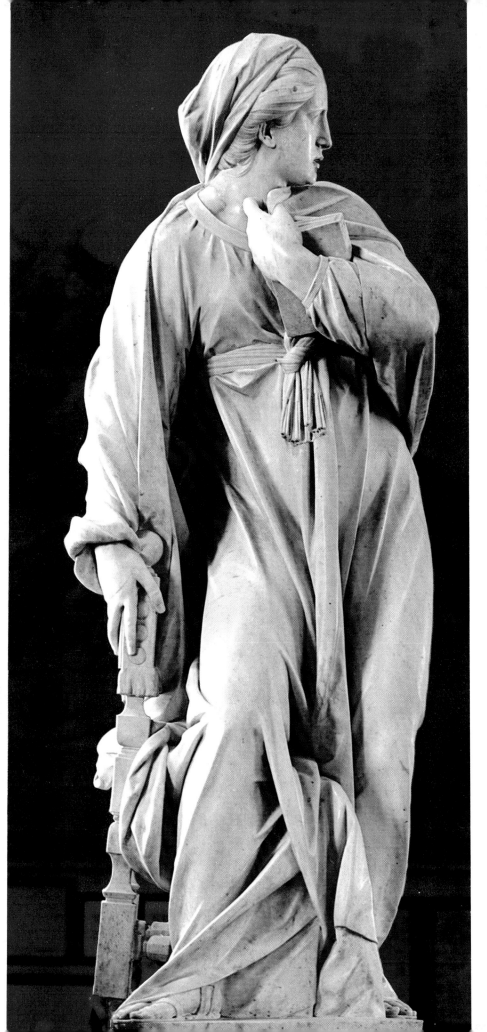

*Left: Francesco Mochi
(Montevarchi 1580–Rome 1654),
The Virgin of the Annunciation,
c. 1608.
Marble; height 6 ft. 10 in.
Orvieto, Museo dell'Opera del Duomo.
The Virgin is depicted as she rises from
a chair, startled by the angel's
appearance and clutching a prayer
book to her bosom. She is wearing a
long dress tied by a sash under the
bosom and a mantle over her head and
shoulders; she is wearing Roman
sandals on her feet. The statue,
commissioned by the Orvieto
Cathedral, was placed until last century
on the side of the main altar, opposite
the* Angel *(see page 89).*

*Right: Francesco Mochi
(Montevarchi 1580–Rome 1654),
The Angel of the Annunciation, 1605.
Marble; height 6 ft. 8 in.
Orvieto, Museo dell'Opera del Duomo.
The winged angel is shown with his
billowing robes and his left arm
extended heavenwards, referring to
God's command.*

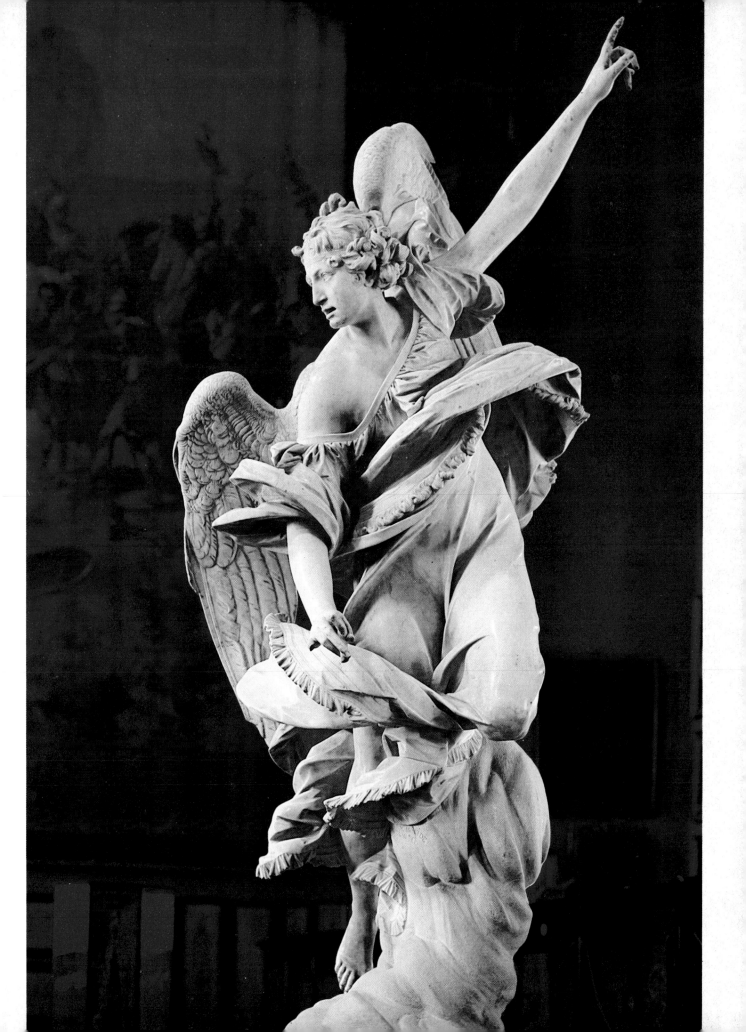

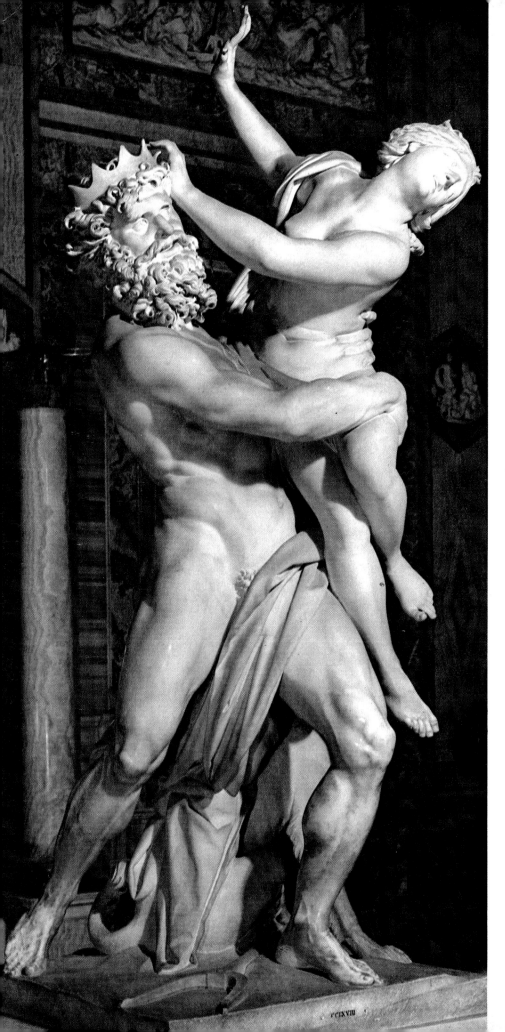

Left (whole), right and page 2 (details): Giovanni Lorenzo Bernini (Naples 1598–Rome 1680), The Abduction of Proserpina, *1621–1622. Marble; height 7 ft. 5 in. Rome, Galleria Borghese. This work illustrates the myth of Proserpina's abduction by the god of Hell, who wished to make her his wife. Behind the two naked figures is Cerberus, the three-headed dog, guardian of the nether regions. The group, commissioned by Cardinal Scipione Borghese, was given as a present to Cardinal Ludovisi in 1623 and remained in his villa until 1908.*

Pages 36 and 37 (whole and detail): Giovanni Lorenzo Bernini (Naples 1598–Rome 1680), Apollo and Daphne, *1622–1625. Marble; height 8 ft. Rome, Galleria Borghese. This mythological episode, taken from Ovid's* Metamorphoses, *relates how the nymph Daphne, pursued by the amorous Apollo, was changed by her father Peneius into a laurel tree. The work was commissioned by Cardinal Scipione Borghese, whose arms contained a laurel tree. The inscription on the base of the group, which warns ill-matched lovers, was dictated by Maffeo Barberini, the future Pope Urban VIII, on a visit to the cardinal's palace when Bernini was at work on the piece.*

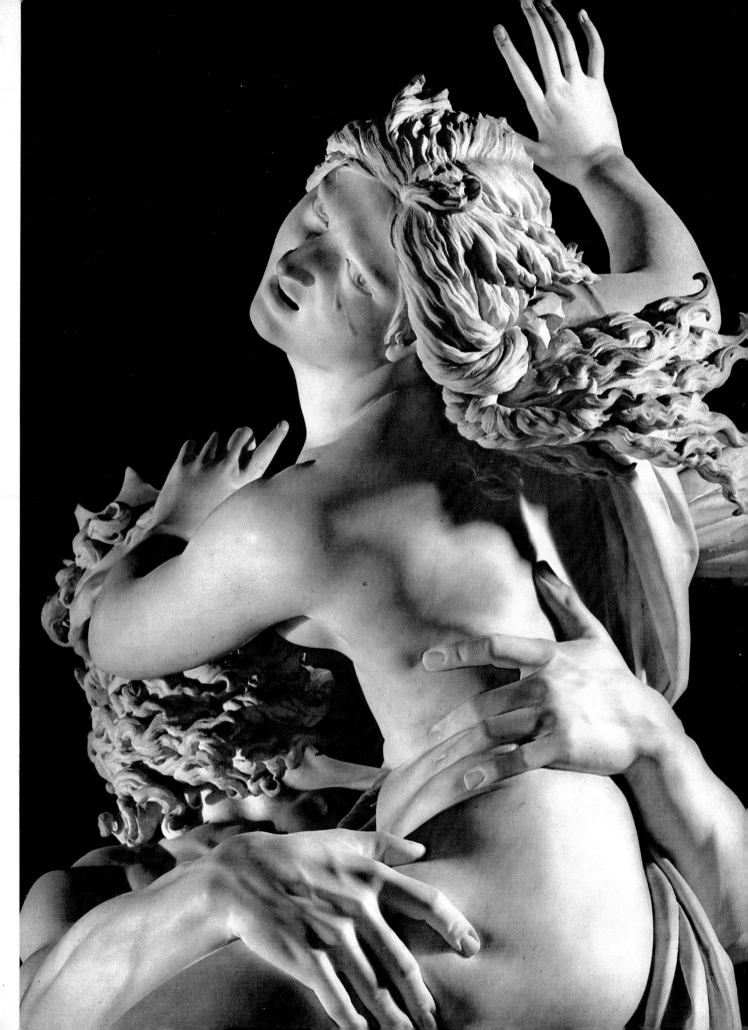

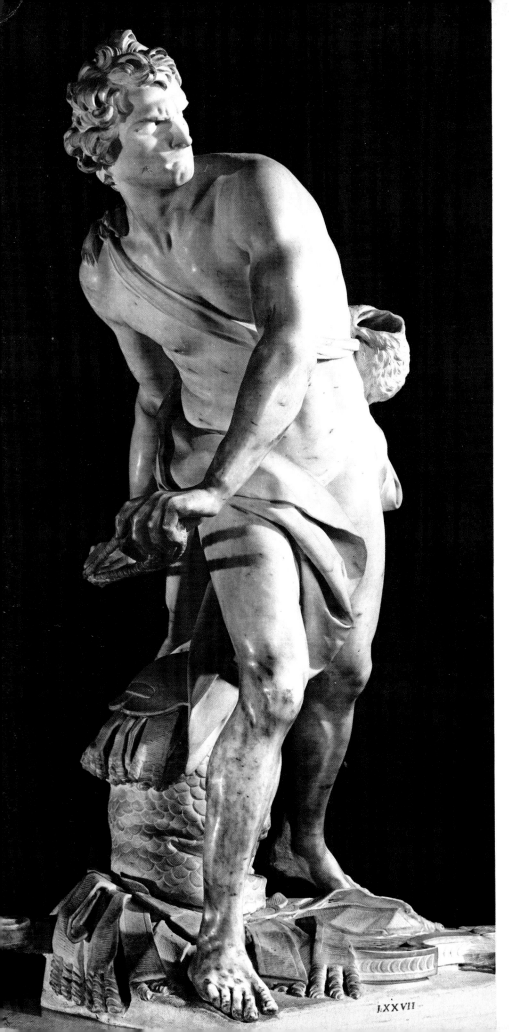

Left (whole) and right (detail):
Giovanni Lorenzo Bernini
(Naples 1598–Rome 1680),
David, 1623–1624.
Marble; height 5 ft. 7 in.
Rome, Galleria Borghese.
The young hero of Renaissance
sculpture is depicted by Bernini as an
adult man at the height of his physical
power. He is shown about to sling the
stone that will kill his enemy, the giant
Goliath. At his feet are the harp with
which he used to soothe King Saul and
the breastplate which he refused to
wear for the fight with Goliath. The
figure of David, therefore, represents a
poet who can, if necessary, become a
warrior; and this may be a reference to
Maffeo Barberini, the future Urban
VIII. The face is traditionally thought
to be Bernini's self-portrait, and it is
said that he carved it while Maffeo
Barberini was holding a mirror for him.
The work was commissioned by the
cardinal Scipione Borghese.

LXXVII

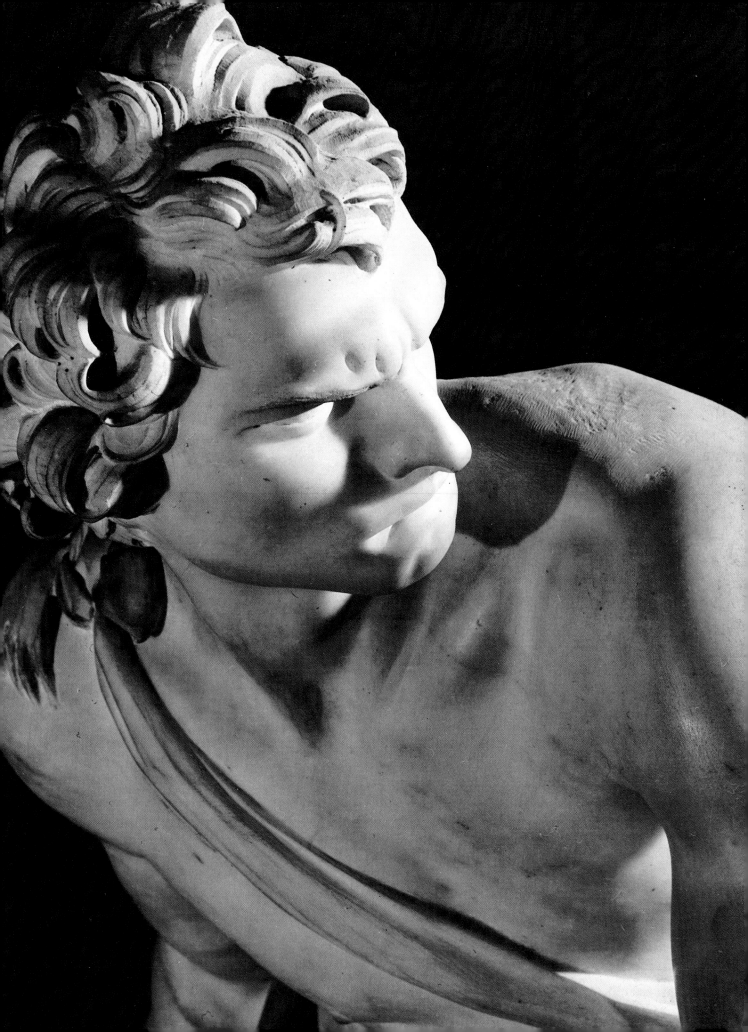

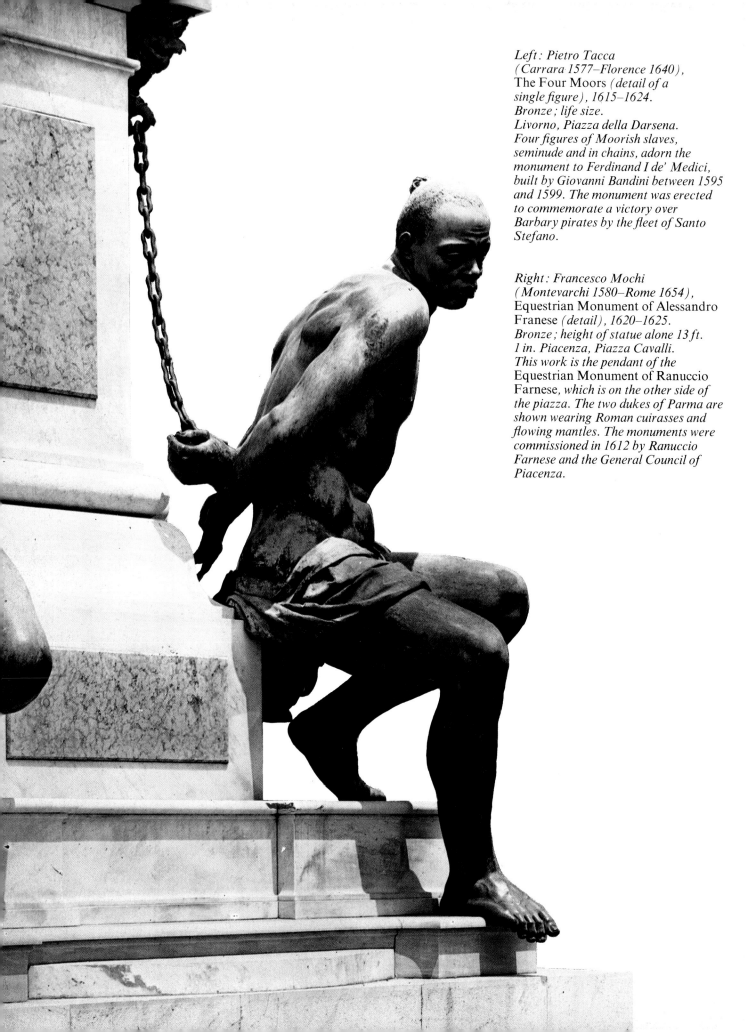

Left: Pietro Tacca
(Carrara 1577–Florence 1640),
The Four Moors (detail of a
single figure), 1615–1624.
Bronze; life size.
Livorno, Piazza della Darsena.
Four figures of Moorish slaves,
seminude and in chains, adorn the
monument to Ferdinand I de' Medici,
built by Giovanni Bandini between 1595
and 1599. The monument was erected
to commemorate a victory over
Barbary pirates by the fleet of Santo
Stefano.

Right: Francesco Mochi
(Montevarchi 1580–Rome 1654),
Equestrian Monument of Alessandro
Franese (detail), 1620–1625.
Bronze; height of statue alone 13 ft.
1 in. Piacenza, Piazza Cavalli.
This work is the pendant of the
Equestrian Monument of Ranuccio
Farnese, which is on the other side of
the piazza. The two dukes of Parma are
shown wearing Roman cuirasses and
flowing mantles. The monuments were
commissioned in 1612 by Ranuccio
Farnese and the General Council of
Piacenza.

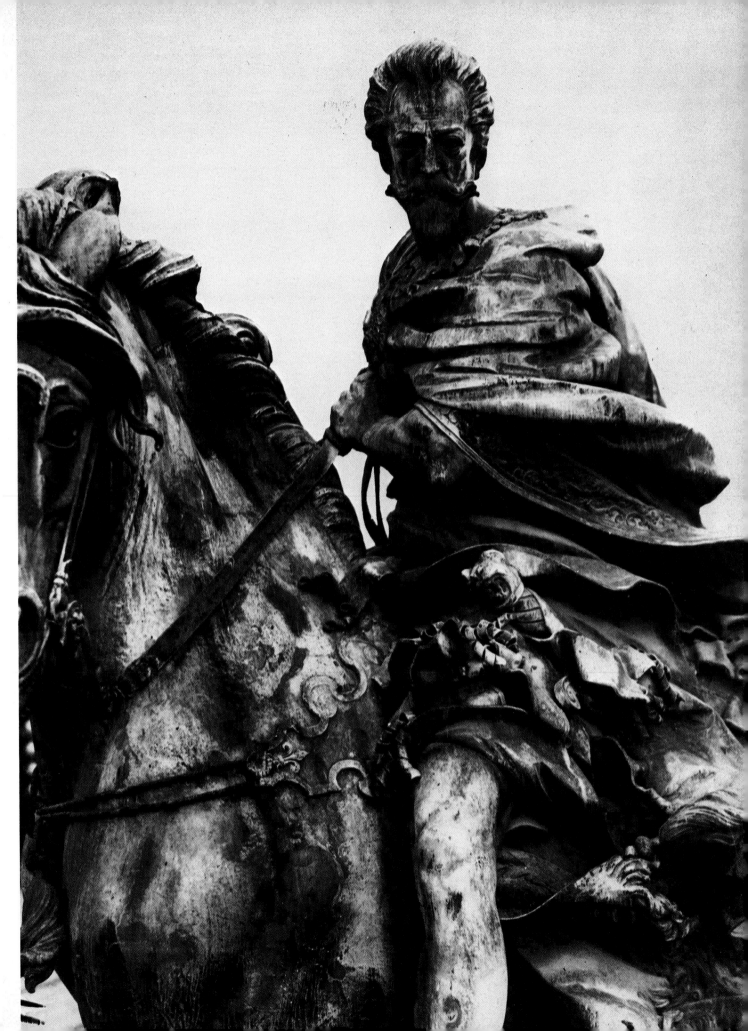

Left: Francesco Mochi
(Montevarchi 1580–Rome 1654),
Putti Bearing Coats of Arms,
c. 1625–1628.
Bronze; height 31 in.
Piacenza, Piazza Cavalli.
These two putti decorate the two
shorter sides of the monument of
Alessandro Farnese (see page 95).

Page 44: François Girardon
(Troyes 1628–Paris 1715),
Apollo and the Nymphs (detail),
1666–1673.
Marble; life size. Versailles, park of
the château.
The group represents the god Apollo,
wearing the quiver and the laurel crown
of classical iconography, seated on a
rock and surrounded by six nymphs
who are bathing him and sprinkling him
with perfumes. The three nymphs
standing behind him were sculpted by
Thomas Regnaudin. The work was
commissioned by Louis XIV for the
Grotte de Théthis in the park at
Versailles, but the group was moved in
1778 to its present place in an artificial
grotto designed by the painter and
landscape designer Hubert Robert.

Page 45: Claude Michel, known
as Clodion (Nancy 1738–Paris 1814),
Cupid and Psyche.
Terra cotta; height 23 in.
London, Victoria and Albert Museum.
The group represents the God of Love
(winged, according to traditional
iconography) carrying off his sleeping
spouse with the help of small winged
putti.

Right: François Duquesnoy
(Brussels 1597–Livorno 1643),
The Young Bacchus, post 1629.
Marble; height 24 in.
Rome, Galleria Doria Pamphili.
According to the more usual
representation of the god of wine in
early seventeenth-century Roman
painting and sculpture, Bacchus is
shown as an adolescent. Naked and
wearing on his head a wreath of vine
leaves, he is leaning against a tree trunk
covered with a climbing vine.

Left and right:
Giovanni Lorenzo Bernini
(Naples 1598–Rome 1680),
Portrait of Costanza Buonarelli,
c. *1635.*
Marble; height 28 in.
Florence, Museo del Bargello.
This bust, with its dishevelled hair and
casually open chemise, is a portrait of
Bernini's mistress, who was also the
wife of his pupil Matteo Buonarelli.
After his marriage to Caterina Tezio in
1640, the sculptor gave the bust to
Monsignor Bentivoglio. After changing
hands several times the bust landed in
the Medici collection in 1645.

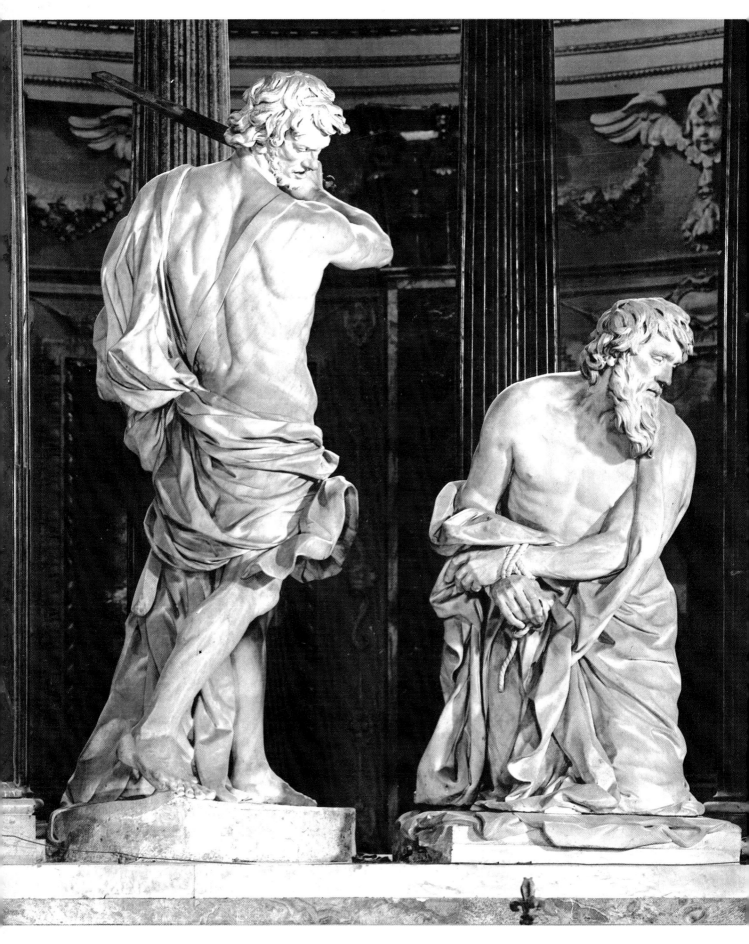

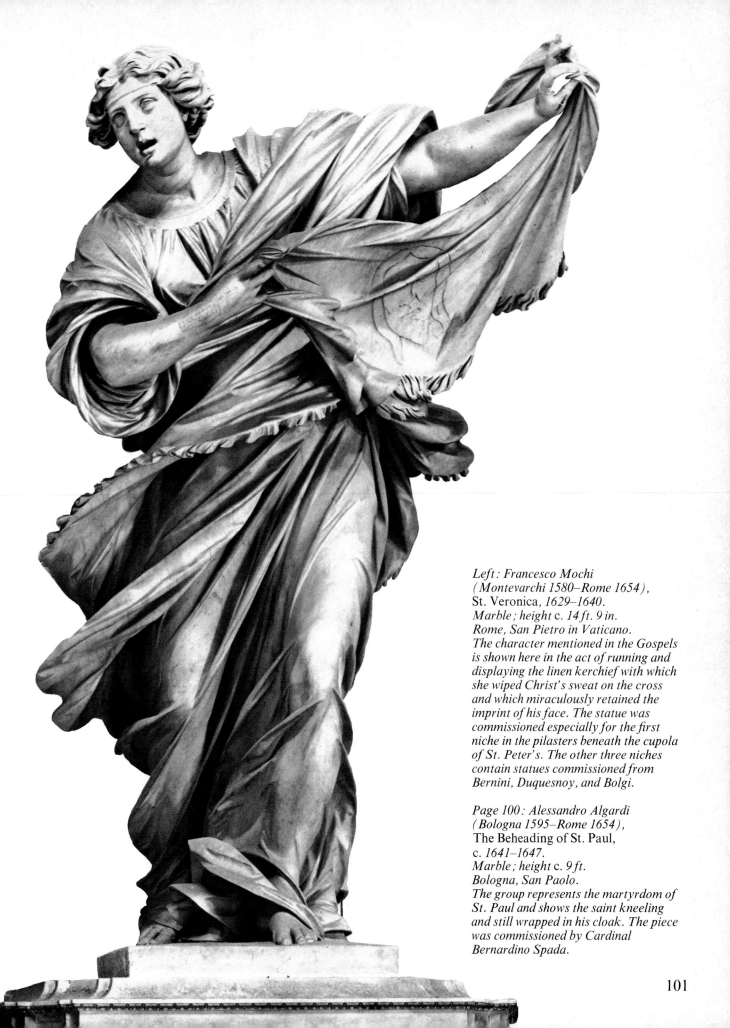

Left: Francesco Mochi
(Montevarchi 1580–Rome 1654),
St. Veronica, 1629–1640.
Marble; height c. 14 ft. 9 in.
Rome, San Pietro in Vaticano.
The character mentioned in the Gospels
is shown here in the act of running and
displaying the linen kerchief with which
she wiped Christ's sweat on the cross
and which miraculously retained the
imprint of his face. The statue was
commissioned especially for the first
niche in the pilasters beneath the cupola
of St. Peter's. The other three niches
contain statues commissioned from
Bernini, Duquesnoy, and Bolgi.

Page 100: Alessandro Algardi
(Bologna 1595–Rome 1654),
The Beheading of St. Paul,
c. 1641–1647.
Marble; height c. 9 ft.
Bologna, San Paolo.
The group represents the martyrdom of
St. Paul and shows the saint kneeling
and still wrapped in his cloak. The piece
was commissioned by Cardinal
Bernardino Spada.

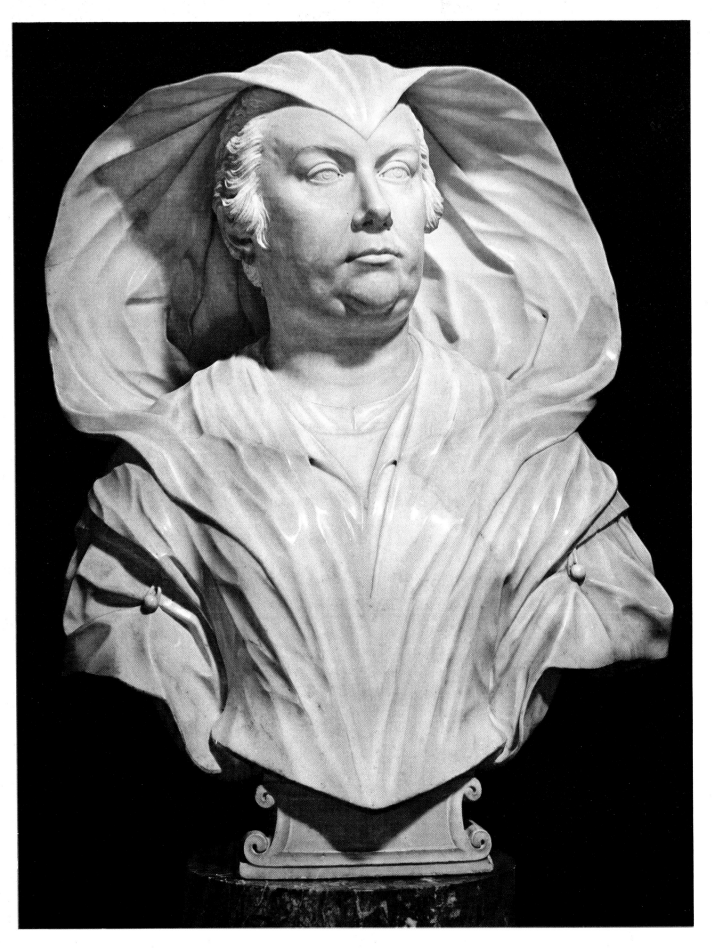

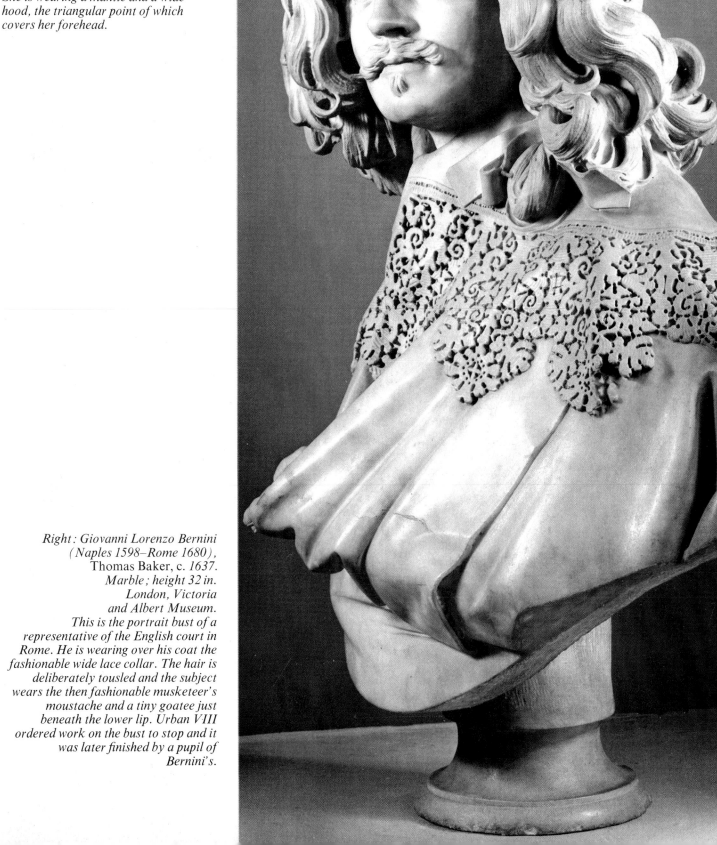

*Left: Alessandro Algardi
(Bologna 1595–Rome 1654),
Donna Olimpia Maidalchini
Pamphili,
c. 1646.
Marble, life size.
Rome, Galleria Doria Pamphili.
This is the portrait bust of Pope
Innocent X's sister-in-law in old age.
She is wearing a mantle and a wide
hood, the triangular point of which
covers her forehead.*

*Right: Giovanni Lorenzo Bernini
(Naples 1598–Rome 1680),
Thomas Baker, c. 1637.
Marble; height 32 in.
London, Victoria
and Albert Museum.
This is the portrait bust of a
representative of the English court in
Rome. He is wearing over his coat the
fashionable wide lace collar. The hair is
deliberately tousled and the subject
wears the then fashionable musketeer's
moustache and a tiny goatee just
beneath the lower lip. Urban VIII
ordered work on the bust to stop and it
was later finished by a pupil of
Bernini's.*

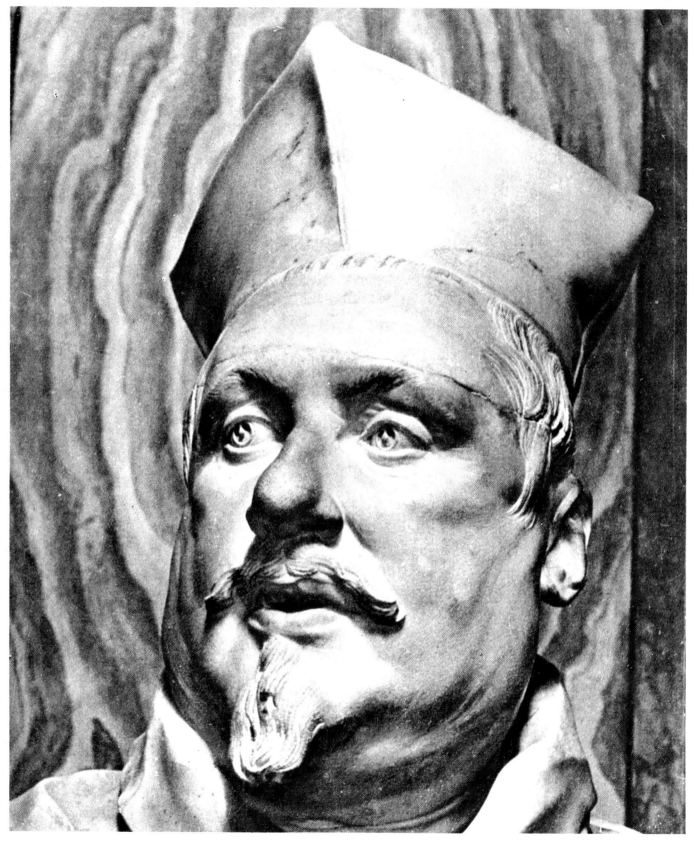

Above: Giovanni Lorenzo Bernini (Naples 1598–Rome 1680), Cardinal Scipione Borghese, 1632. Marble; height 31 in. Rome, Galleria Borghese.
This is the portrait bust of Bernini's first patron in his cardinal's habits. A flaw which developed on the forehead soon after the work was completed caused Bernini to sculpt an almost identical copy (see page 6) in a remarkably short time. According to his biographer Baldinucci, he did it in a single night; according to his son, he did it in three days.

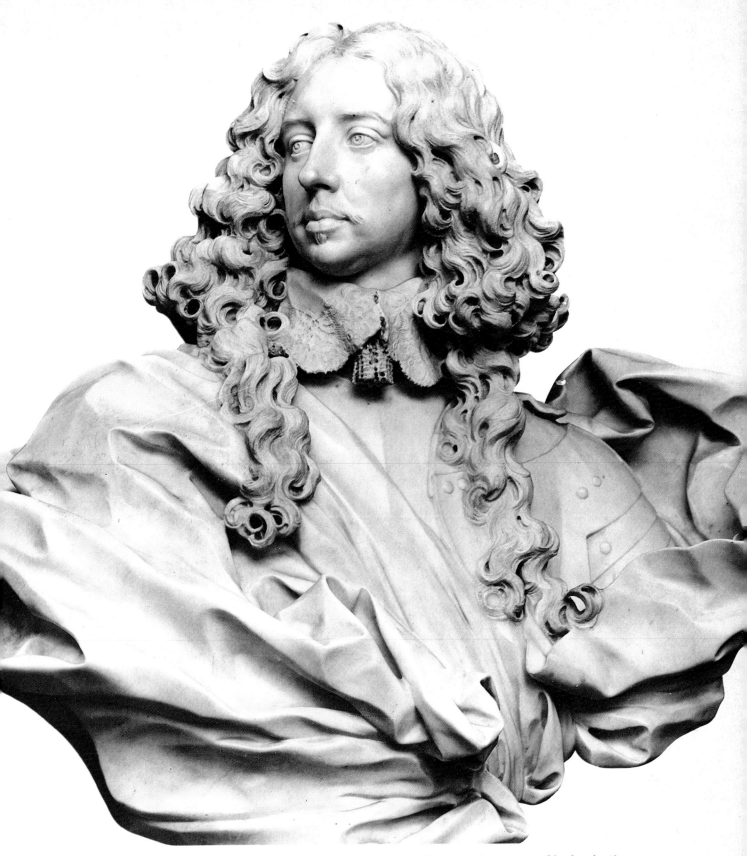

Above: Giovanni Lorenzo Bernini (Naples 1598–Rome 1680), Francesco I d'Este, *1650–1651. Marble; height 42 in. Modena, Museo Estense.*
The duke of Modena is depicted according to the iconography of the so-called "heroic" portrait, that is, with a breastplate partially covered by a flowing mantle. Typical of the fashion of the time, however, are the high lace collar, the flowing wig, and the moustache and tiny goatee.

Above: Giovanni Lorenzo Bernini (Naples 1598–Rome 1680), The Snail Fountain *(detail), 1652. Marble; Rome, Villa Doria Pamphili.*
The central decoration of the fountain consists of three dolphins supporting a huge snail. Made by A. Vannelli after a design by Bernini, the fountain was originally destined for the Piazza Navona, but Innocent X made a present of it to Olimpia Pamphili, who placed it in the garden of her villa.

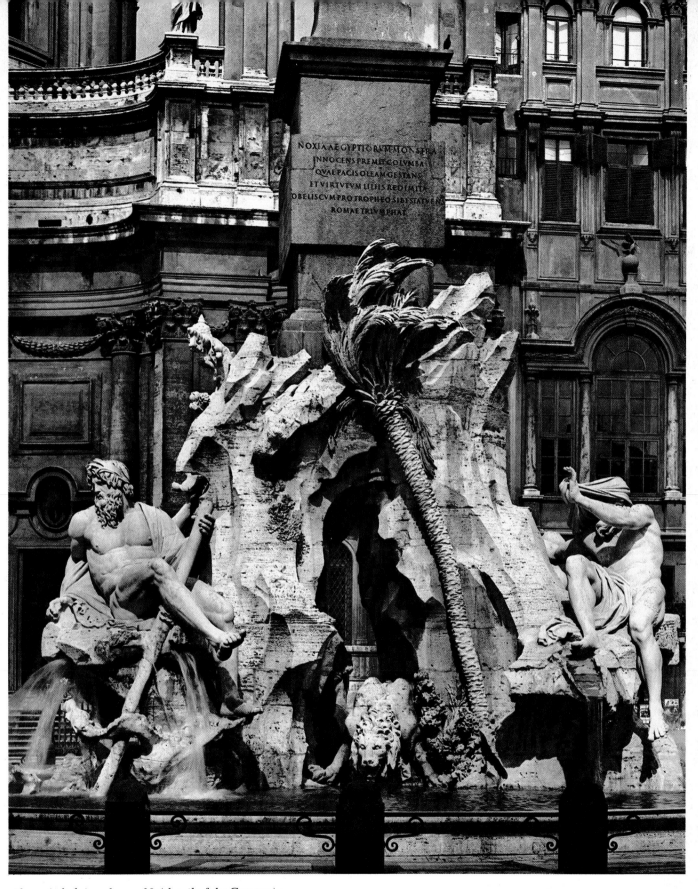

Above (whole) and page 38 (detail of the Ganges):
Giovanni Lorenzo Bernini (Naples 1598–Rome 1680),
The Fountain of the Rivers, *1648–1651.*
Marble and travertine. Rome, Piazza Navona.
See caption on page 108.

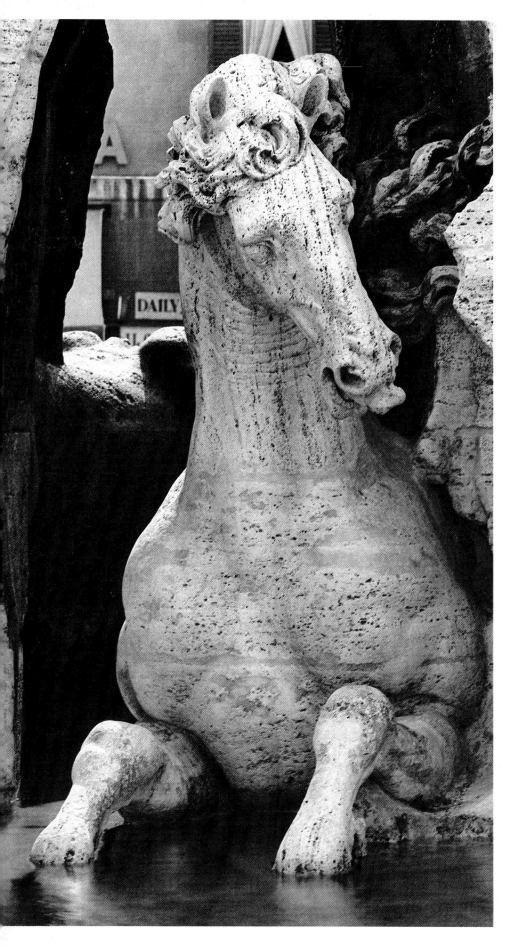

Left and right:
Giovanni Lorenzo Bernini
(Naples 1598–Rome 1680),
The Fountain of the Rivers,
1648–1651 (details of the horse and
the Nile).
Marble and travertine.
Rome, Piazza Navona.
The fountain was commissioned in 1648
by Pope Innocent X, who wanted to
decorate the piazza in front of the
Palazzo Pamphili, which belonged to
his family. The monument also included
the Roman obelisk placed by the tomb
of Cecilia Metella. Bernini designed a
base for it cut out of the rock in the
vague shape of a Roman arch,
decorated with marble figures
personifying four great rivers at its four
corners.

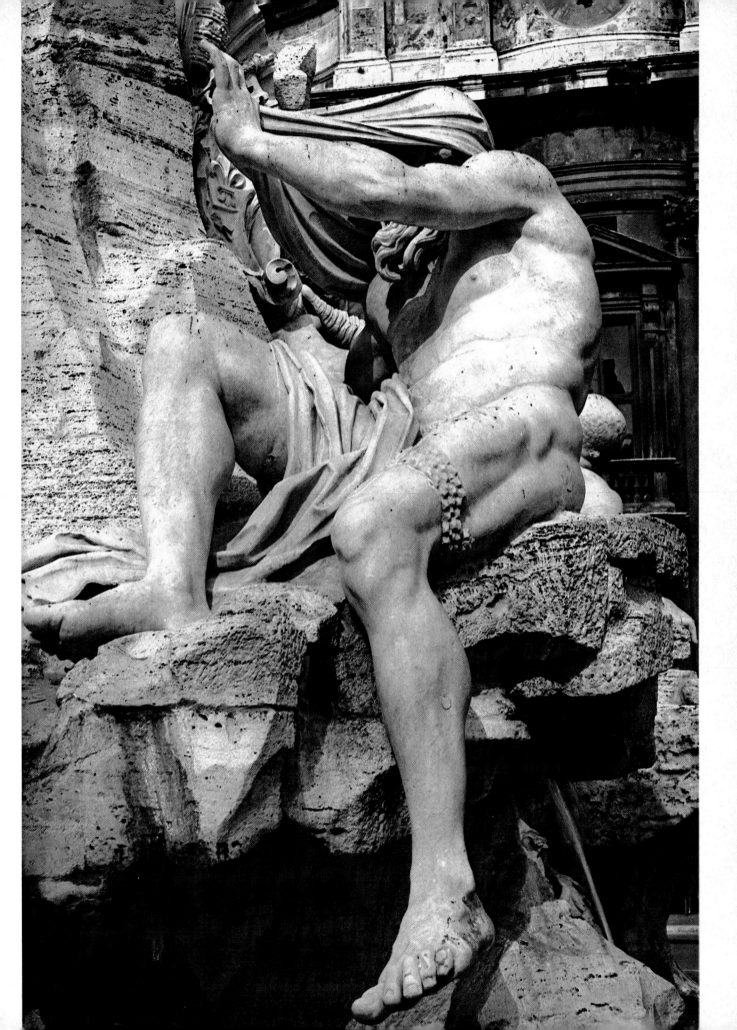

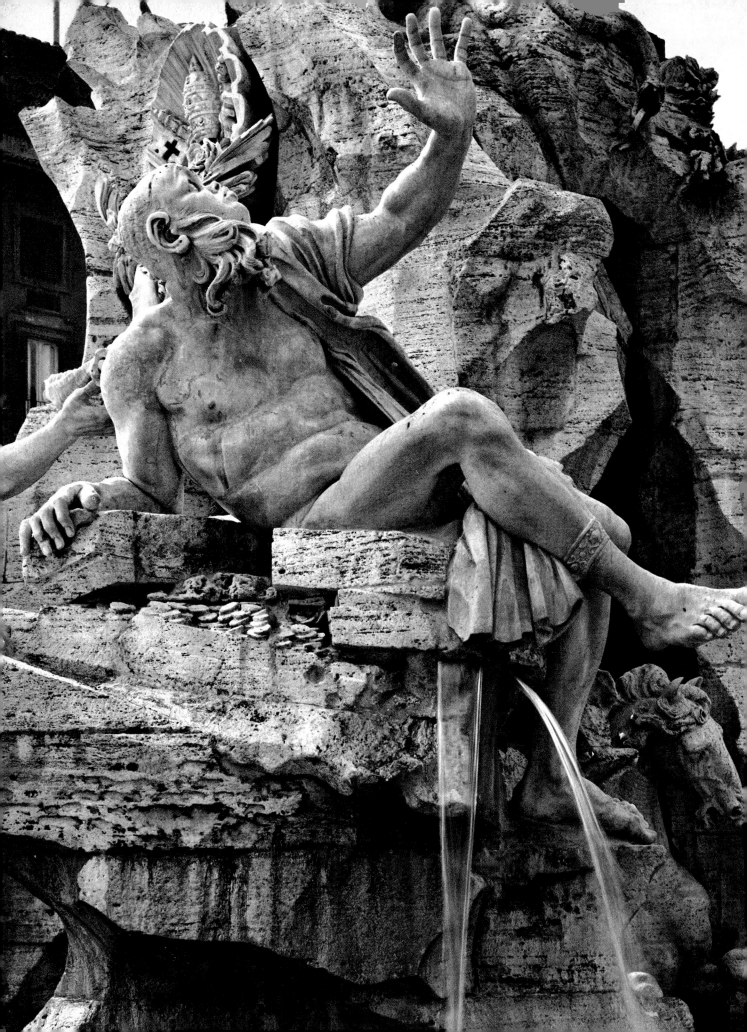

Left and right:
Giovanni Lorenzo Bernini
(Naples 1598–Rome 1680),
The Fountain of the Rivers,
1648–1651 (details of the River Plate
and the Danube).
Marble and travertine.
Rome, Piazza Navona.
On the side of the piazza which faces
Sant' Agnese, Bernini placed the statues
of the Danube, *which pays respect to*
the Pamphili coat of arms, and the
River Plate, *in a defensive attitude;*
these two figures are the allegories
respectively of Europe and America.
On the other side are the Nile, *with*
covered head (see caption on page
108), and the Ganges *(see page 38);*
these last two figures are allegories of
Africa and Asia. In the corners are four
animals relating to each of these rivers:
for the Danube, *the dolphin (which*
also appears on the Pamphili coat of
arms); for the River Plate, *the*
armadillo; for the Nile, *the lion*
(drinking beneath a palm tree), and for
the Ganges, *the horse (see page 108).*
All the animals are carved out of
travertine. The allegorical significance
of the fountain is the pope's supremacy
over the entire world. Bernini is himself
responsible for all the travertine
figures, but the Ganges *was sculpted by*
Claude Poussin, the Danube *by*
Antonio Raggi, and the Nile *by*
Giacomo Antonio Fancelli.

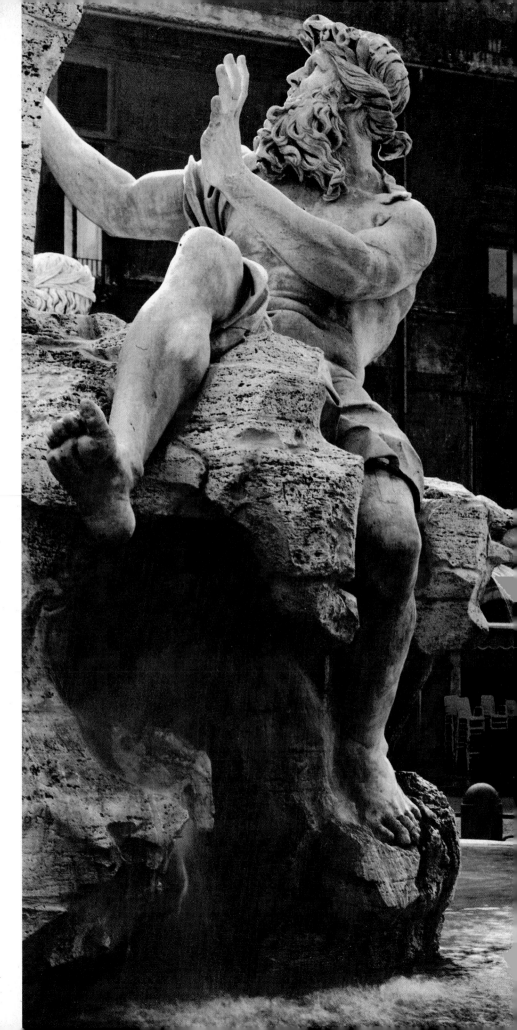

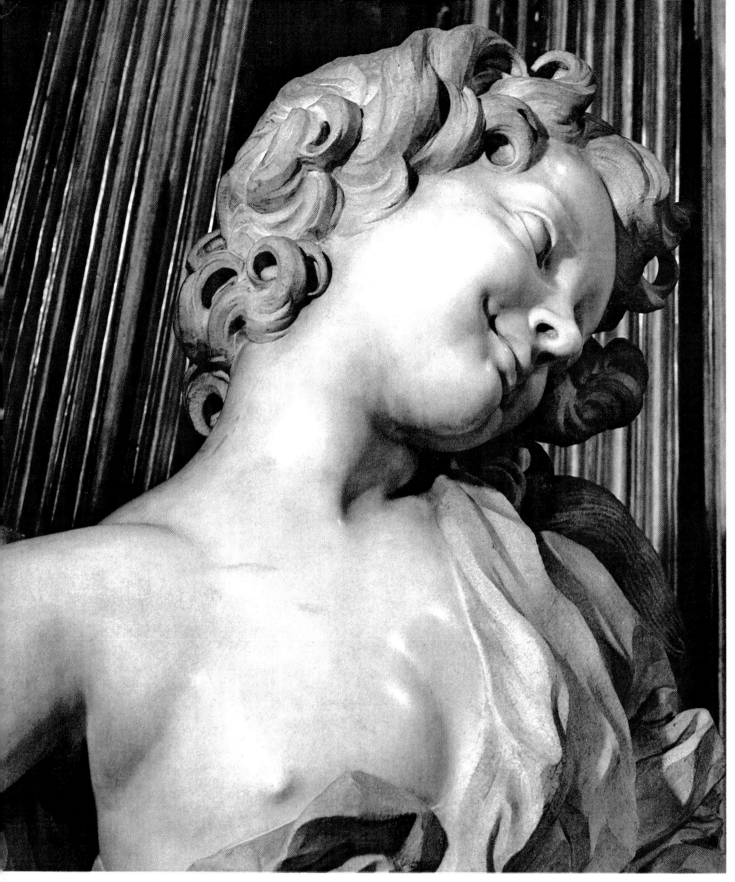

Above and on pages 113 and 33: Giovanni Lorenzo Bernini (Naples 1598–Rome 1680),
The Ecstasy of St. Theresa *(details and whole), c. 1647–1652. Marble and gilded bronze; height 11 ft. 3 in. Rome, Cornaro Chapel in Santa Maria della Vittoria.*
This representation of the ecstasy experienced by St. Theresa of Avila is placed on the altar of the funerary chapel commissioned from Bernini by Cardinal Federigo Cornaro. The group illustrates rather closely the mystical experience

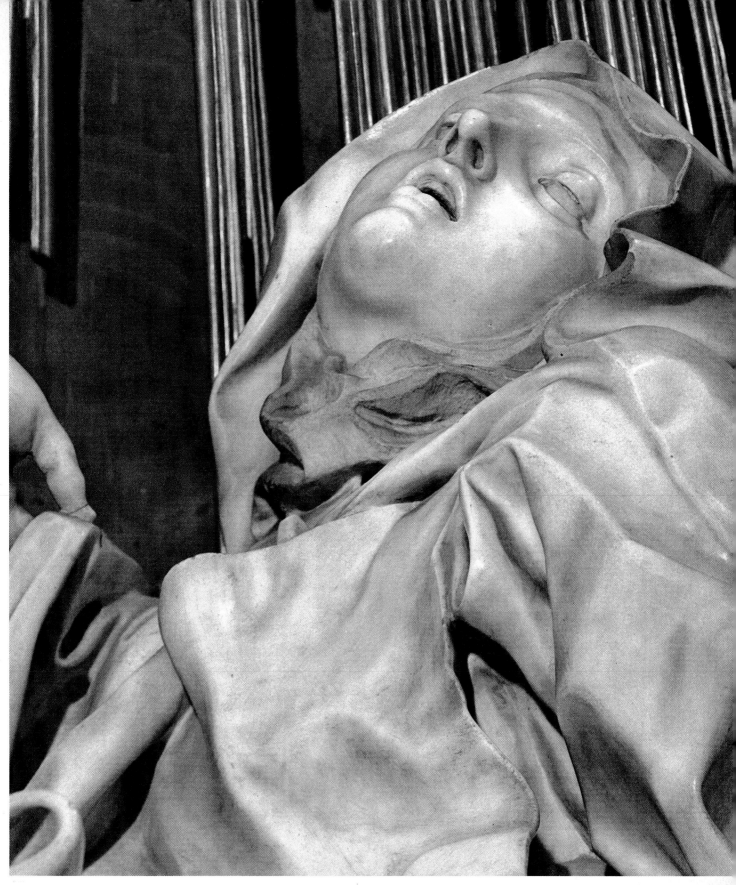

described by the saint in her Life. Her abandoned body, infused with the love of God, is transported on a cloud; from her lips come weak groans and cries. The angel "who seemed made of light" holds in his hand a "long, golden arrow" with which he seems about to "pierce the saint's heart and enter her innermost parts," leaving her "glowing with the love of God."

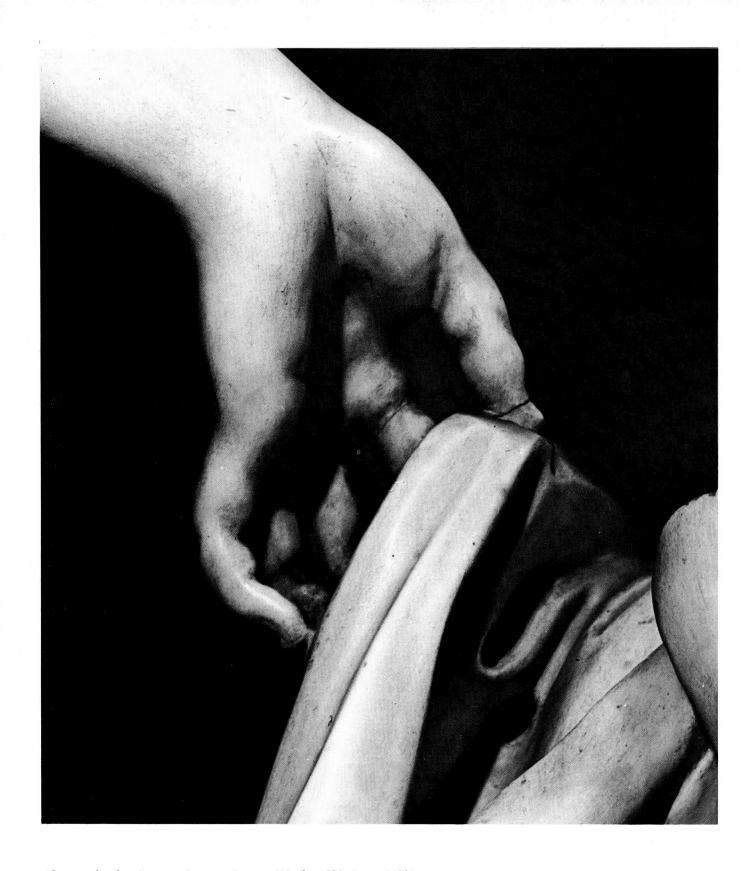

Above and right: Giovanni Lorenzo Bernini (Naples 1598–Rome 1680),
The Ecstasy of St. Theresa *(details), c. 1647–1652. Rome, Cornaro Chapel in Santa Maria della Vittoria.*
All the decorations of the chapel, designed by Bernini himself, are linked to the central group of St. Theresa: on the dome, a
fresco by G. Abbatini, representing Paradise*; on the floor, two skeletons, inlaid in marble, indicate that death can be*
trampled on; on the side walls are two reliefs in polychrome marble, representing two theater boxes filled with members of
the Cornaro family gathered there for the miracle play of the saint's ecstasy.

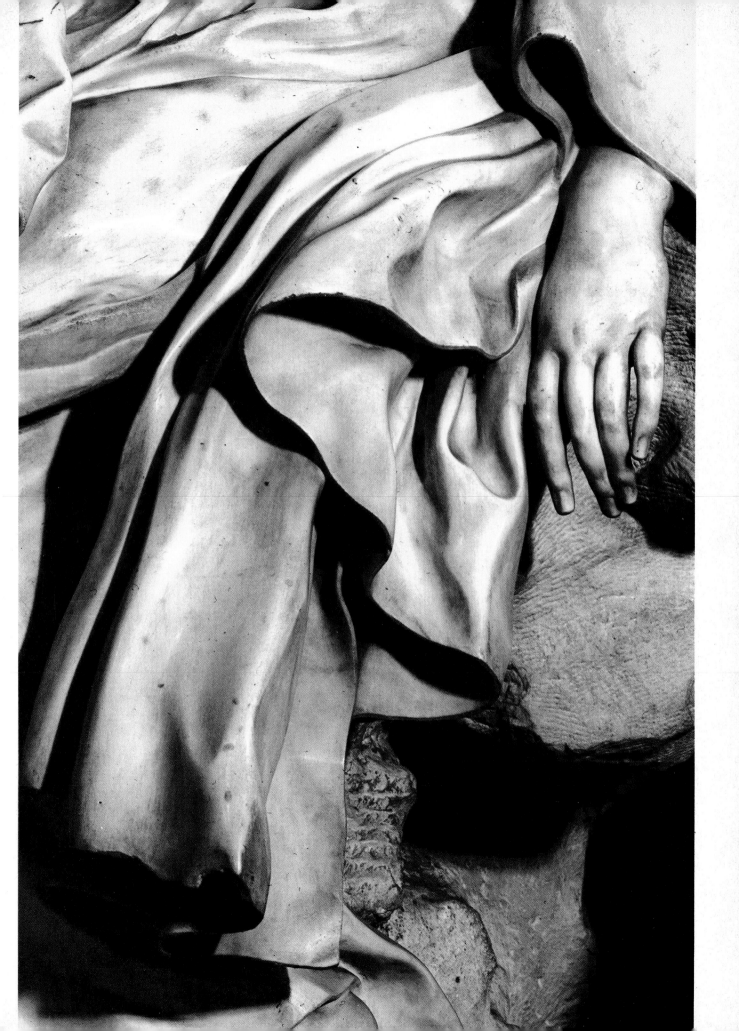

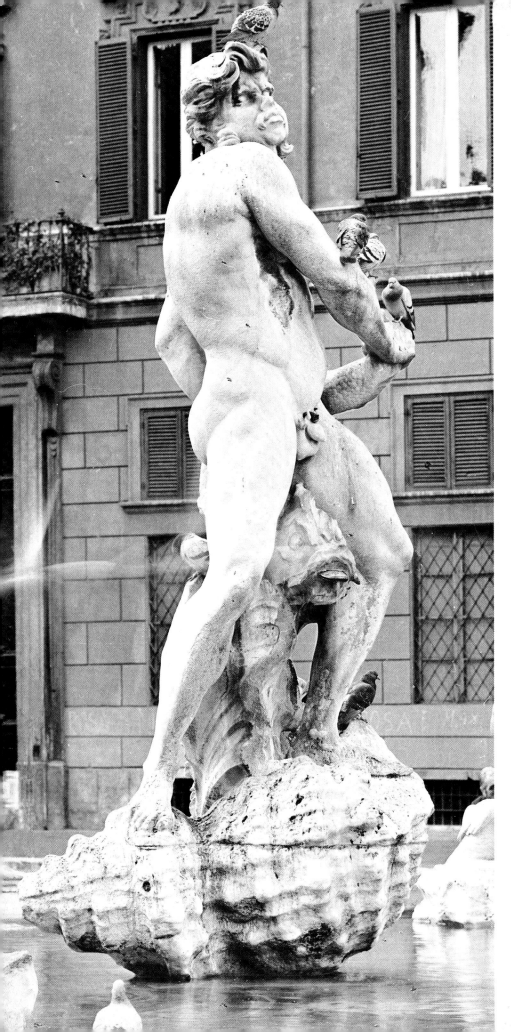

Left and right:
Giovanni Lorenzo Bernini
(Naples 1598–Rome 1680),
The Moor's Fountain,
1653–1654; details with the
Moor and the Triton.
Marble. Rome, Piazza Navona.
This is a remodelling of an already
existing fountain by Giacomo della
Porta. Bernini added new figures, such
as that of the huge, naked Moor
straddling a dolphin and that of the
kneeling Triton, with his scale-covered
legs, blowing in two trumpet-like shells.
An anecdote relates that Bernini was
not pleased with the results of his work
and would cover his eyes with a corner
of his coat every time he walked past
the fountain.

Page 39: Giovanni Lorenzo Bernini
(Naples 1598–Rome 1680),
The Triton Fountain (detail),
1642–1643. Travertine;
height c. 6 ft.
Rome, Piazza Barberini.
Four dolphins support on their tails a
huge shell upon which kneels a triton
blowing in a shell. Between the bodies
of two of the dolphins is the coat of
arms with the three bees of the
Barberini family, who commissioned
the work. The water flows out from the
top of the fountain, collects in the
central shell, and pours out from there
into the basin below, which is in the
shape of a stylized lily, possibly an
allusion to the pro-French policy
adopted by the Barberinis.

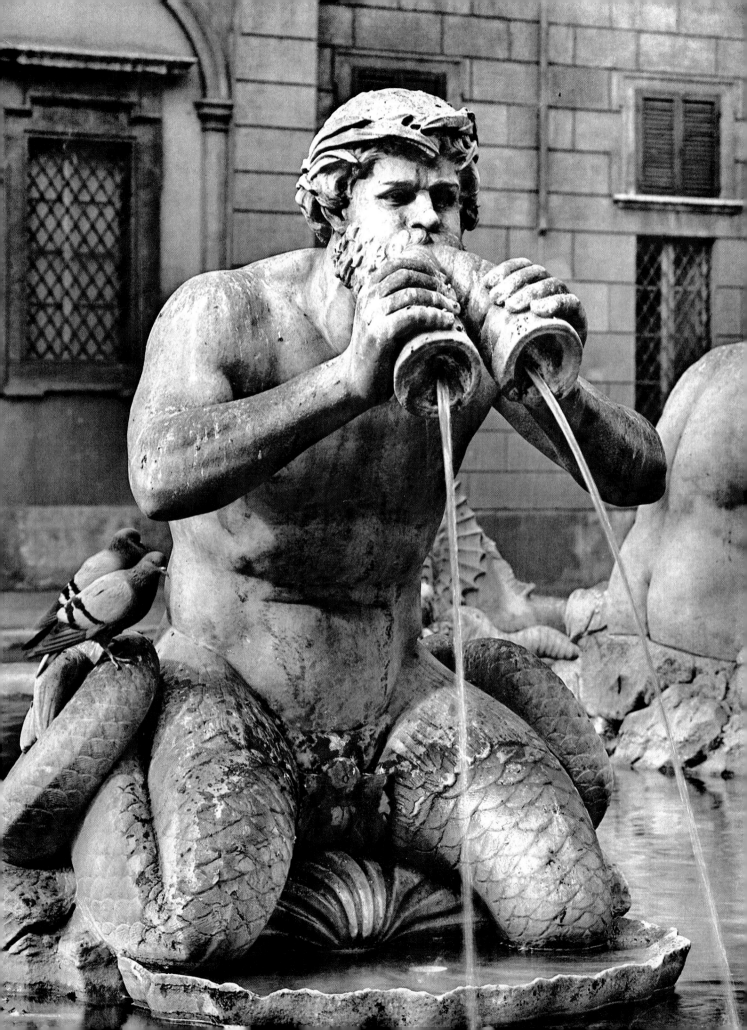

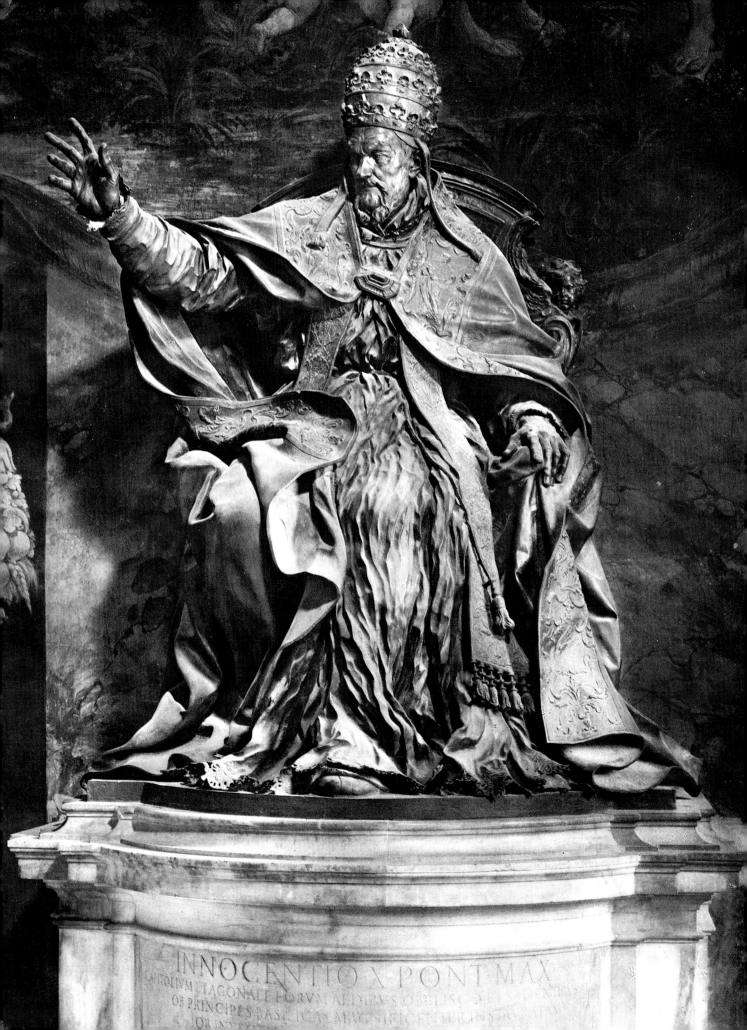

INNOCENTIO X PONT MAX

*Left: Alessandro Algardi
(Bologna 1595–Rome 1654),
Pope Innocent X, 1645–1650.
Bronze; height 7 ft. 10 in.
Rome, Palazzo dei Conservatori.
Giovanni Battista Pamphili, who
became Pope Innocent X, is
represented here in the act of blessing,
wearing ceremonial dress and the papal
triple crown. The work was
commissioned by the Roman Senate,
and Algardi obtained the commission
after a long struggle against his rival
Francesco Mochi.*

*Page 41: Francesco Borromini
(born in Bissone, in the Ticino,
1599–Rome 1667),
The Spada Chapel, post 1660.
Polychrome marble, jasper, and onyx.
Rome, San Girolamo della Carità.
Every detail in this funerary chapel of
the Spada family refers to the
fleetingness and precariousness of life
on earth. The onyx walls are inlaid with
acanthus leaves and heraldic motifs
consisting of crossed swords; they are
further decorated by relief medallions
with busts of saints. On either side are
two marble sarcophagi with the
semireclining figures of Giovanni and
Bernardino Spada. The ground is inlaid
with flowers (an allusion to worldly
possessions) surrounding a snake
swallowing its own tail, a symbol of
time and eternity. The traditional
balustrade consists of two kneeling
angels (c. 1 ft. high) holding between
them the Eucharist cloth, made of
horizontally striped jasper. The angels'
wings are mobile and serve as entrance
barriers.*

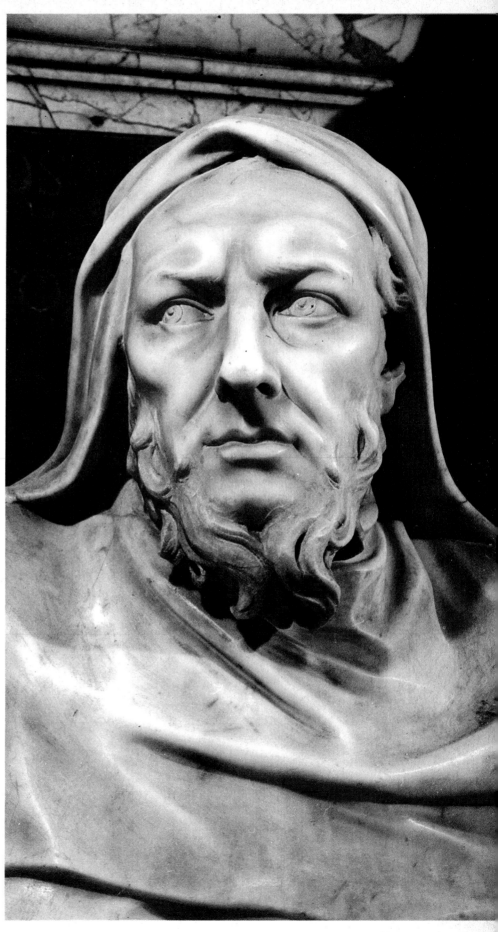

*Right: Cosimo Fancelli
(Rome 1620–1688),
Giovanni Spada (detail),
post 1660.
Marble; Rome, Spada Chapel in
San Girolamo della Carità.
The semireclining figure of Giovanni
Spada is placed on the left-hand
sarcophagus of the chapel designed by
Francesco Borromini.*

*Left: Alessandro Casella
(active in Turin during the second
quarter of the seventeenth century),
Decoration of the Sala di Marino,
1645–1646. Stucco.
Turin, Castello del Valentino.
This corner decoration comprises a
grotesque mask ending in acanthus
leaves, the figures of a siren, a winged
male being, and two putti, and mixed
garlands of flowers, fruits, and leaves.
The horizontal mouldings are
decorated with classical geometric
motifs.*

*Page 40: Pierre Legros II
(Paris 1666–Rome 1719),
Tomb of St. Stanislaus Kostka,
last quarter of the seventeenth century.
Polychrome marble. Rome, Convent
of Sant' Andrea al Quirinale.
This funerary monument was erected in
memory of Stanislaus Kostka
(1550–1568), a Polish Jesuit who
spent his novitiate in the convent of
Sant' Andrea al Quirinale and was
canonized in 1726. The young Jesuit,
wearing the tunic of the Company of
Jesus, is shown lying on his deathbed.*

*Right: Antonio Gherardi
(Rieti 1644–Rome 1702),
Decoration of the Cupola of
the Avila Chapel, 1680. Stucco.
Rome, Santa Maria in Trastevere.
The base of the circular colonnade in
the cupola is linked with the ceiling by
means of four huge putti.*

*Above: Francesco Borromini
(Bissone, Ticino, 1599–Rome 1667),
Cherub, 1637–1650.
Stucco. Rome, Casa dei Filippini.
This cherub's head, framed by six
wings, is part of the decoration of the
ceiling above the oratory altar.*

*Right (whole) and left (detail):
Francesco Borromini (Bissone, Ticino,
1599–Rome 1667),
The Angels' Cella, post 1653.
Rome, Sant' Andrea delle Fratte.
The cella, decorated with eight hermae
busts of angels, is part of the campanile
of the church and is situated between
the bell chamber and the coping.*

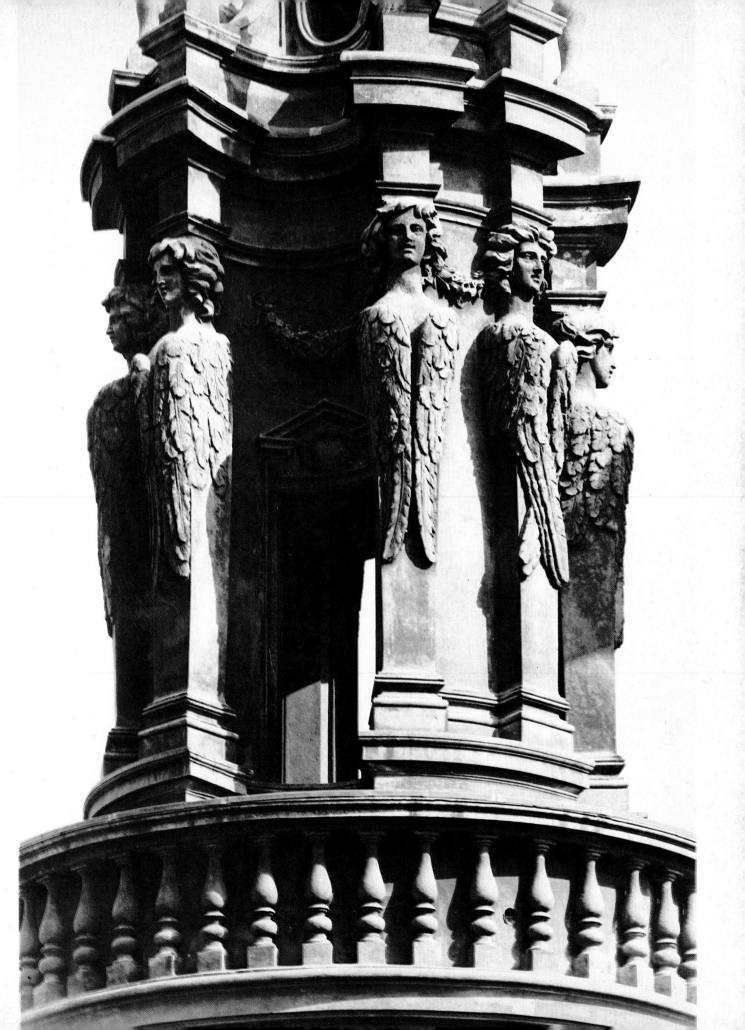

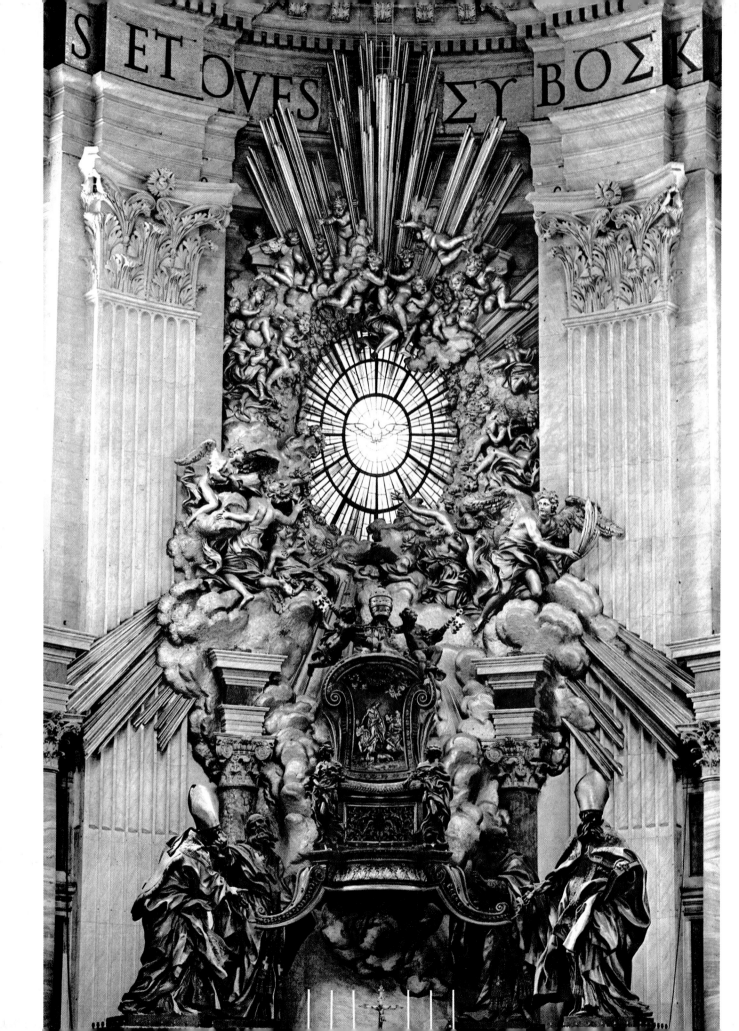

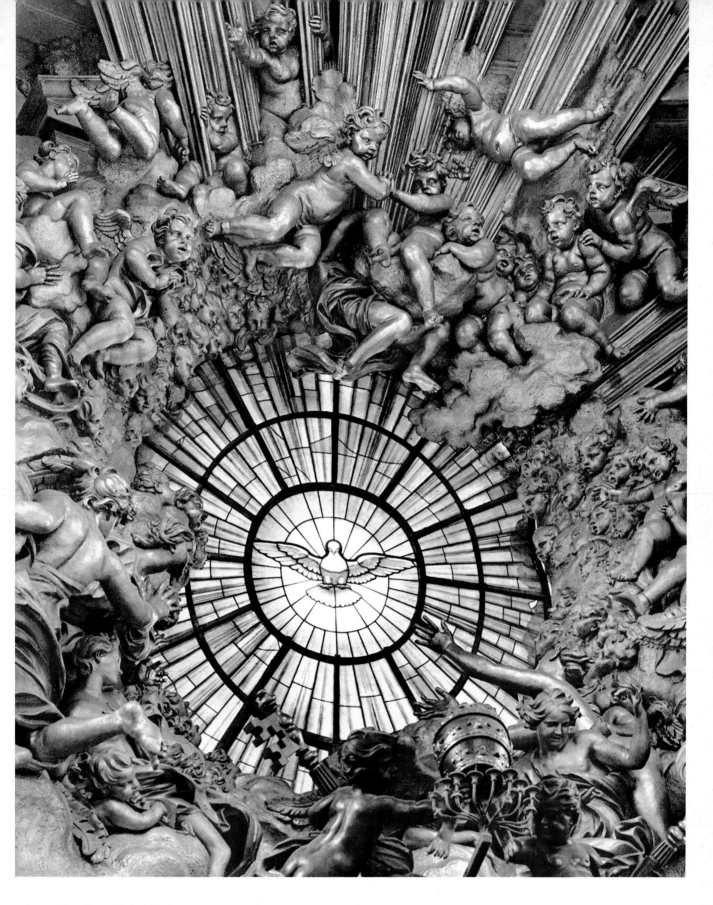

Above (detail) and left (whole): Giovanni Lorenzo Bernini (Naples 1598–Rome 1680), St. Peter's Chair, *1657–1666. Bronze, polychrome marble, and gilded stucco; height c. 59–65 ft. Rome, apse of San Pietro in Vaticano. Four doctors of the Church (St. Ambrose, St. Augustine, St. Athanasius, and St. John Chrysostom) support the bronze chair, which acts as shrine to the relic of St. Peter's chair. Above them is the triumph of the Holy Spirit.*

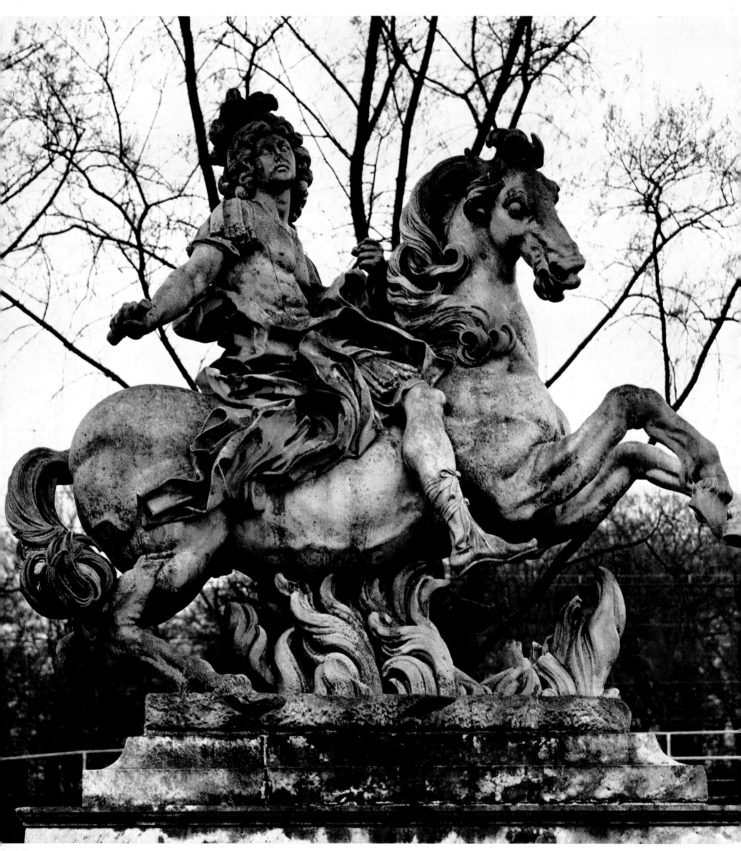

Above: Giovanni Lorenzo Bernini (Naples 1598–Rome 1680), Equestrian Monument of Louis XIV, *1669–1673. Marble; height 9 ft. 10 in. Versailles, park of the château, near the Bassin des Suisses.*
The French king is represented as the victorious Alexander the Great. The work, which was mostly done by assistants, did not please the king, and he asked François Girardon to retouch it in 1688. Girardon changed the likeness to Alexander into a likeness to Marcus Curtius leaping over the flames.

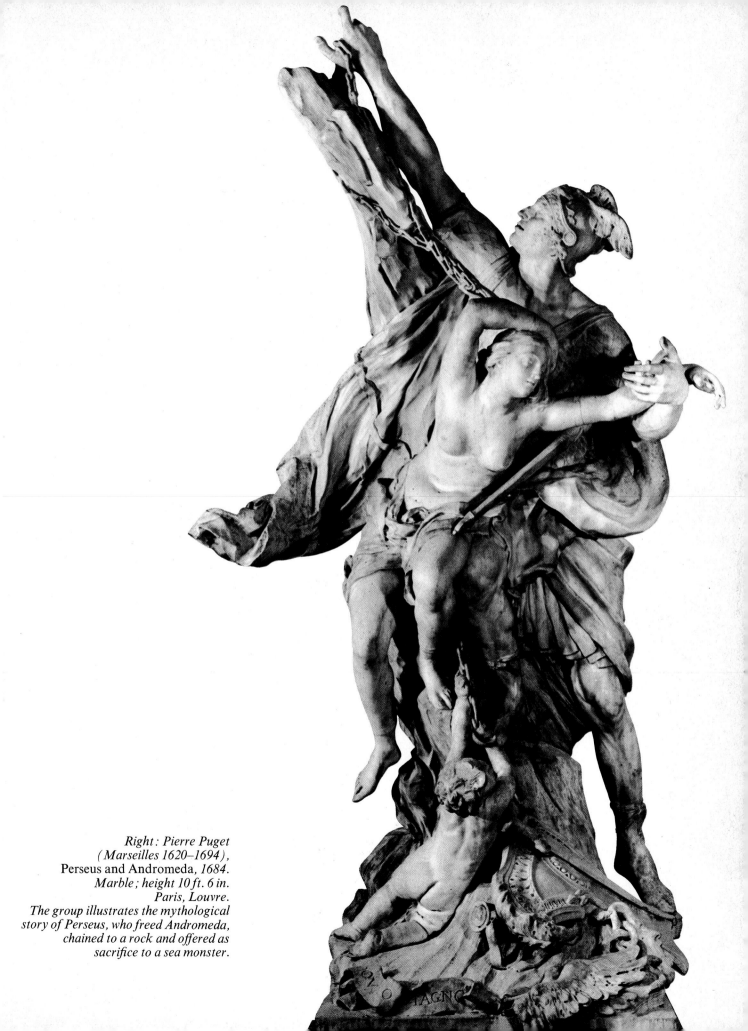

*Right: Pierre Puget
(Marseilles 1620–1694),
Perseus and Andromeda, 1684.
Marble; height 10 ft. 6 in.
Paris, Louvre.
The group illustrates the mythological
story of Perseus, who freed Andromeda,
chained to a rock and offered as
sacrifice to a sea monster.*

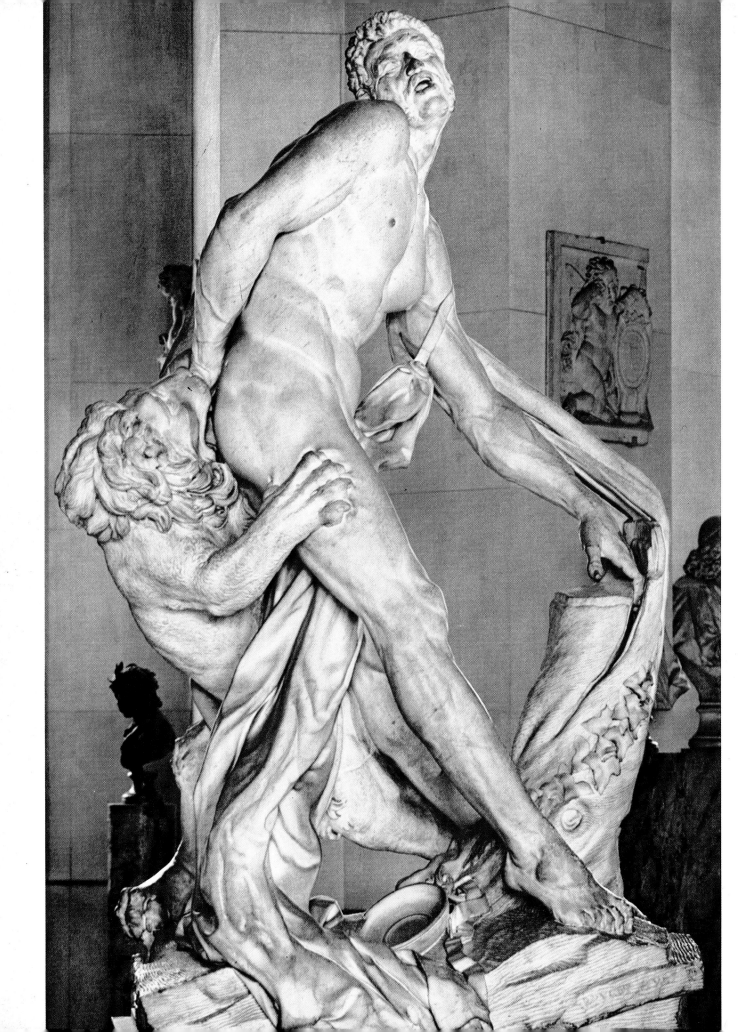

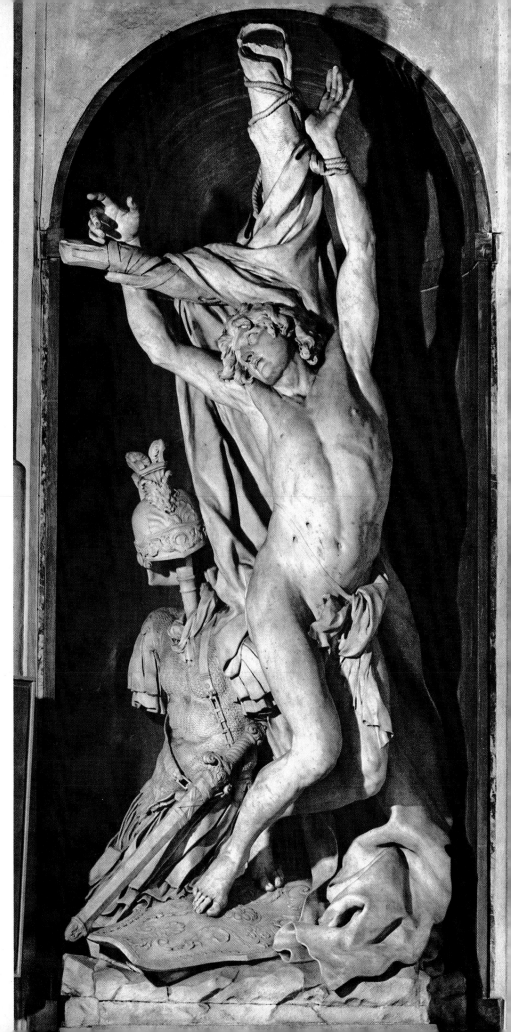

Left: Pierre Puget
(Marseilles 1620–1694),
Milo of Crotona, 1672–1683.
Marble; height 8 ft. 10 in.
Paris, Louvre.
The group illustrates the story of the
athlete Milo, whose hand was caught in
a tree trunk and who was eaten by a
lion. The work, commissioned by
Colbert for Louis XIV, was destined
for Versailles.

Page 42: Pierre Puget
(Marseilles 1620–1694),
St. Sebastian, c. 1666.
Terra cotta; height 3 ft.
Paris, Petit Palais.
This small piece is a study for a much
larger work (see illustration on the
right) made in marble at Genoa.

Page 43: Pierre Puget
(Marseilles 1620–1694),
The Immaculate Conception,
post 1661, but pre 1667. Marble.
Genoa, Oratorio di San Filippo Neri.
The group consists of the Virgin Mary,
depicted with half-closed eyes and a
smile on her face; of two cherubs at her
feet and the defeated serpent. The work
was commissioned by Emanuele
Brignole.

Right: Pierre Puget
(Marseilles 1620–1694),
St. Sebastian, 1666–1669.
Marble; height 13 ft. 1 in.
Genoa, Santa Maria di Carignano.
This work depicts St. Sebastian tied
to a tree just before his martyrdom;
his weapons, cuirass, and shield lie at
his feet. The piece was commissioned
by Francesco Maria Sauli.

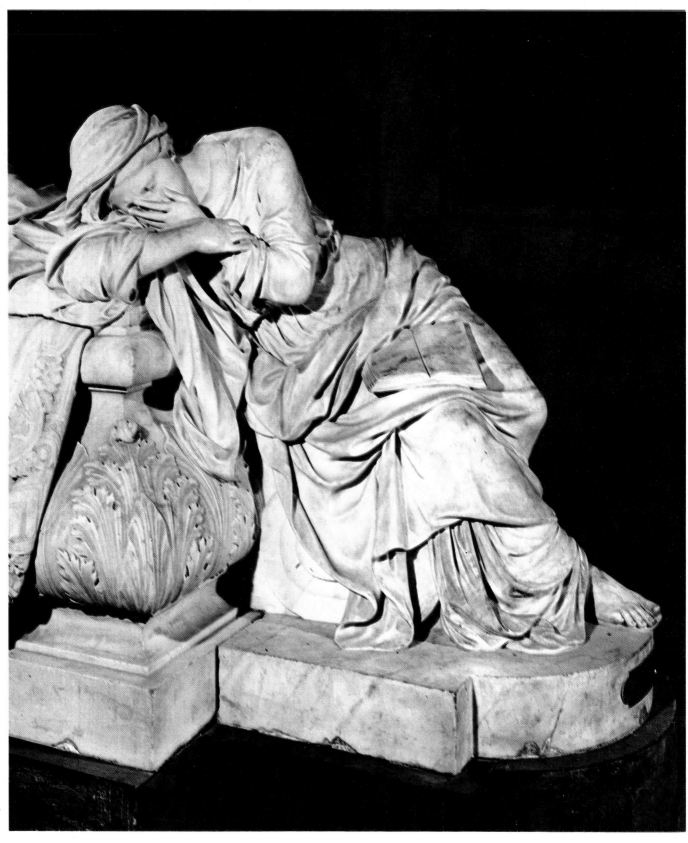

Above: François Girardon (Troyes 1628–Paris 1715),
Funeral Monument of Cardinal Richelieu
(detail showing Christian Doctrine*), 1675–1694.*
Marble; length 15 ft. 1 in.; width 5 ft. 7 in.
Paris, Church of the Sorbonne.

Right: Pierre Puget (Marseilles 1620–1694),
The Virgin of the Assumption.
Marble bas-relief;
49 × 38 in. Berlin, Staatliche Museen.
The bas-relief depicts an ecstatic Virgin
carried to Heaven by two angels.

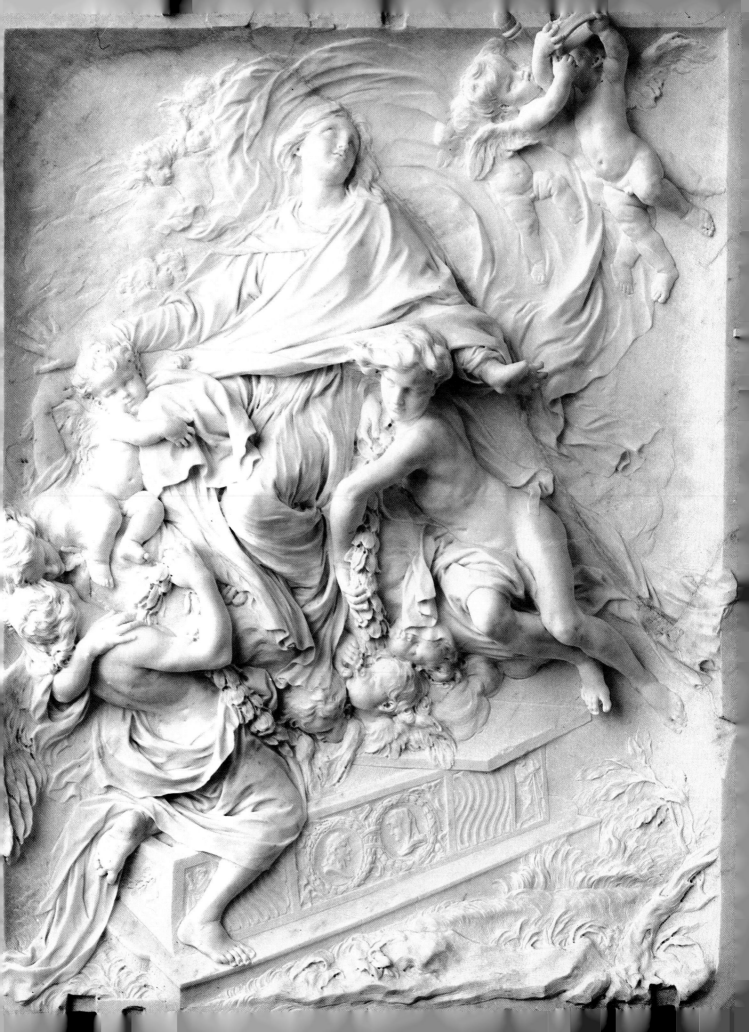

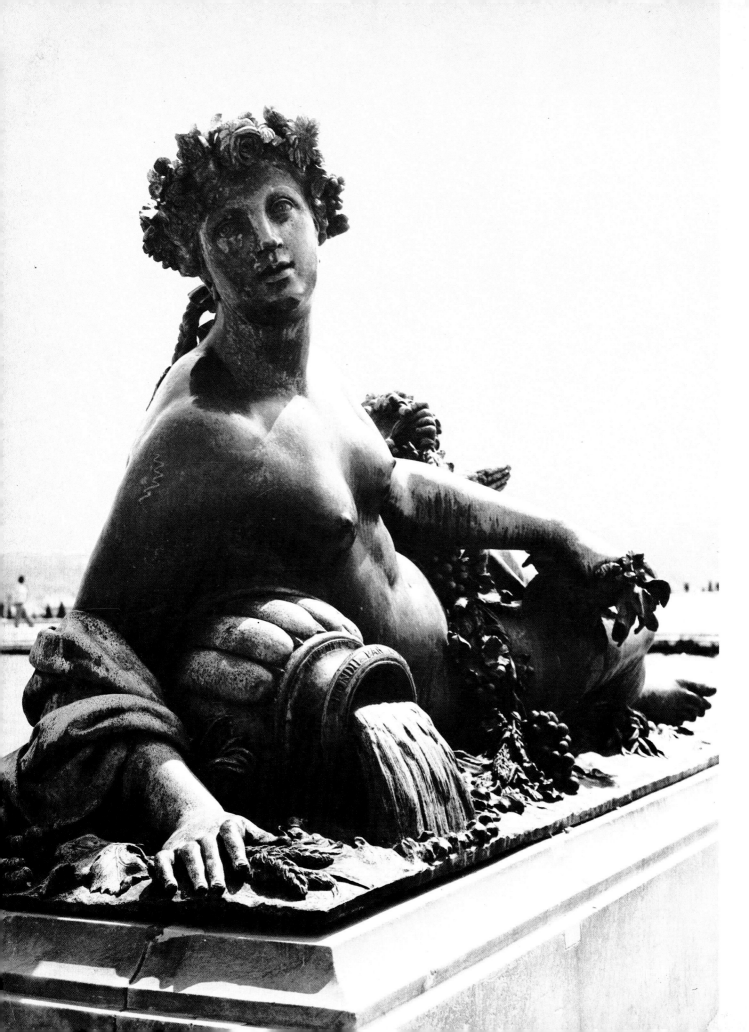

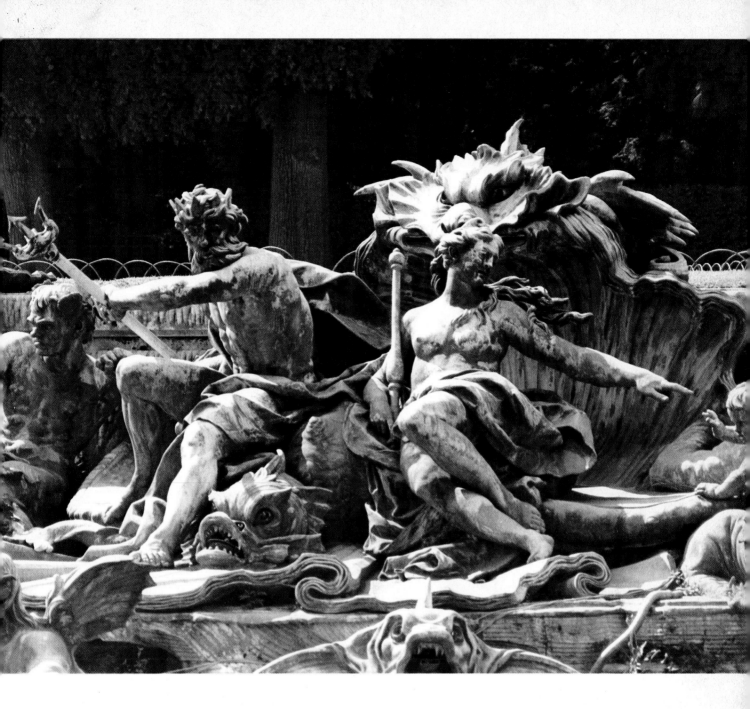

Left:
Jean Baptiste Tuby II (Paris 1665–1735),
The Saône (detail), 1687. Lead.
Versailles, park of the château.
The river Saône is personified by a sensual-looking female
figure leaning against an amphora from which the water
flows; a putto *presents her with a bunch of grapes (an*
allusion to the vineyards which abound about the southern
course of the river). The group is placed in the southern
part of the Esplanade d'eau.

Above:
Lambert Sigisbert Adam (Nancy 1700–Paris 1759),
and Nicolas Sébastien Adam (Nancy 1705–Paris 1778),
The Triumph of Neptune and Amphitrite, 1740.
Lead. Versailles, park of the château.
The group, in the Basin of Neptune, represents the God of
the Sea and his spouse borne over the water by sea
monsters in a huge shell, with a retinue of tritons and
Nereids.

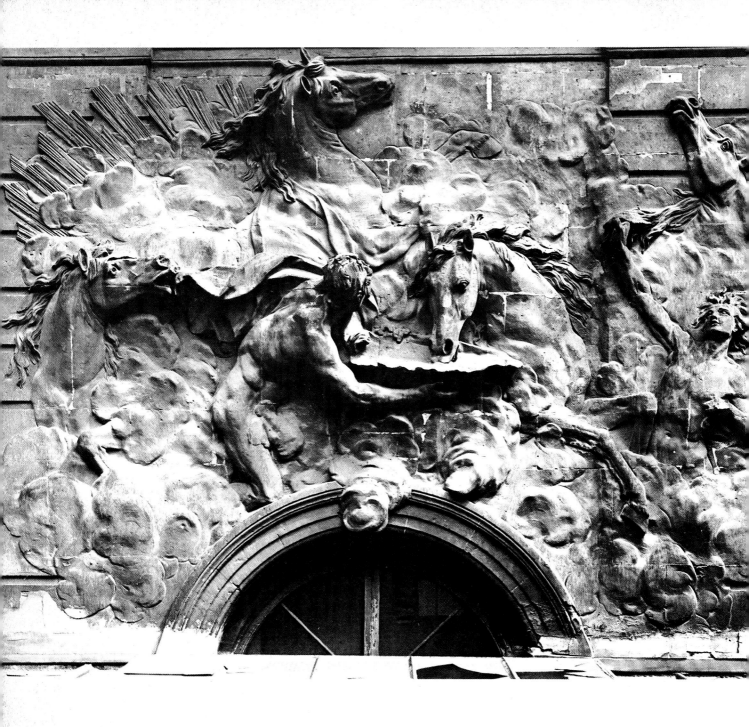

Above: Robert Le Lorrain (Paris 1666–1734),
The Sun Horses, c. *1712.*
Stone bas-relief. Paris, Hôtel de Rohan.
The bas-relief, which adorns the door to the stables in the
Hôtel de Rohan, represents the horses of Apollo's chariot
bursting out of the clouds at dawn and bathed in the first
rays of the sun. In the center of the group a naked male
figure gives one of the horses water in a shell. On the right
a youth holds on to a rearing horse.

Right: Nicolas Sébastien Adam (Nancy 1705–
Paris 1778), Prometheus, *1738–1762.*
Marble; height 46 in. Paris, Louvre.
The work illustrates the story of Prometheus, who was
punished by the gods for having stolen fire in order to give
it to mankind. The punishment consisted of his being
chained to a rock with a torch burning at his feet, while an
eagle, an animal sacred to Zeus, devoured his entrails. The
preparatory study for this work was exhibited at the Salon
of 1738 and gained the sculptor admission to the Royal
Academy.

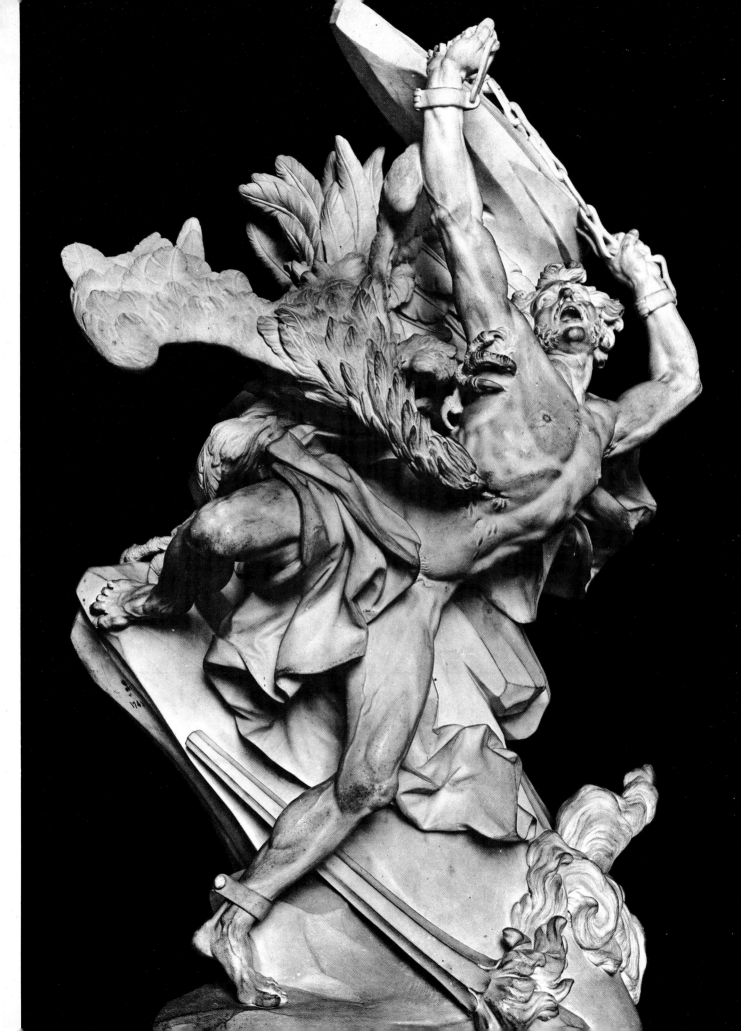

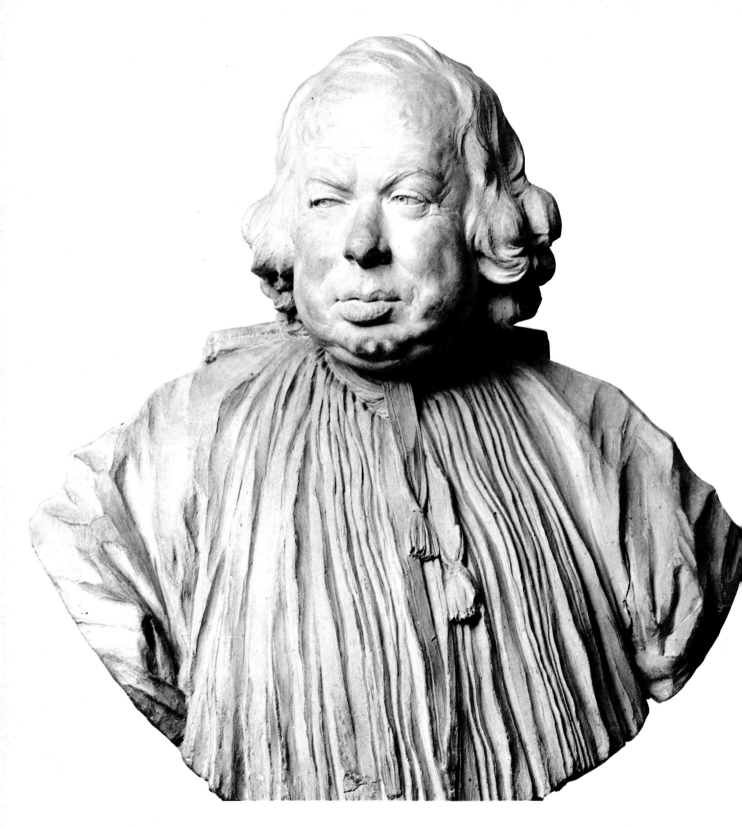

Above: Jean Jacques Caffiéri
(Paris 1723–1792),
The Astronomer Pingré, *1789.*
Terra cotta; height 28 in.
Paris, Louvre.
This bust is a portrait of the prelate
Pingré (shown wearing a cassock),
who was well known as an astronomer.

Page 46: Jean Jacques Caffiéri
(Paris 1723–1792),
Pierre Corneille, *1779.*
Terra cotta; height 61 in.
Rouen, Musée des Beaux-Arts.
This "historical" portrait of the
playwright Corneille shows him wearing
a bourgeois's everyday dress.

Right: Jean Baptiste Lemoyne II
(Paris 1704–1778),
Mademoiselle Dangeville as Thalia,
1771.
Marble; height 29 in.
Paris, Comédie-Française.
The Comédie-Française actress is
depicted as the Muse of Comedy and
Comic Poetry.

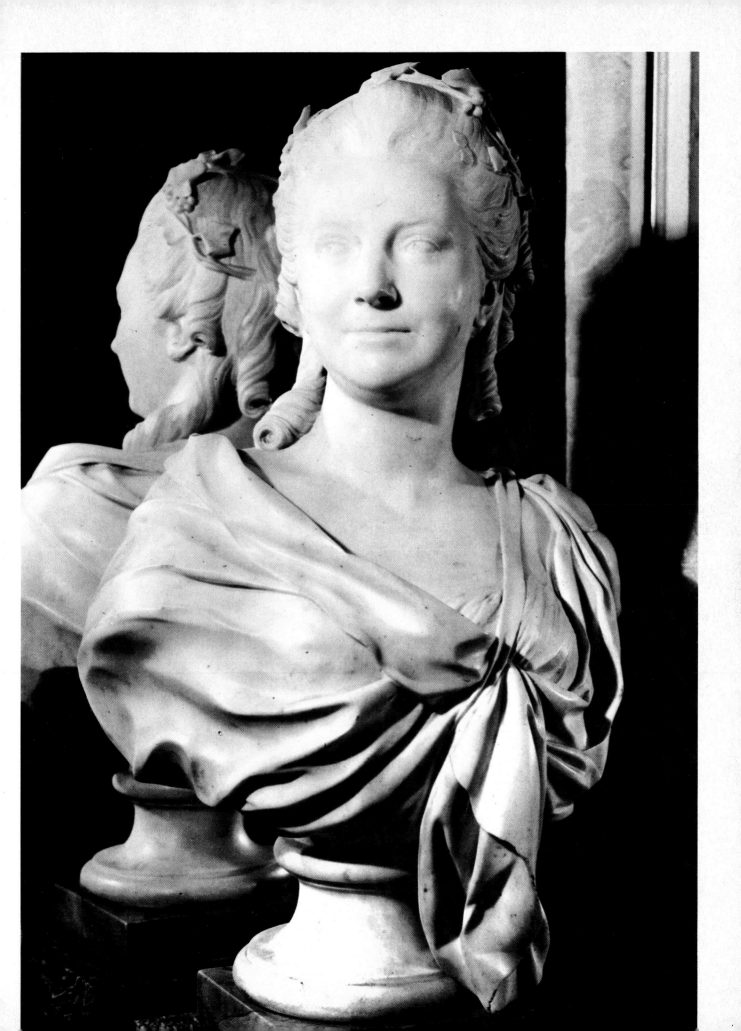

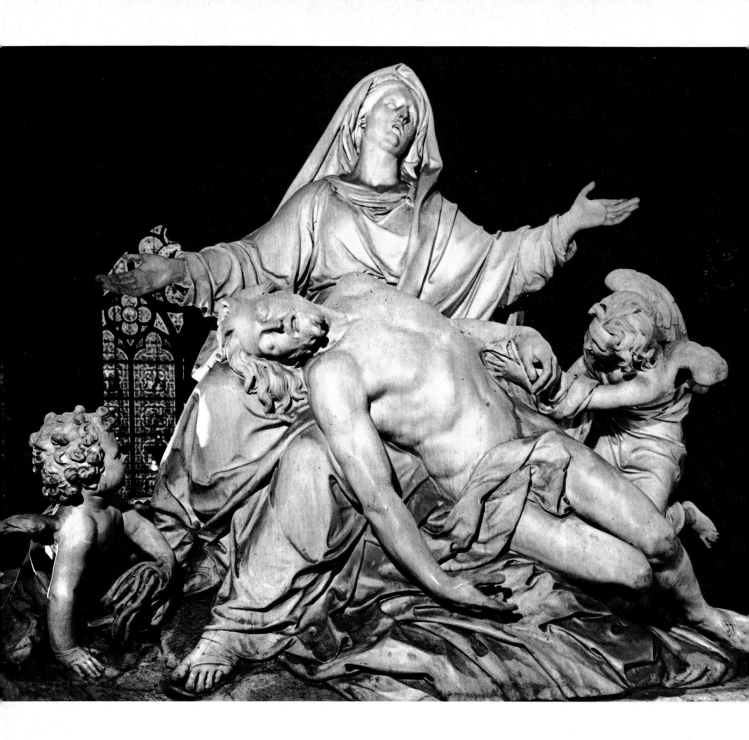

Above: Nicolas Coustou (Lyons 1658–Paris 1733),
Pietà, *1712–1723.*
Marble. Paris, Notre-Dame.
*The traditional rendering of the subject is varied here by
the addition of two small angels. Instead of gazing at the
face of her dead son, the Virgin is depicted imploring the
heavens. The group was made for Louis XIV, who was
carrying out his father, Louis XIII's, wish to renovate the
main altar of the Paris cathedral.*

Right: Edme Bouchardon (Chaumont 1698–Paris 1762),
Mater Dolorosa, *1734–1750.*
Marble; height 7 ft. 11 in.
Paris, Saint Sulpice.
*The mourning Virgin, wrapped in her
mantle, is depicted with her face raised
heavenwards. This is one of ten statues
sculpted by Bouchardon at the height of
his career for the church of Saint
Sulpice.*

Jean Baptiste Pigalle (Paris 1714–1785),
The Child with the Cage, *post 1750.*
Biscuit ; height 19 in.
Sèvres, Musée National de Céramique.
This small biscuit piece was made by the Sèvres
Manufactury after the great success in the Salon of 1750
of Pigalle's marble piece on the same subject, in which he
had portrayed the son of the financier Paris de
Montmartel. The biscuit version shows the addition of the
standing child.

Left : Jean Antoine Houdon (Versailles 1741–
Paris 1828), Winter, 1783.
Marble ; height 4 ft. 7 in.
Montpellier, Musée Fabre.
This piece, known also as La Frileuse, *is an allegory of*
Winter, represented by a nude and shivering woman
shielding her head and shoulders from the cold. The piece
was made for M. de Saint-Wast and exhibited at the 1783
Salon, where her partial nudity caused a scandal.

141

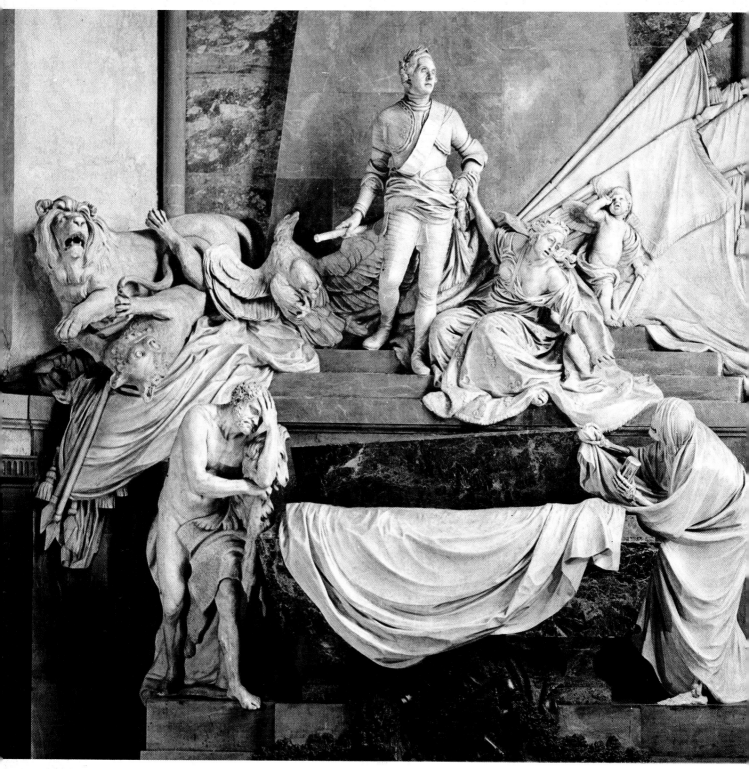

Above: Jean Baptiste Pigalle (Paris 1714–1785),
Monument of the Marshall of Saxony *(detail),*
1735–1776. Marble. Strasbourg, Saint-Thomas.
The monument features Maurice of Saxony, with his
marshall's baton and a pyramid (symbol of immortality)
behind him, going down some steps towards his awaiting
grave and the figure of Death next to it. On his left the
figure of France tries to hold him back. On his right are the
symbols of the nations he had subdued: the leopard, the
lion, and the eagle (England, the Netherlands, and
Austria).

Right: Jean Antoine Houdon (Paris 1741–1828),
Voltaire, *1780.*
Marble; height 48 in.
Paris, Bibliothèque Nationale.
In this portrait the philosopher is shown wearing a toga.

Page 47: Jean Baptiste Pigalle,
The Negro Paul, *c. 1760.*
Terra cotta; height 24 in.
Orléans, Musée des Beaux-Arts.
This is the portrait of a black servant in the service of the
sculptor's friend Thomas Aignan Desfriches.

142

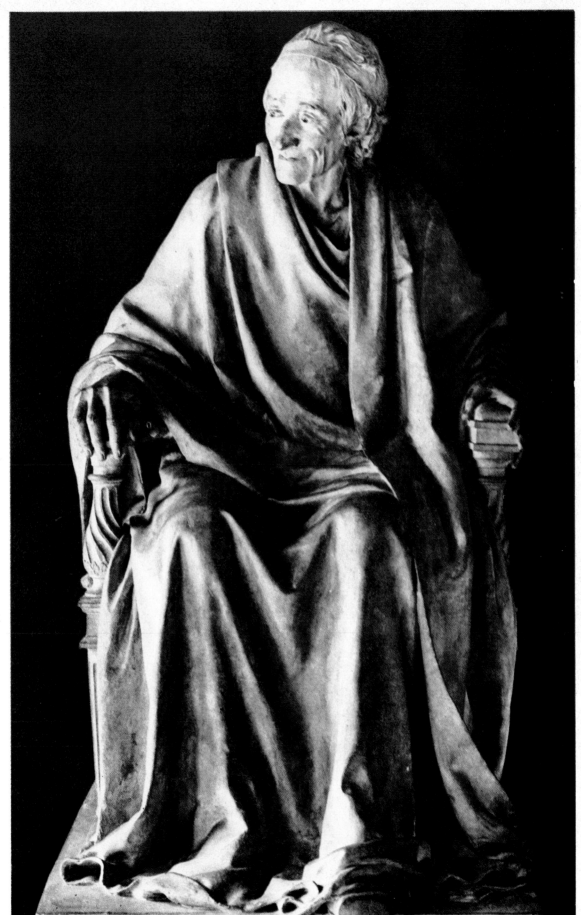

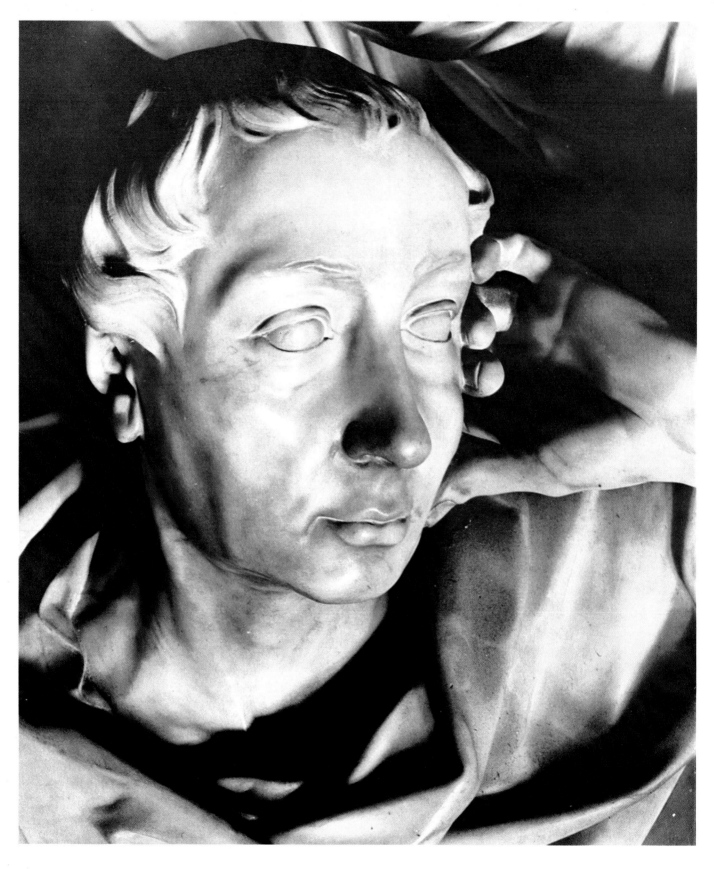

Above: Edward Pierce (d. 1695), Sir William Walworth *(detail), 1684. Wood.*
London, Fishmongers' Hall.
This is a full-length "historical" portrait of the fourteenth-century Lord Mayor of London who warned the king of William
Tyler's rebellion. His costume, however, is typically Tudor.

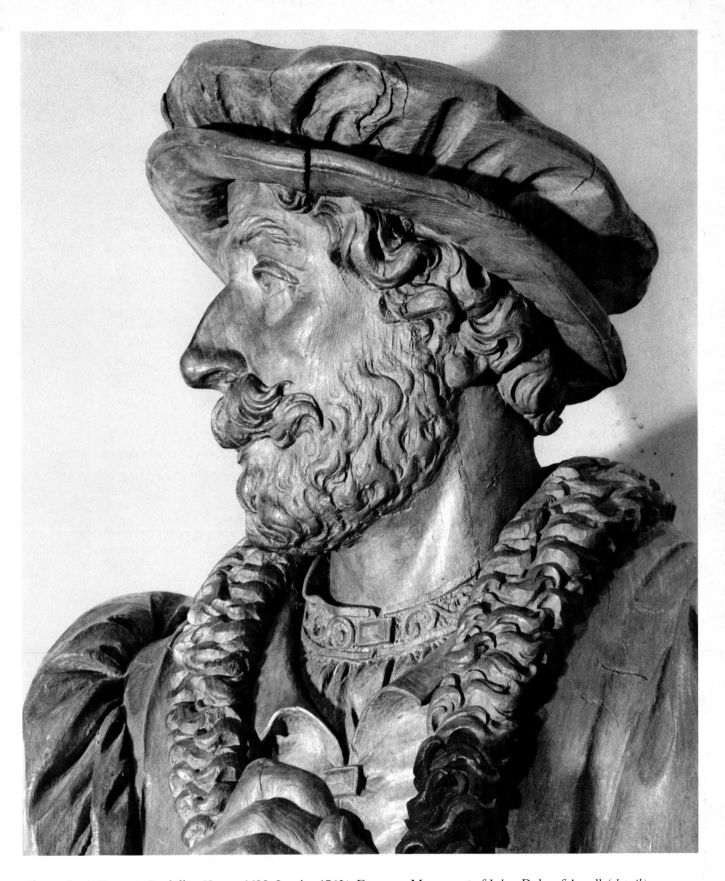

Above: Louis François Roubillac (Lyons 1695–London 1762), Funerary Monument of John, Duke of Argyll *(detail), 1745–1749. Polychrome marble. London, Westminster Abbey.*
The monument consists of a catafalque topped by a pyramid, symbol of immortality. Before the pyramid is an angel, writing the epitaph and supporting the semireclining figure of the Duke.

Left: Giacomo Serpotta
(Palermo 1656–1732),
Putto, 1710–1717.
Stucco; height c. 16–20 in.
Palermo, Oratory of the Rosario
di San Domenico.
This is a detail of the stucco decoration
of the Oratory walls.

Page 48: Luigi Vanvitelli
(Naples 1700–Caserta 1773),
The Great Cascade (detail with
the group of Diana), c. 1770.
Marble; height three times life size.
Caserta, park of the Palazzo Reale.
For the most important fountain in the
Palazzo Reale, Vanvitelli designed a
cascade with two marble groups below
it, representing on one side Diana and
the nymphs bathing and on the other
the huntsman Acteon, who had
surprised them and whom the goddess
transformed into a deer, who was
subsequently put to death by his own
dogs. The groups were sculpted by
Andrea Violani, Angelo Brunelli,
Angelo and Pietro Solari, Gaetano
Salomone, and Paolo Persico.

Page 51: Giacomo Serpotta
(Palermo 1656–1732),
Fortitude, 1710–1717.
White and gilded stucco.
Palermo, Oratory of the Rosario
di San Domenico.
This allegorical figure is one of ten
Virtues placed in niches along the side
walls of the Oratory. The costume, with
its lace and frills, the little breastplate
and the plumed helmet, may have been
inspired either by the female fashions of
the time or by contemporary theatrical
garb.

Right: Giacomo Serpotta
(Palermo 1656–1732),
Young boy, 1685–1688.
Stucco; height 44 in.
Palermo, Oratory of the Rosario
di Santa Zita.
This is a detail of the cornice above the
far wall door, which represents the
Battle of Lepanto. The boy is seated on
the cornice itself, with his hand resting
on a helmet, symbol of the Christian
forces.

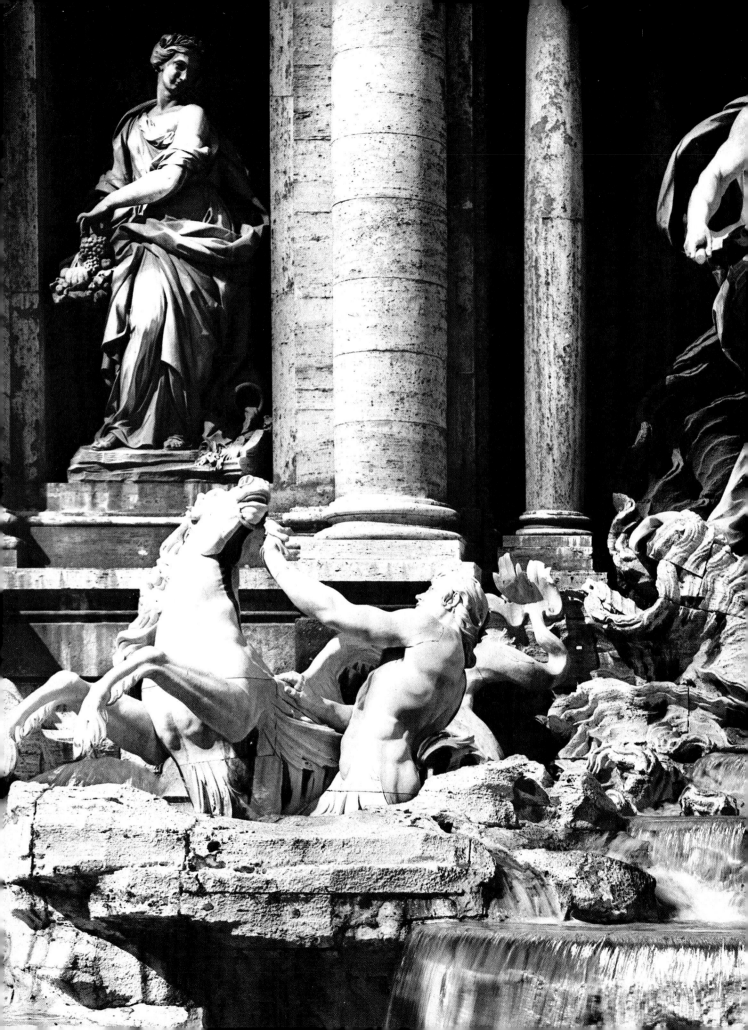

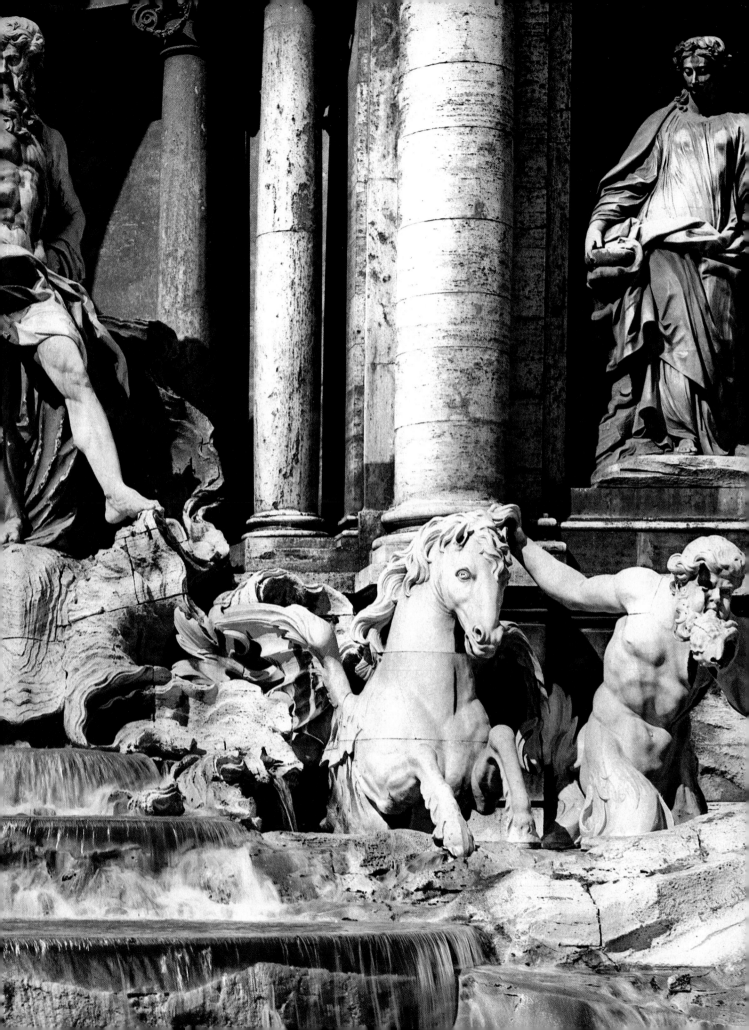

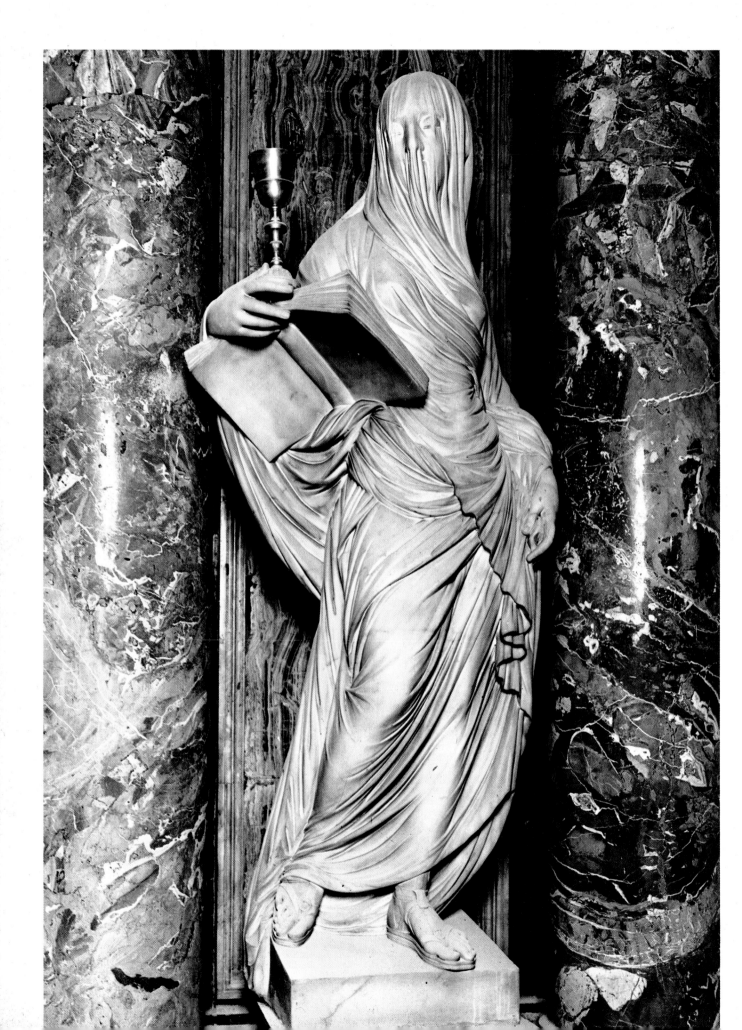

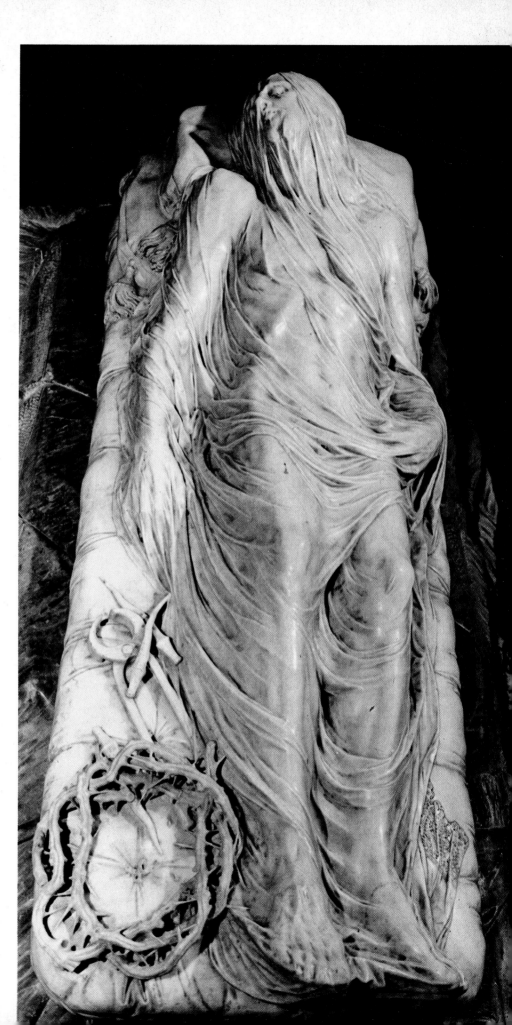

*Left: Innocenzo Spinazzi
(d. Florence 1798),* Faith.
*Marble. Florence,
Santa Maria Maddalena de' Pazzi.
This allegorical figure features a
completely veiled woman reading the
Gospels and holding up the chalice used
during Mass.*

*Preceding pages and page 49:
Niccolò Salvi (Rome 1697–1751)*
The Trevi Fountain *(detail of
the central group), 1732–1762.
Marble. Rome, Piazza di Trevi.
The fountain, built against the façade
of the Palazzo Poli, represents Ocean
standing on a huge shell drawn by two
horses driven by Tritons. The niches on
either side contain allegorical figures of
Abundance and Healthiness. The work
was commissioned by Clement XII.*

*Page 50: Antonio Corradini
(Este 1668–Naples 1752),*
Chastity, *post 1749. Marble.
Naples, Sansevero di Sangro Chapel.
This allegorical figure, known also as*
Modesty, *is depicted nude but
completely covered with a transparent
veil. It holds in its hands a garland of
roses, symbol of the fleetingness of
earthly things.*

*Right: Giuseppe Sammartino
(Naples 1720–1793),*
Shrouded Christ, *1753.
Marble; length 37 in. Naples,
Sansevero di Sangro Chapel.
The dead Christ, wrapped in his shroud,
is depicted lying on a bed. By his side
are the nails by means of which he was
crucified, the pincers that were used to
take him down, and the Crown of
Thorns.*

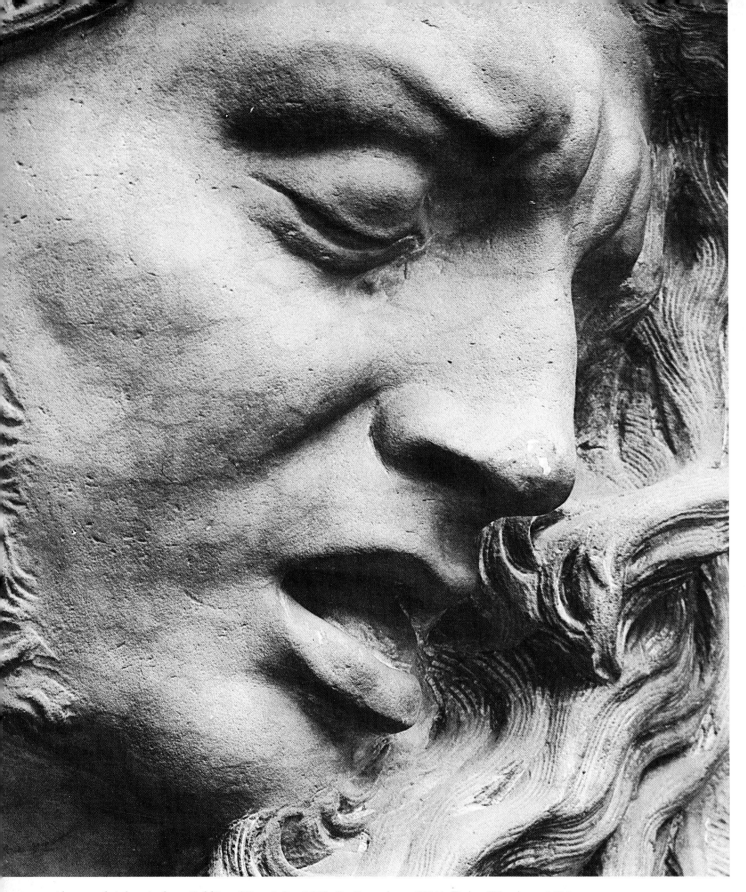

Above and right: Andreas Schlüter (Danzig? c. 1660–St. Petersburg 1714), Dying Warriors, *1696.*
Marble reliefs on keystones of arches. Berlin, Zeughaus (Arsenal).
The decoration of the Berlin Arsenal was Schlüter's first important commission. This was commissioned from the German architect and sculptor by the Elector Frederick III of Brandenburg, the future Frederick I of Prussia, son of the Great Elector and grandfather of Frederick the Great.

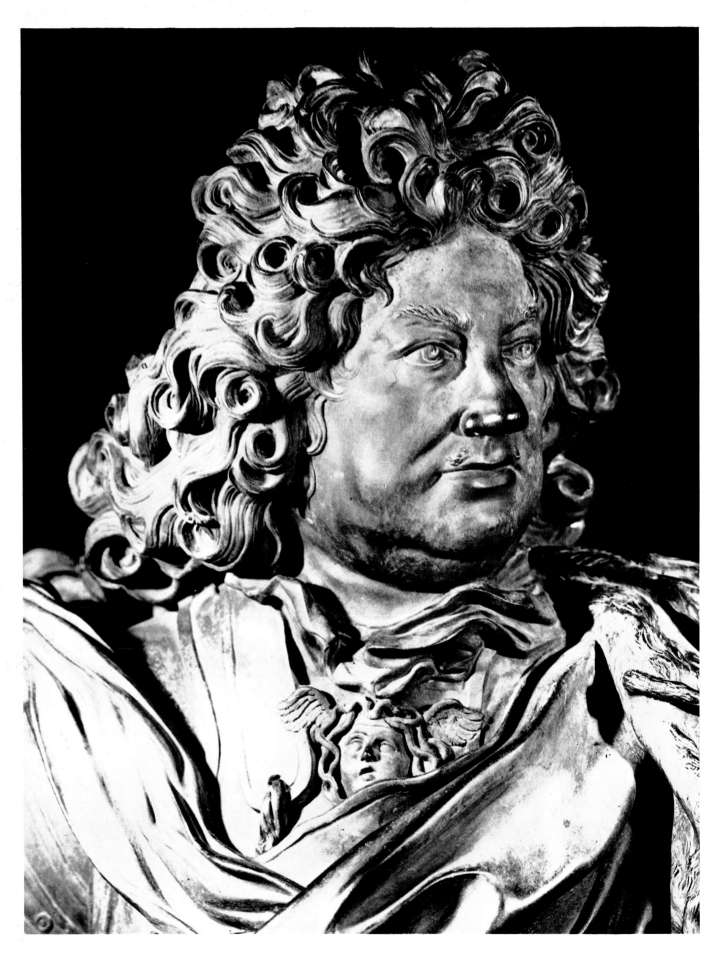

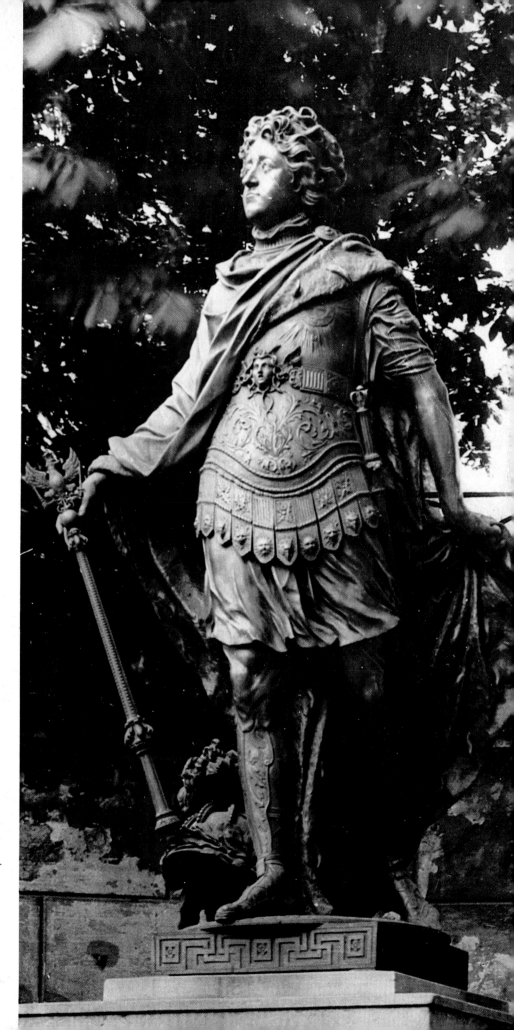

Left: Andreas Schlüter
(Danzig? c. 1660–St. Petersburg
1714),
Friedrich von Hessen-Homburg
Bronze; height 3 ft., base 10 in.
Homburg, Homburg von der Höhe
Schloss.
This portrait bust shows the landgrave
wearing a wig, a classical-looking
cuirass, and a fur-trimmed coat over his
shoulders.

Right: Andreas Schlüter
(Danzig? c. 1660–St. Petersburg
1714),
Monument of Frederick I of Prussia,
1697. Königsberg
(the present Kaliningrad).
Frederick I was the first king of
Prussia; son of the Great Elector,
Frederick William of Brandenburg,
Duke of Prussia (whom Schlüter also
immortalized in a famous equestrian
monument), he was crowned at
Königsberg in 1701.

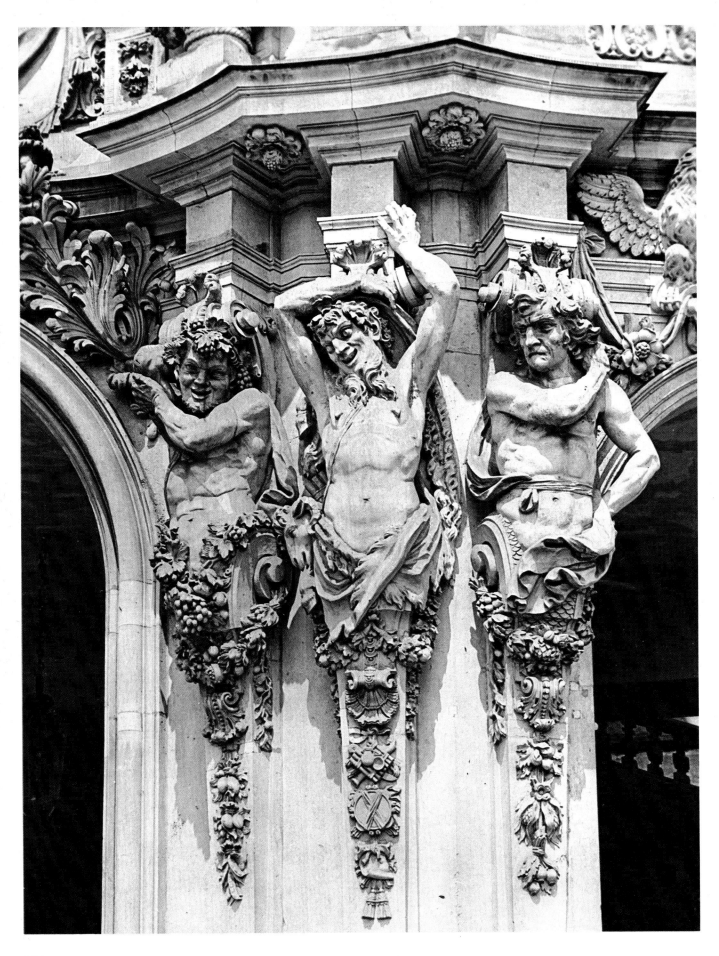

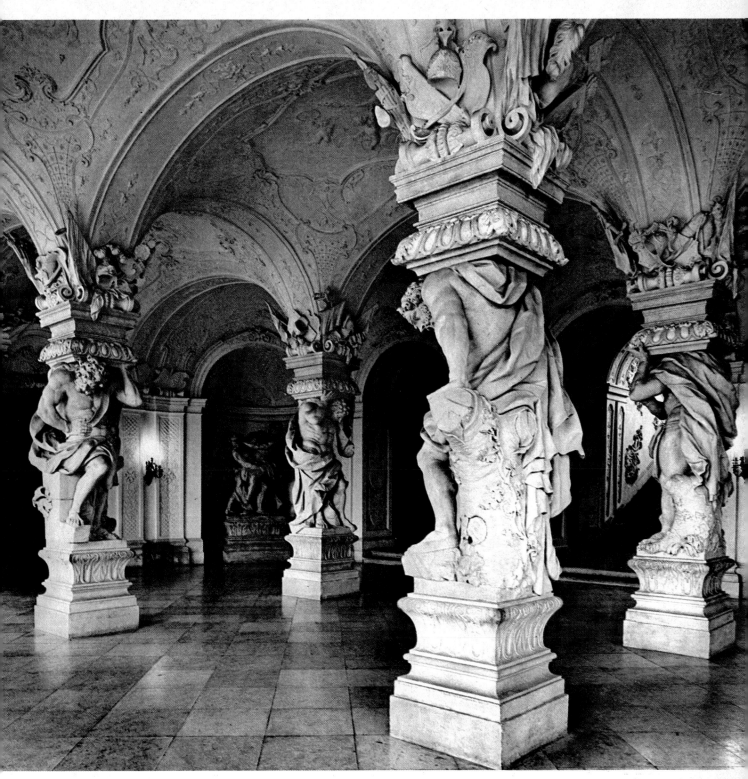

Left: Balthasar Permoser
(Kammer 1651–Dresden 1732),
Atlantes, 1714–1718.
Marble reliefs. Dresden, Zwinger.
This is a detail of the last pavillion of
the Zwinger, a group of pleasure
buildings built by Daniel Pöppelmann
for Augustus, Elector of Saxony.

Above: Johann Lucas von Hildebrandt
(Genoa 1668–Vienna 1745),
Hall of the Atlantes (detail)
Marble; Vienna, Upper Belvedere.
This ground-floor hall of the Upper
Belvedere Palace—which the architect-
sculptor Hildebrandt built for Prince
Eugene of Savoy—has vaults supported
by massive pillars in the shape of
Atlantes.

Page 54: Balthasar Permoser
(Kammer 1651–Dresden 1732),
St. Ambrose (detail), 1725.
Polychrome wood; height 6 ft. 7 in.
Bautzen, Stadtmuseum.
This statue was made as a pendant to
the statue of St. Augustine, for the
Hofkirche in Dresden. In 1751 both
works were transferred to the Bautzen
cathedral, and they are now in the
museum at Bautzen.

*Left: Franz Ignaz Günther
(Altmannstein 1725–Munich 1775),
The Virgin of the Apocalypse
(detail), 1768–1770.
White and gilded stucco. Mallersdorf,
former Abbey.
The work shows the Virgin standing
before the sun and drawing back in
front of the dragon which the
Archangel Michael will presently be
slaying. The group is placed above and
to the right of the main altar.*

*Page 55: Franz Ignaz Günther
(Altmannstein 1725–Munich 1775),
The Archangel Raphael, c. 1770.
Wood; height 6 ft. 5 in.
Munich, Bayerisches Nationalmuseum.
The archangel is represented as a
wayfarer (he is indeed the patron saint
of wayfarers) wearing a tunic, a cloak,
and a wide-brimmed hat. He is wearing
thonged sandals on his feet.*

*Page 56 (detail) and page 57
(whole): Franz Ignaz Günther
(Altmannstein 1725–Munich 1775),
The Annunciation, 1764.
Polychrome wood;
height of Virgin 63 in.
Weyarn, Convent Church.
The group, which was designed to be
carried about in processions, shows the
Virgin kneeling on a prie-dieu and
receiving the angel's message. The
angel is carrying lilies, symbol of
purity, and on the prie-dieu is the image
of the Holy Spirit in the shape of a
dove.*

*Right: Franz Ignaz Günther
(Altmannstein 1725–Munich 1775),
The Empress Cunegonda (detail),
1760–1762. Polychrome wood.
Rott am Inn, Abbey Church.
This is a statue representing the
medieval empress wearing fantasy
clothes which are a mixture of court
and theatrical costumes of the
eighteenth century. The statue is placed
near the altar, together with a statue of
Henry II and those of St. Corbiniano
and St. Benno.*

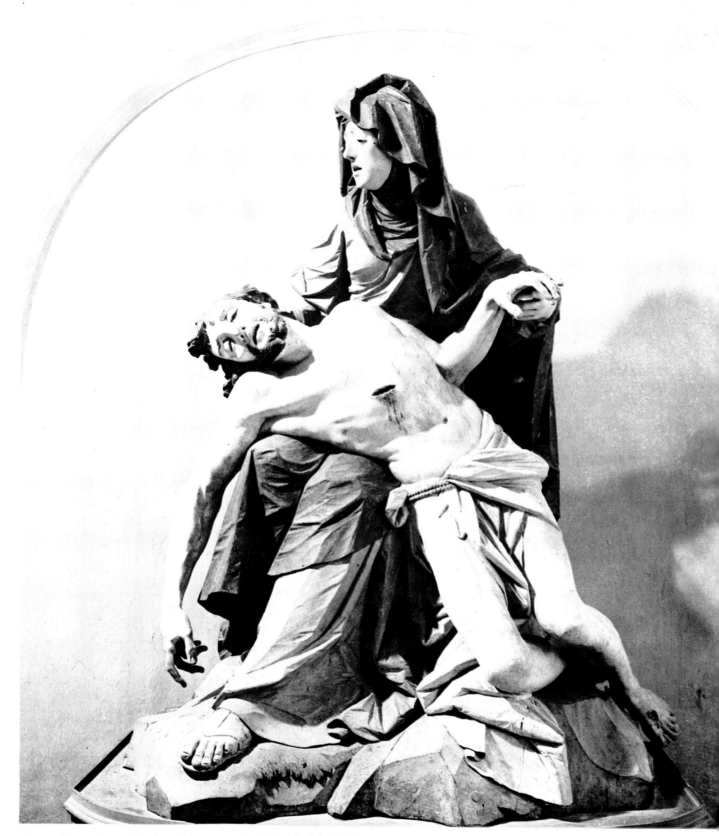

Above: Franz Ignaz Günther (Altmannstein 1725–Munich 1775),
Pietà, *1774.*
Polychrome wood. Nenningen, Cemetery Chapel.
The group represents the traditional subject matter of the Pietà, *with the Virgin gazing down at Christ's face while she holds him on her lap.*

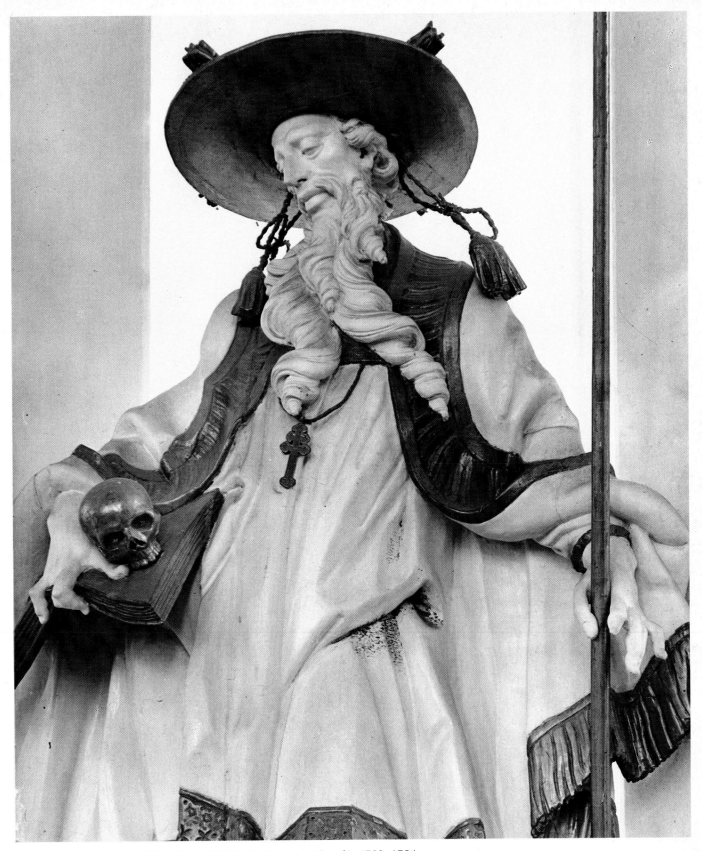

Anton Sturm (?1690–1695—Füssen 1757), St. Jerome *(detail), 1753–1754.*
Polychrome wood. Wies, Parish Church.
The saint is depicted wearing a lace-trimmed garment, a cloak, and a minister's hat; he is holding in his left hand the bishop's baton and in his right a skull and the Vulgata, *his usual attributes. This statue is one of four representing the Doctors of the Church, the other three being St. Augustine, St. Gregory, and St. Ambrose. The four statues adorn the main altar of the church at Wies.*

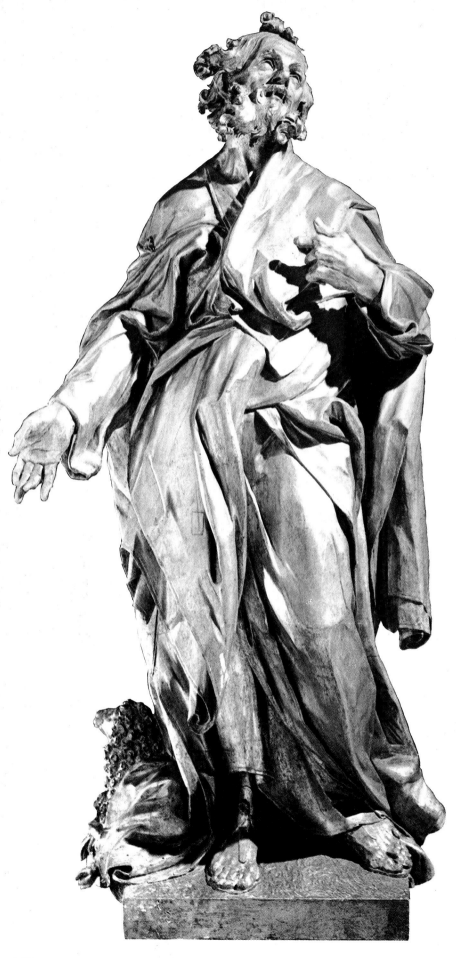

Left: Paul Egell
(Mannheim 1691–1752),
St. Joachim, 1731.
Polychrome wood.
Hildesheim, Cathedral.
The figure of this saint is part of the
group representing the Immaculate
Conception, placed above one of the
altars in the cathedral.

Page 52: Cosmas Damian Asam
(Benediktbeuren 1686–Munich 1739)
and Egid Quirin Asam
(Tegernsee 1692–Mannheim 1750),
Altar of St. George (detail),
1721–1724.
Marble and stucco, partially gilded.
Weltenburg, Abbey Church.
The altar was designed by Cosmas
Damian Asam (who also painted the
fresco at the back, representing the
Immaculate Conception), and sculpted
by his brother Egid Quirin Asam. The
central group represents St. George on
horseback slaying the dragon, while the
frightened princess draws back. The
altar is contained within four torsaded
columns which also support the abbey
coat of arms, borne by angels.

Page 53: Egid Quirin Asam
(Tegernsee 1692–Mannheim 1750),
Altar of the Assumption (detail),
1718–1722. Marble and stucco,
partially gilded.
Rohr, Augustinerkirche.
This work, placed on the main altar,
consists of an open bier, surrounded by
the figures of the apostles. Above the
group, the Virgin, wearing sumptuous
clothes, soars up to heaven in the arms
of a couple of angels. A huge marble
backcloth makes up the background.

Right: Georg Raphael Donner
(Esslingen 1693–Vienna 1741),
The River Ybbs (detail), 1737–1739.
Lead; height 49 in.
Vienna, Osterreichische Galerie,
Barockmuseum (in the Museum der
Stadt).
This half-naked female figure
personifies one of the tributaries of the
Danube. Together with the other three
(the Enns, the Traun, and the March),
it once adorned the Mehlmarkt (Old
Market) fountain in Vienna, which is
still there, but adorned nowadays with
copies of the original statues.

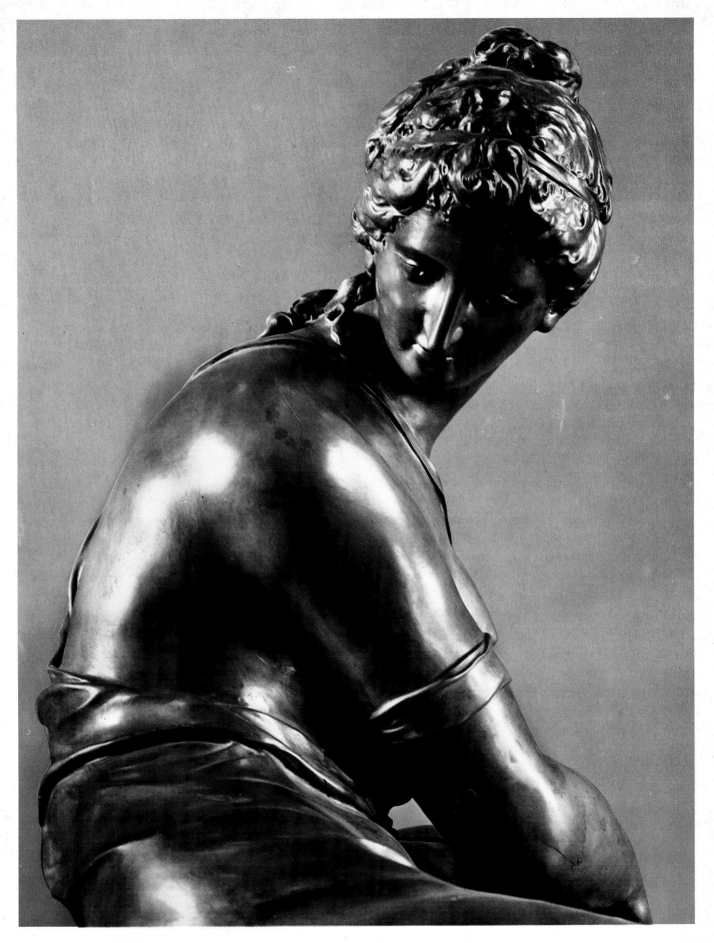

Above: Egid Quirin Asam
(Tegernsee 1692–Mannheim 1750),
Cosmas Damian Asam, 1716–1723.
Stucco. Weltenburg, Church of the Benedictine Abbey.
The portrait of the sculptor's brother (wearing contemporary clothes) is part of the stucco decoration of the cornice on the cupola of the abbey church.

Right: Adam Ferdinand Dietz (1708–1777),
Athena (detail), 1765–1768.
Stone. Veitschöchheim, park of the palace.
The figure of the goddess, wearing clothes borrowed from contemporary theater, is part of a group of statues for the garden of the bishop prince Adam Friedrich von Seinsheim.

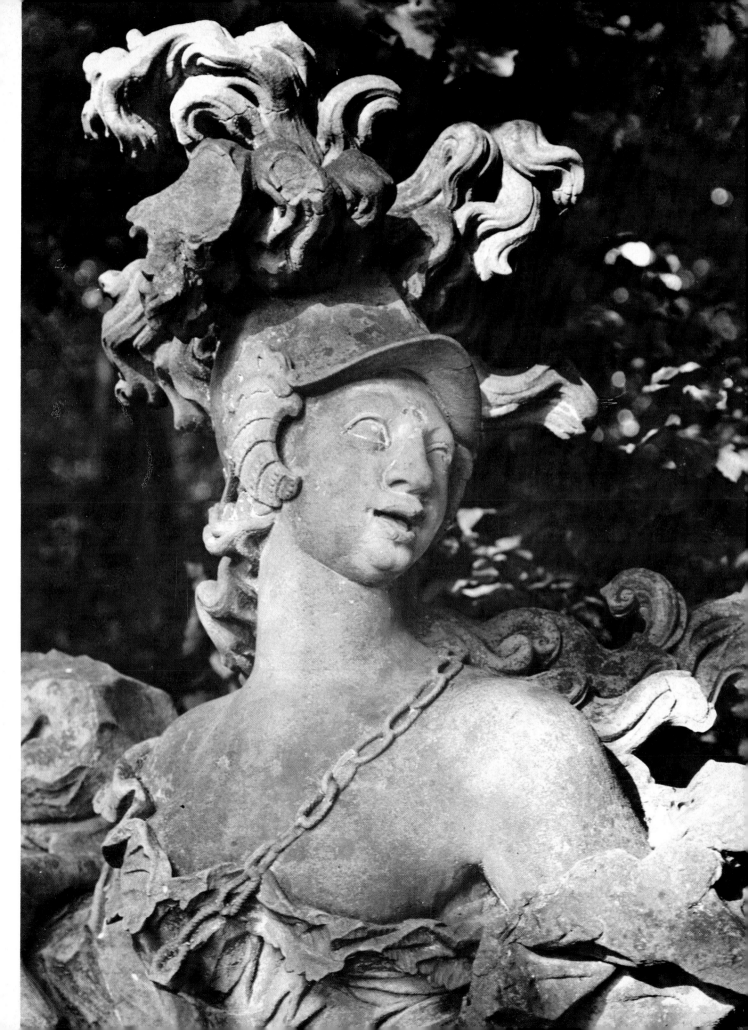

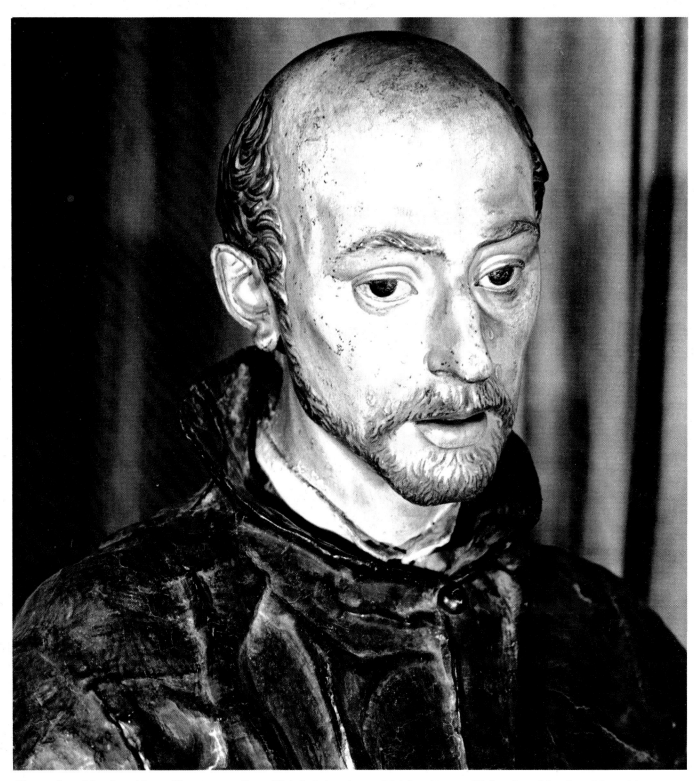

Above: Juan Martínez Montañés
(Alcalá la Real 1568–Seville 1649),
St. Ignatius Loyola (detail), 1610.
Polychrome wood. Seville,
University Chapel.
The saint is represented preaching and
wearing the habit of the Company of
Jesus, of which he was the founder.

Page 59 (whole) and page 58 (detail),
Narciso Tomé (Toro? 1690–Toledo
1742),
The "Transparent" Altarpiece,
1721–1732.
Polychrome marble and stucco,
partially gilded.
Toledo, Cathedral.
The altarpiece was dubbed
"transparent" because of the
"lacework" between the figures which
allows the light from the windows
behind to filter through.

Right: Juan Martínez Montañés
(Alcalá la Real 1568–Seville 1649),
St. Domingo de Guzmán, 1605.
Polychrome wood; height 59 in.
Seville, Museo de Bellas Artes.
The saint is represented as a penitent,
flagellating his naked chest while
gazing fixedly at a crucifix.

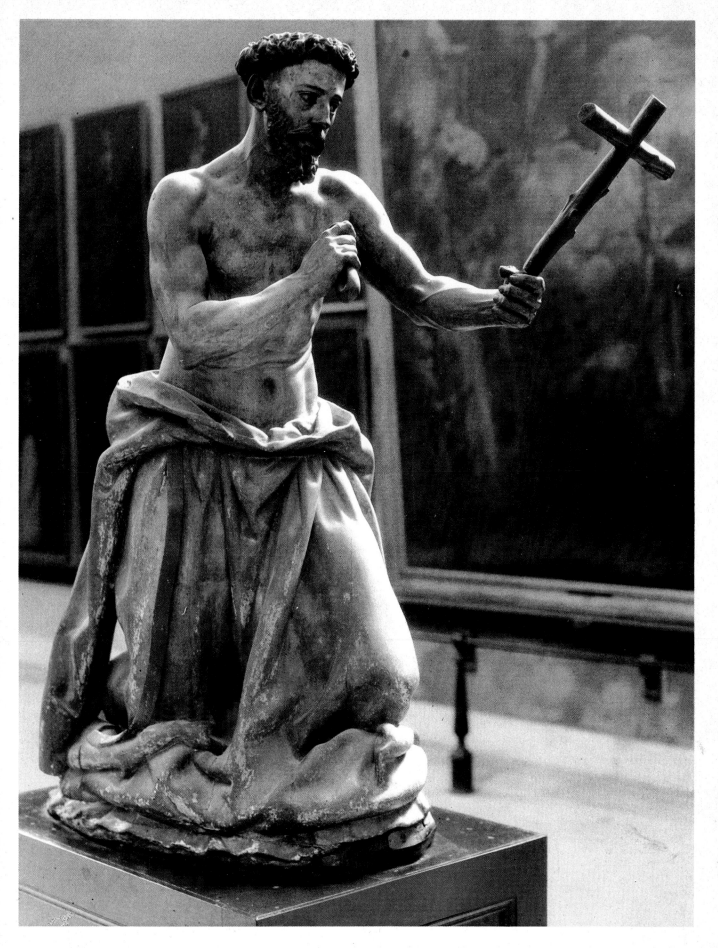

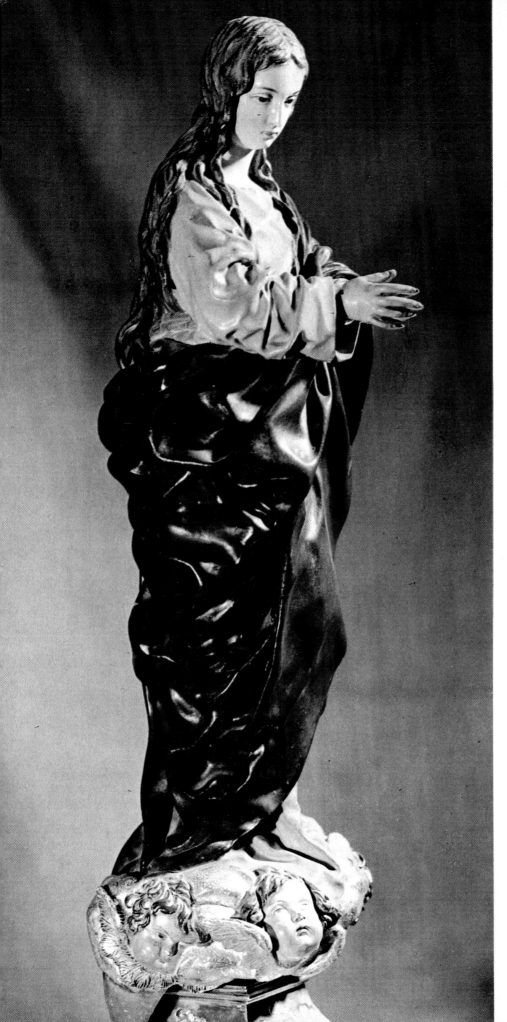

Left: Alonso Cano
(Granada 1601–1667),
The Immaculate Conception, *1656.*
Polychrome wood; height 20 in.
Granada, Sacresty of the Cathedral.
This very youthful Virgin is shown
wearing the traditional dress and
mantle; her hair is loosened and she has
her head bowed in prayer and her hands
joined. The base of the statue consists
of a garland of angels' heads.

Page 62: Hipolíto Rovira
(Valencia 1693–1765), and
Ignacio de Vergara (Valencia
1715–1776),
Portal, *1740–1744. Marble relief.*
Valencia, Palacio Dos Aguas.
Above the doorway is a group
consisting of the Virgin, the Child
Jesus, and the young St. John the
Baptist, surrounded by a glory of
angels and overhung by a baldachin. On
either side of the doorway two naked
telamones stand out against a stylized
forest of intertwined plants and
animals.

Page 63: Altarpiece,
eighteenth century.
Gilded and polychrome wood.
Tepotzotlán, Convent,
Chapel of St. Joseph.
The decoration includes both the
altarpiece and the background itself.
The whole forms a homogeneous
mixture of intertwined plants and
geometric elements surrounding figures
of angels and saints.

Right: Gregorio Hernández
(Pontevedra 1576–Valladolid
1636),
The Baptism of Christ, *post 1605.*
Polychrome wood relief;
height 10 ft., width 6 ft. 1 in.
Valladolid, Museo de Esculturas.
On the right, St. John the Baptist,
wearing a goatskin, baptizes Christ
with a shell containing water from the
Jordan. In the background is a river
landscape and above is a relief
representing God the Father and the
dove of the Holy Spirit with a cortège
of angels. The work was made for the
convent of the Discalced Carmelites.

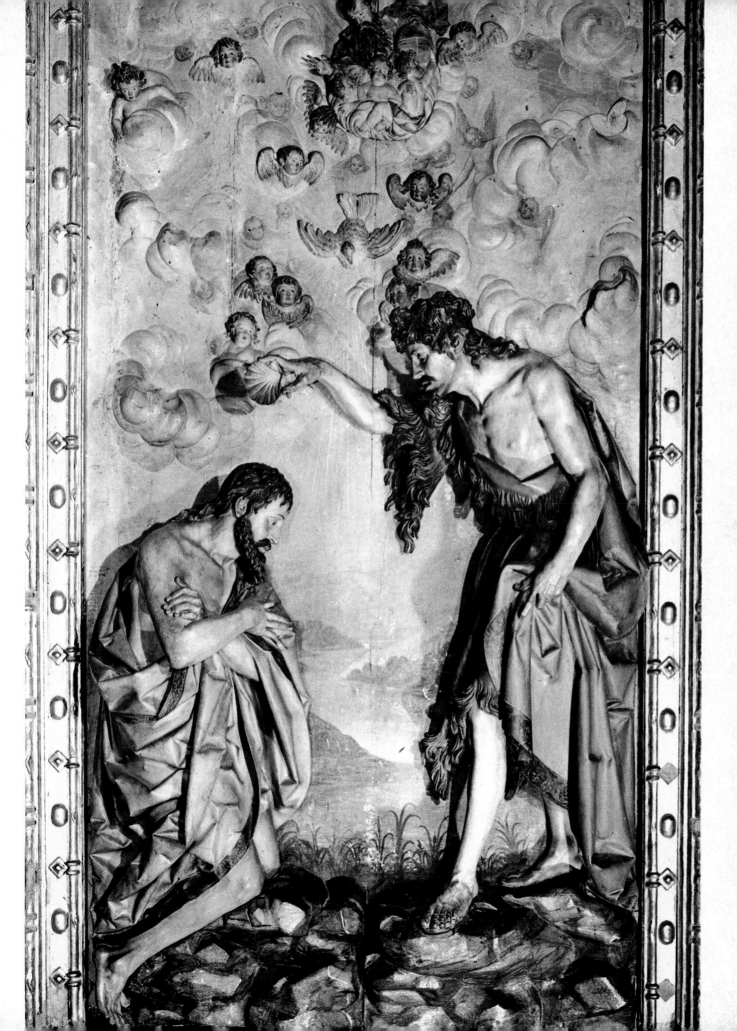

Left: Juan Martínez Montañés
(Alcalá la Real 1568–
Seville 1649),
The Child Jesus Blessing
(detail, 1606.
Polychrome wood.
Seville, Cathedral, Sagrestia de los
Calices.
This is an example of an imagen de
vestir, i.e., a statue that can be dressed
up in sumptuous clothes and jewels
according to the various holy days. It
was made for the Fraternity of the
Santissimo Sacramento.

Page 60: Juan Martínez Montañés
(Alcalá la Real 1568–Seville 1649),
Christ Bearing His Cross
(detail), c. 1619.
Polychrome wood and gilded bronze.
Seville, San Lorenzo.
This is another imagen de vestir, made
especially for the Holy Week
procession in Seville. It represents
Christ bearing his cross and wearing
the Crown of Thorns.

Page 64: The Chapel of the Rosario
(detail), 1596–1690.
Coloured plaster relief.
Puebla, Convent of Santo Domingo.
The decoration covers all the walls with
a pattern of intertwined geometrical
and plant elements into which are
inserted figures of saints and angels.

Right: Alonso Cano (Granada
1601–1667),
The Virgin of Bethlehem.
Polychrome wood; height 21 in.
Granada Museo de la Catedral.
The very young-looking Virgin, with
her legs in an unusual pose, gazes down
at the child on her lap.

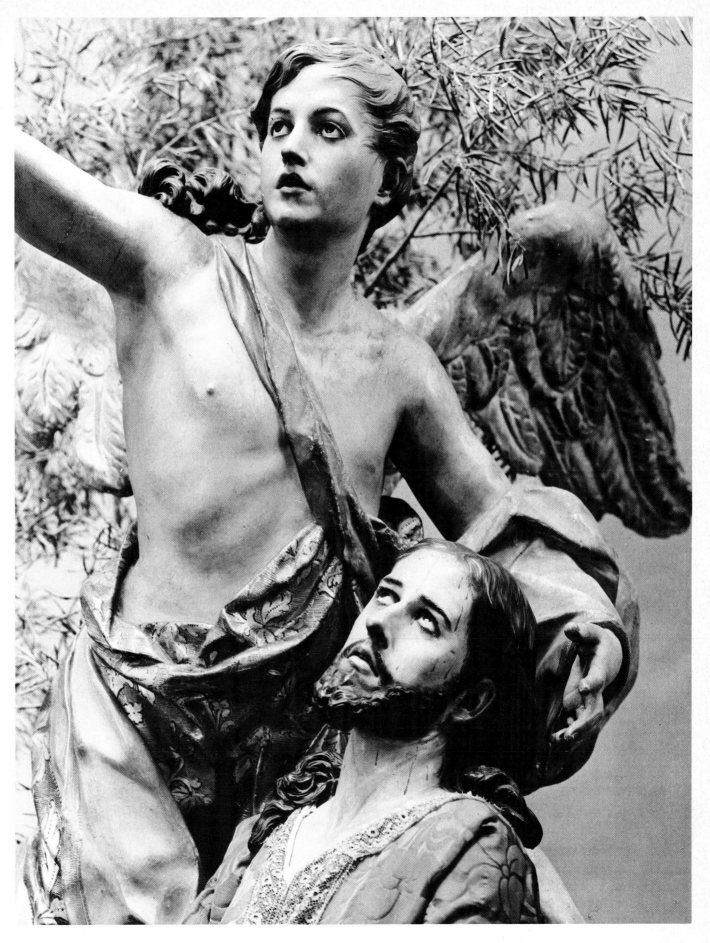

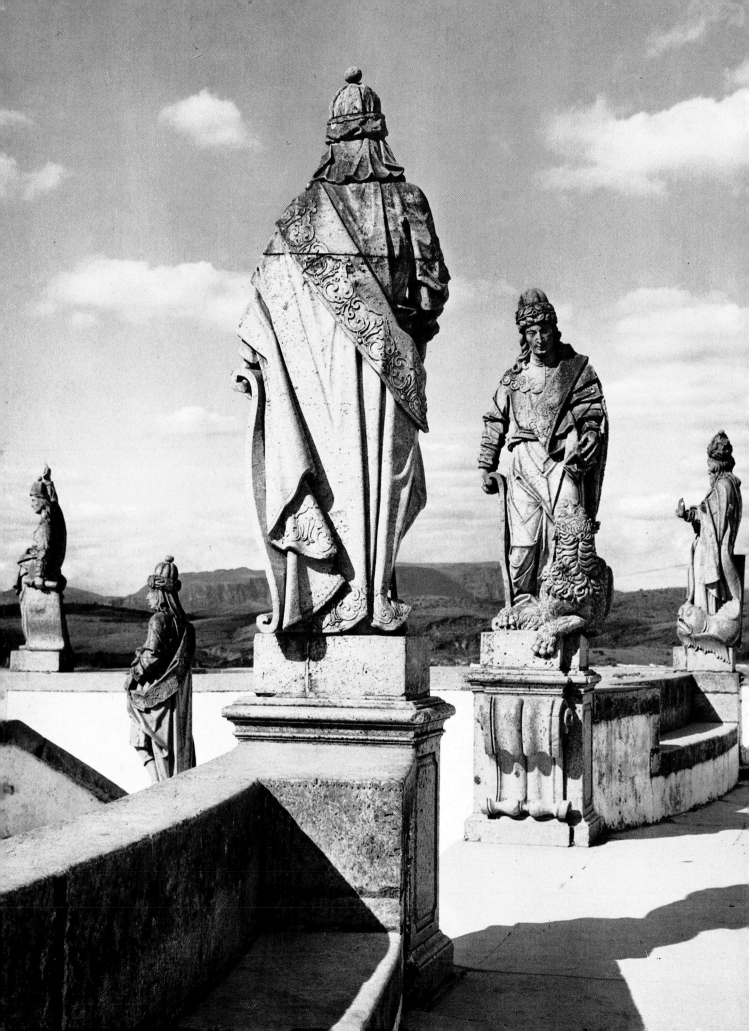

NOTES

THE DIFFUSION OF BAROQUE AND ROCOCO

Baroque and Rococo sculpture was diffused above all in Europe: in the Italian peninsula, Sicily, Malta, the Iberian peninsula, France, the part of central Europe that comprises German-speaking countries, Switzerland, the Netherlands, Belgium. As far as eastern Europe is concerned, Poland, Czechoslovakia, and Hungary are also included within the confines of the movements, and, to a much lesser extent, the Ukraine and part of Russia. In Great Britain diffusion was mostly limited to England and above all the London area. In Latin America the Baroque and Rococo movements spread from Mexico to Peru, Ecuador and Brazil, i.e., in the territories which, had become Spanish and Portuguese dominions.

Let us now examine the situation in greater detail. Baroque was the style of the day in the seventeenth century in the whole of Italy, with Rome as its indubitable center. Other important centers were Florence, Genoa, and, later, for Rococo, Turin and Venice. In southern Italy the important centers were Naples, Palermo, and Catania.

In Spain, as far back as the end of the sixteenth century, there were schools of sculpture established in Aragon and in the Basque and Navarre areas. Seville, too, was an important center. For the Baroque movement the school of Valladolid and the southern workshops of Granada and Seville were among the most important, although Madrid was where most works were sent. In Portugal there was great pre-Baroque activity in the sixteenth century at Coimbra. In the seventeenth century the important centers were Braga, Tibaes, Vilar de Frades, Vila do Conde, Santo Tirso, Oporto, Coimbra, Torres Vedras, and Evora. In the eighteenth century, Braga once again, Arouca, Aveiro, Evora, Elvas, Lisbon, Alcobaça, and Mafra.

In France the most important center for both Baroque and Rococo was Paris and, in particular, the Versailles area. There was also a lesser center in Provence, in the region extending from Marseilles to Toulon.

In German-speaking countries the main centers were Munich, Augsburg, Frankfurt, Nuremberg. Dresden, Würzburg, Vienna, Nymphenburg, Gurk, Presburg, Diessen, Rohr, Osterhofen, Weltenburg, Schönbrunn, Innsbruck, and Wilhering. In Switzerland, Lucerne, Freiburg, the Valais region, Bern, and Einsiedeln. In northern Europe, Antwerp, Liège, Brussels, Ghent, Bruges, Delft and Amsterdam. In eastern Europe, Prague and the whole of Bohemia, Moravia, Budapest, Györ, Maryabesnyö, Pécs, and Gyula.

DATES AND ARTISTS

In comparison with the rest of Europe, Baroque sculpture started remarkably early in Italy and was soon flourishing. This was due above all to Alessandro Algardi and Giovanni Lorenzo Bernini, who represent the two cornerstones of Italian Baroque (and indeed of Baroque sculpture in general), though the former had a rather classical bent whereas the latter was totally Baroque. It is important to point out, however, that these two tendencies—classical and Baroque proper—did not run parallel but often met and merged, and indeed there were many sculptors in Rome in the seventeenth century who alternated between Bernini's workshop and Algardi's.

Undoubtedly the greatest Baroque sculptor was Bernini (1598–1680), who established Italian supremacy in the movement. His output was enormous, starting about 1615, the year in which he sculpted *Zeus Drinking the Milk of the Goat Amalthea*, until about 1678, the year in which he finished the funerary monument of Alexander VII. Bernini moved beyond the Mannerist style quite early in his career and showed a certain inclination towards the Hellenistic style, especially Rhodian, Pergamene, and Alexandrian art.

Apart from Francesco Mochi (1580–1654), who was really a law unto himself, for the whole of the seventeenth century the work of Bernini and Alessandro Algardi (1595–1654) was the most important point of reference for sculptors, both Italian and otherwise.

These included François Duquesnoy (1597–1643), Giuliano Finelli (1601–1657), Andrea Bolgi (1605–1656), Francesco Baratta (1590–1666), Ercole Ferrata (1610–1685), Antonio Raggi (1624–1686), Domenico Guidi (1625–1701), Melchiorre Caffà (1630–1667), and Cosimo Fansaga (1591–1678).

The Academy of France was established in Rome in 1666, but there was also in Italy a permanent colony of French sculptors, such as Pierre Legros (1666–1719), Jean Baptiste Théodon (1646–1713) and Pierre Etienne Monnot (1657–1733). The Baroque movement was progressively transformed into Rococo with the work of sculptors active after Camillo Rusconi (1658–1728): Agostino Cornacchini (1685–post 1740), Filippo della Valle (1698–1770), Giovanni Battista Maini (1690–1752), and Pietro Bracci (1700–1773).

During the Roman Rococo period, the two most important achievements were the decoration of the Corsini Chapel, built by Alessandro Galilei between 1732 and 1735 in San Giovanni in Laterano, and the Trevi Fountain, on

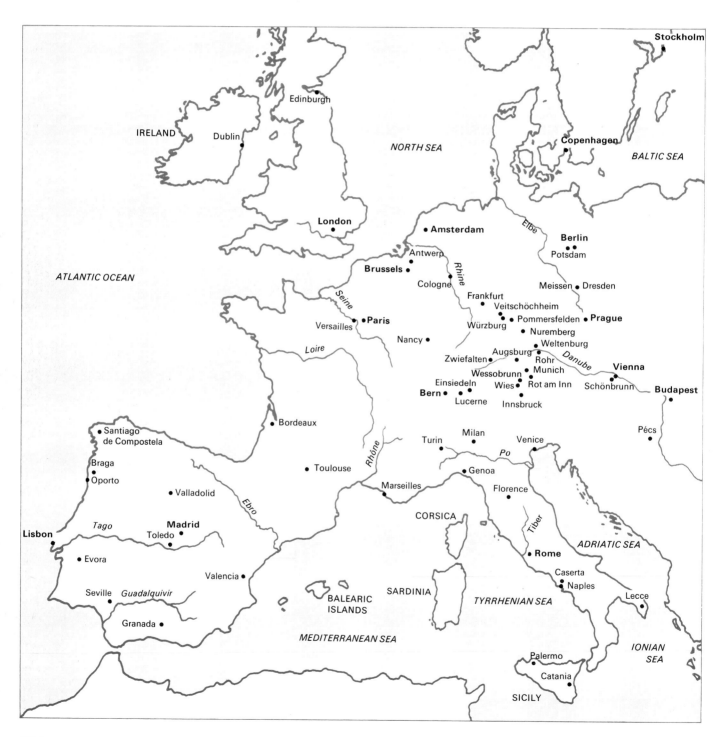

STOCKHOLM

Edinburgh

IRELAND Dublin

NORTH SEA

Copenhagen

BALTIC SEA

London

Amsterdam Berlin
 Potsdam

Antwerp

ATLANTIC OCEAN

Brussels Cologne Rhine Meissen Dresden

Frankfurt

Seine Veitschöchheim

Paris Würzburg Pommersfelden Prague

Versailles Nancy Nuremberg Weltenburg

Loire Augsburg Rohr Danube Vienna

Zwiefalten Munich

Wessobrunn Schönbrunn Budapest

Einsiedeln Wies Rot am Inn

Bern Lucerne Innsbruck Pécs

Bordeaux

Santiago Milan Venice
de Compostela Turin Po

Braga Rhône Genoa

Oporto Toulouse Florence

Valladolid Marseilles

Ebro CORSICA Tiber

Tago Madrid ADRIATIC SEA

Lisbon Toledo Rome

Evora Caserta

Valencia Naples

Seville Guadalquivir SARDINIA TYRRHENIAN SEA Lecce

BALEARIC
ISLANDS

Granada IONIAN
SEA

MEDITERRANEAN SEA

Palermo

Catania

SICILY

which Niccolò Salvi (1697–1751) and others worked. In Florence, the work of Giovanni Battista Foggini (1652–1737) for the Corsini Chapel (1677–1679) in the church of Santa Maria del Carmine, and for the Feroni Chapel (1691–1693) in the Santissima Annunziata is important. We must also mention Andrea Fantoni (1659–1734), Francesco Queirolo (1704–1762) and Giacomo Serpotta (1656–1732), who were active in Lombardy, Campania and Sicily.

The mystically tinged and dramatic German Baroque style is quite distinct from the more refined and sumptuous Italian style. It first appeared on the European scene in the second half of the seventeenth century and became important mostly between the end of the seventeenth century and the beginning of the eighteenth.

In Austria, the Pestsäule, decorated between 1679 and 1694, marked the beginning of the Baroque period in the area. Nevertheless, before that late date Baroque sculptors such as Georg Petel (1591–1633), Michael (1580–1649) and Leonhard (1588–1662) Kern, and Matthias Rauchmiller (1645–1686) were active. The late-Baroque masters include Giovanni Giuliani (1663–1744), Balthasar Permoser (1651–1732), Andreas Faistenberger (1647–1735), Andreas Schlüter (1660 or 1664–1714), Raphael Donner (1693–1741), and Bernhard Braun von Braun. In the Rococo period, next to courtly sculpture, religious subject matters carved in wood and stucco played an important part. Sculptors such as Ignaz Günther (1725–1775), Joseph Anton Feichtmayr (1696–1770), Paul Egell (1691–1752), and Johann Baptist Straub (1704–1784) all emphasized the realistic side of their religious subject matters. We should also mention Egid Quirin Asam (1692–1750), Ferdinand Dietz (1708–1777), Johann Georg Dorfmeister (1736–1786), Franz Xaver Messerschmidt (1736–1783), and Johann Joachim Kändler (1706–1775).

In France Baroque sculpture was to a large extent conditioned by the prevalent academic taste for classicism, which reached its height during the reign of Louis XIV, becoming more rigid when confronted with the works of Bernini and Puget, which were fully Baroque, and eventually favouring the decorative side of the art. Typical of this are Versailles itself and the works of François Girardon (1628–1715) and Antoine Coysevox (1640–1720). It was the latter who, well in advance of the rest of Europe, established the basis of Rococo which was to flourish best in France, above all with the Slodtz family: Sébastien (1655–1726), Sébastien the Younger (1694–1754), Jean Baptiste (1699–1759), Paul Ambroise (1702–1764), and René Michel (1705–1764), known as Michelange, who pursued several elements of the Bernini tradition. There was also the Lemoyne family: Jean Louis (1665–1755), Jean Baptiste I (1679–1731), Jean Baptiste II (1704–1778), and the porcelains of Etienne Falconet (1716–1791).

In England Baroque and Rococo sculpture were relatively unimportant and show the influence of Flemish and Italian sculpture. Nicholas Stone (1586–1647) was the pupil, in Amsterdam, of Pieter de Keyser; there were also Louis François Roubiliac (c. 1705–1762) and Caius Gabriel Cibber (1630–1700); and the porcelains of Longton Hall and Chelsea.

In Belgium and Holland important sculptors include François Duquesnoy (already mentioned in relation to Italy), his brother Hieronymus II (1602–1654), Artus I Quellin (1609–1668), Lucas Faydherbe (1617–1697), Rombout Verhulst (1624–1698), Artus II Quellin (1625–1700), and Pieter de Keyser (1595–1676).

In Spain and Portugal, where the spirit of the Counterreformation was stronger than anywhere else, the Baroque style was present for the whole of the seventeenth and part of the eighteenth century in a popular and markedly expressionistic form. Nonreligious allegory and mythological subjects were taboo. Sculptors included Gregorio Hernández (1566–1636), Juan Martínez Montañés (1568–1649), and Alonso Cano (1601–1667).

The Iberian peninsula practically ignored the presence, elsewhere in Europe, of the Rococo style, which was above all a manifestation of frivolity, with its galant subject matters, its sensuousness, the elegant decoration of salons and bedrooms. The religious aspect and the popular idiom of Iberian sculpture is evident in the Christmas crib figures (a genre which also found its way to Latin America) popular in Portugal, and also in Spain, as can be seen from the works of Francisco Salzillo.

In the overseas dominions of Spain and Portugal the Baroque movement, characterized by the same elements as in its mother country, prevails during the whole of the eighteenth century and even beyond. The twelve prophets in the sanctuary of Bom Jesus at Congonhas do Campo were in fact carved between 1800 and 1805 by António Francisco Lisboa (1738–1814), better known as Aleijadinho ("the lame one").

TECHNIQUE

Stone or wood sculpture is different from bronze sculpture in that, for the latter, the preparatory model, be it in wax or clay, plays an important role, whilst in the other two cases it plays a merely secondary role and indeed may even be redundant, for stone and wood are materials on which an artist can continue to work once the final shape has been set, unlike metal, which takes, after it has hardened, a form that is difficult to alter.

Wood sculpture, which was extremely popular in the Middle Ages, became so once again in the seventeenth century, especially in the Iberian peninsula, where the Church encouraged the naturalistic aspect of sculpture. It was popular in some cases in Italy (e.g., the Sacri Monti sculpture and the works of Andrea Fantoni); in German and Slav countries, on the other hand, there was a vogue for wood sculpture in the eighteenth century.

In order to achieve movement, which would have been difficult with a single block of wood, the sculptors would usually carve individual pieces (assessing proportions with the help of a wax or clay model), then fit them to a central piece. This method made it necessary to use colour not only as a way of achieving a naturalistic effect but also to cover up joints and the different patterns of wood grain; sometimes the wood would be lacquered white, in imitation of the "noblest" type of marble.

The technique used in stone sculpture during the Baroque era is similar to that used during the Renaissance. The stone used was usually travertine, sandstone, or marble. Special care was always taken in choosing the block of stone so as to avoid imperfections such as "hair," which might ruin the work. White marble was, of course, the favourite material, but polychrome marble was often used as well. The instruments used included chisels and mallets, augers,

files, pumice, and emery. The sculptor might make several preparatory models and drawings, a sketch in reduced dimensions in the early stage, and a final model with the same proportions as the stone work. For large sculptures reduced models were used and brought up to scale. From the fifteenth century onwards sculptors had been using the *definitor*, an instrument consisting of a circle marked out in degrees, with an arm, also marked out in degrees, to which was attached a plumb line. The square, the square frame, and the wooden cage were other techniques used.

Ivory carving assumed a certain importance during the Baroque era. Particularly famous for their fine ivories were Georg Petel, the Zick family, Balthasar Stockamer, Melchior Barthel, Balthasar Permoser, Jean Cavalier, David Le Marchand, and Antonio Leoni.

Bronze is an alloy consisting of copper and tin or zinc in varying proportions. A higher percentage of tin makes the alloy more fluid during the process of casting but also more fragile when it has solidified. In the eighteenth century, Boffrand, describing Girardon's equestrian statue of Louis XIV, which had been cast by Balthasar Keller, said that it consisted of eighty-five percent copper, about twelve percent zinc, and four percent tin.

The techniques of lost wax and "loose section negative" (this latter was used above all from Giambologna on) were used in casting. In lost wax the model was made of clay reinforced by an iron "spinal cord," and wax was applied to it; clay was then added to the wax to make it more resistant to the pressure of the cast metal. There were narrow channels for the evacuation of the wax and vent holes for the steam to come out of. The whole thing was then placed in an ordinary cooking oven; the wax would then melt and the shape remain. The molten metal then was poured

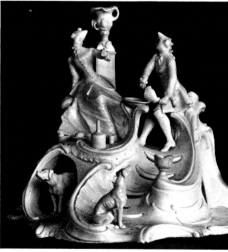

Above: Francesco Antonio Bustelli,
Nymphenburg Porcelain, c. *1760.*
London, Victoria and Albert Museum.
Top: Borromini, stuccowork in
the cupola of Sant' Ivo alla Sapienza,
Rome. Finished in 1660.

where the wax had been, and once set it retained the shape of the mould. Then the clay covering was chiselled off.

In "loose section negative" the model was made of clay onto which pieces of plaster were applied. Then a plaster mould was made, which meant that the model was not lost once it was fired, as happened with wax models.

After it had set, the bronze form could then be polished and chiselled when it was cold.

The art of porcelain, mentioned by Marco Polo and Queen Maria of Naples and Sicily (in her testament, 1323), was first practiced in China. It was not until January 15, 1708, that Johann Friedrich Böttger succeeded in obtaining a kind of porcelain equal to Chinese porcelain. Two years later a factory was set up at Meissen, which was followed in 1717 by another one in Vienna; then at Vezzi (1720), Chantilly (1725), Doccia (1735), Vincennes (1738, transferred to Sèvres in 1756), Capodimonte (1743), Bow (1744), Chelsea (1745), Höchst (1746), Berlin (1749), Worcester and Fürstenberg (1751), Bassano (1752), Nymphenburg (1753), Frankenthal (1755) and Ludwigsburg (1758).

The mixture of kaolin, feldspar, and quartz was fired in a kiln at an extremely high temperature, in three phases: 900°C, 1400–1500°C, 800–900°C. The last firing was done after the glazes had been applied. Before the discovery of this type of hard porcelain, a softer mixture was used, which consisted of glass, alabaster, lime, marble, and steatite. The firing temperature then did not exceed 1100°C.

Plaster is made up of lime, powdered marble, washed sand, and casein. In the seventeenth and eighteenth century plaster was carved on an iron base. The Carloni family, especially Diego (1674–1750) and Carlo Innocenzo (1686–1775), were particularly successful at this type of decoration. The lighter parts, such as figures hanging in the air and clouds, were carved on a core of wood, straw, or pressed cardboard, for metal cores would have been too heavy. The instruments used in this kind of sculpture were sieves, paintbrushes, spatulas, small shovels, files, scrapers, spoons, pumice, and lengths of cloth.

PATRONS

Apart from various religious orders, the patrons of Baroque and Rococo sculptors were popes, kings, and, more generally, noblemen, whose motives were always the glorification of their own person or their policies. Particularly significant is the case of the façade of Santa Maria del Giglio in Venice, commissioned by Antonio Barbaro and built between 1675 and 1683. It is decorated with numerous sculptures representing Antonio Barbaro and his brothers, together with the arms of the family and allegorical figures such as *Glory*, the *Cardinal Virtues*, *Fame*, *Wisdom*, etc., and it represents one of the most interesting examples of the glorification of a family.

Bernini's own case is also extremely interesting because it throws light on the phenomenon of the commission. Bernini's patrons included popes, kings, noblemen, and religious orders, among them Urban VIII, Alexander VII, Cardinal Scipione Borghese, Louis XIV of France, Charles I of England, Duke Francesco d'Este, Cardinal Richelieu, such prelates as Montoya, Bellarmino, Dolfin, Valier, and such noblemen as Thomas Baker and Paolo Giordano Orsini. His relationship with Urban VIII stands out from among his rapports with his patrons; the pope wanted—and indeed it was customary at the time—that Bernini should work for him exclusively, and Charles I of England and Cardinal Richelieu had to use all their considerable talent at diplomacy to obtain from Urban VIII a special permission so that Bernini could make their portrait—a permission which Urban VIII granted because it was convenient politically to do so. Bernini was undoubtedly the most famous and the most highly paid sculptor of his time. His works were extravagantly expensive: the marquis of Carpio, Spanish ambassador to Rome, once offered him the unheard of sum of 30,000 *scudi* for the equestrian monument of Louis XIV.

Urban VIII was not the only pope who was possessive about his official sculptor: Cardinal Mazarin tried to lure Alessandro Algardi to France twice, offering him extremely advantageous conditions, but Innocent X intervened and forbade Algardi to go to France.

Apart from Bernini and Algardi there were other Italian sculptors who were offered high positions in foreign courts. Francesco Fanelli, a Florentine who had studied under Giambologna, Francavilla, and Tacca, was invited to England by Charles I, who became his patron together with the Duke of Newcastle, tutor of the Prince of Wales, for whom he made several small bronzes of horses. Lord Arundel commissioned Fanelli to make his funerary monument, though he failed to get Bernini and Duquesnoy to make his portrait. It should be said, however, that the bronze bust Fanelli made of the king is still strongly Manneristic in style and rather poor in expressive power.

Giuliano Finelli, a pupil of Bernini's, was invited to sojourn at the Spanish court of Naples by the Viceroy, Count Monterey, who commissioned him to sculpt portraits of himself and of his wife and helped him obtain an important part in the decoration of the cathedral on which Giovanni Lanfranco and Domenico Zampieri (Il Domenichino) were already working.

In central Europe Balthasar Permoser was invited to the court of Prince Eugene of Savoy, who was a man of great taste. He made a marble *Apotheosis* for the Winter Palace in Vienna. Lorenzo Mattielli and

Domenico Antonio Parodi also worked for Prince Eugene, in the salon and gardens of the two Belvedere palaces.

We close this quick survey of patrons with an example of an "occasional commission"—on a visit to Genoa—about 1700, Admiral Pekemburg asked Domenico Parodi to make his portrait.

After the Council of Trent, new religious orders such as the Jesuits, the Oratorians, and the Theatines represented the activist side of the Church, that part of the clergy, that is, that exerted itself to make sure that the principles established at the Council were respected. These orders were, of course, encouraged by the pope; indeed Gregory XV actually had Ignatius Loyola and Francesco Saverio (the two leaders of the Company of Jesus), together with Filippo Neri (founder of the Oratorians), canonized.

These religious orders used sculptors, painters, and architects as instruments to glorify their action in defense of the Holy Catholic Faith, and therefore their policies. In a number of cases the relationship between the patron and the artist was a close one: The Jesuit Giovanni Paolo Oliva, for instance, who was made a general in 1661, was a great friend of Bernini's who had been in the Jesuits' good graces since he was a child, and had indeed grown up to share their ideas. In 1658 the task of building the Jesuit church of Sant'Andrea al Quirinale was entrusted to Bernini.

The French sculptor Legros was also employed by the Jesuits. To him was entrusted the prestigious task of carving a statue of St. Ignatius for the altar of the left transept in the church of the Gesù, in Rome. His fellow-countryman, Jean Baptiste Théodon, was commissioned to make *Faith Defeating Idolatry*, which is placed on the side of the same altar.

The Oratorians patronized Alessandro Algardi, who was commissioned to work on their church of Santa Maria in Vallicella.

SUBJECT MATTERS

Baroque iconography was influenced by the historical and political situation of the Church in the seventeenth century and the aftermath of the Counterreformation; episodes from the lives of saints (ecstasies, assumptions, martyrdoms, etc.) were particularly favoured. At the same time the taste of the ruling class favoured, for the decoration of palaces and churches, profane subjects, mostly taken from classical mythology, and treated allegorically; artists, therefore, enjoyed a certain freedom of subject matter.

In the second half of the seventeenth century the triumph of Louis XIV's policy of absolutism, and later the reign of Louis XV, caused iconography to be subject to the fashion of the time, which was to glorify the king and the high dignitaries, often by means of allegorical subject matters.

Apart from traditional subject matters such as sacred or profane statues used in the decoration of buildings, altars, gardens, theaters and palaces, and bas-reliefs also used in decoration, the Baroque era yielded some hitherto unexploited subject matters which were often due to Bernini's innovative genius. The fountain, for example, was "rediscovered." In comparison with its Manneristic counterpart, which usually consisted of a simple basin capped by one or two smaller ones (the favourite device of Giacomo Della Porta, the leading Mannerist fountain designer), the Baroque fountain is an elaborate and constantly changing subject matter. The most typical Baroque fountain is the *Fountain of the Rivers* on the Piazza Navona in Rome, which may be described as a "total" monument, comprising all the elements of seventeenth-century art.

Giovanni Lorenzo Bernini was responsible for establishing types of subject matters which were to serve as models for generations of sculptors. His

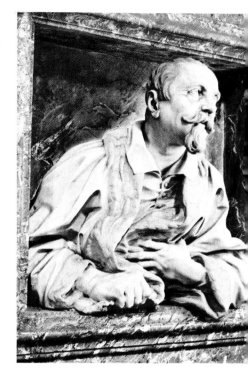

Giovanni Lorenzo Bernini,
Effigy on the Tomb of Gabriele
Fonseca,
c. *1664–1668. Finished in 1673.*
Rome, San Lorenzo in Lucina,
Fonseca Chapel.

Tomb of Urban VIII (1628–1647, Rome, St. Peter's), which was partly based on either Guglielmo Della Porta's *Tomb of Paul III* or Michelangelo's tombs of the Medicis, became a model which many sculptors later imitated; on the other hand his *Tomb of Alexander VII*, which came later, in 1671–1677, found only one follower, in the person of Pietro Bracci (*Tomb of Benedict XIII*, 1734, Rome, Santa Maria sopra Minerva). The *Tomb of Urban VIII* served as inspiration to Alessandro Algardi for his *Tomb of Leo XI* (1634–1650, Rome, St. Peter's), to Pierre Etienne Monnot for his *Tomb of Innocent XI* (1697–1704, Rome, St. Peter's), and Angelo De'Rossi for his *Tomb of Alexander VIII* (1691–1725, Rome, St. Peter's). Massimiliano Soldani (1656–1740), who preferred to work in bronze, established, with his *Tomb of the Grand Master Zondadari* in the cathedral at Valletta, a new, "heroic" type of funerary monument, which he elaborated in the funerary monument of the Great Master De Vilhena in the same cathedral.

The type of funerary monument established by Bernini prevailed during practically the whole of the eighteenth century. For example: Camillo Rusconi's *Monument to Gregory XIII* (1719–1725, Rome, St. Peter's), Giovanni Battista Maini and Carlo Monaldi's *Tomb of Clement XII* (1734, Rome, San Giovanni in Laterano), Filippo Della Valle's *Tomb of Innocent XII* (1746, Rome, St. Peter's), Pierre Legros and Etienne Monnot's *Monument of Gregory XV* (Rome, Sant'Ignazio); a few elements of Algardi's *Tomb of Leo XI* were also adopted by these artists. In France Girardon and Coysevox, in their tombs of Cardinal Richelieu and Cardinal Mazarin, respectively in the Sorbonne church and the Institut de France, in Paris, showed that they were sensitive to the Italian way of treating figures, but the structure of their tombs is quite different from the Italian structure.

Michelangelo Slodtz used classical elements in his funerary monument for the prelate Languet de Gergy (*c.* 1760, Paris, Saint-Sulpice), whilst the prevailing taste for rockery motifs is evident, in a macabre way, in the statues. Nicolas Sébastien Adam, too, in his *Tomb of Queen Catherine Opalinska* (Nancy, Notre-Dame de Bon Secours) achieves a kind of balance between the classical element of the pyramid and the urn and the Rococo gracefulness of the angel and the queen.

Another original contribution of Bernini's was the type of funerary monument consisting of a portrait of the dead encased in the flagstones, such as the one for Monsignor Alessandro Valtrini (1639, Rome, San Lorenzo in Damaso), the one for the jurisconsult Ippolito Merenda (*c.* 1640–1641, Rome San Giacomo alla Lungara), and for Suor Maria Raggi (1643, Rome, Santa Maria sopra Minerva). These are counterbalanced by Duquesnoy's classical flagstone monument of Ferdinand Van Den Eynde (*c.* 1640, Rome, Santa Maria dell'Anima). Bernini's type of flagstone monument was taken up by Pietro Bracci for his tomb of Cardinal Carlo Leopoldo Calcagnini (1746, Rome, Sant'Andrea delle Fratte) by Angelo Gabriello Piò, for his *Monument of General Marsigli* (1733, Bologna, San Domenico), by Michelangelo Slodtz for his tomb of Marquis Capponi (1745–1746, Rome, San Giovanni dei Fiorentini), by Paolo Posi and Agostino Penna for their monument of Maria Flaminia Chigi Odescalchi (Rome, Santa Maria del Popolo).

Another iconographic type that had a certain success during the Baroque period was the altarpiece consisting of a statue of the titular saint within an urn. The prototype was Stefano Maderno's *St. Cecilia*, and the subject matter was later taken up by Niccolò Menghini, in his *St. Martina* (Rome, Santi Luca e Martina), by Antonio Giorgetti, with his *St. Sebastian* (Rome, San Sebastiano

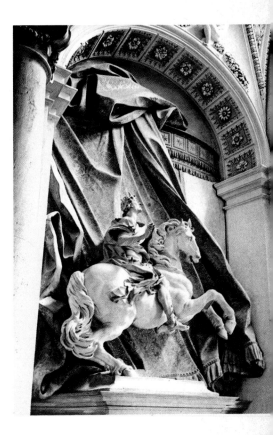

Giovanni Lorenzo Bernini,
Equestrian Monument of Constantine,
1662–1668, unveiled in 1670.
Rome, St. Peter's
(niche near the Scala Regia).

181

fuori le Mura), by Francesco Aprile and Ercole Ferrata, with their *St. Anastasia* (Rome, Santa Anastasia), by Giovanni Battista Maini, with his *St. Anne* (Rome, Sant'Andrea delle Fratte), by Giusto Le Court, with his statue of the dead Christ (Venice, Sant'Andrea della Zirada), and by Melchiorre Caffà, with his *St. Rose of Lima* (Lima, San Domingo).

In portraiture the types of portrait established by Bernini and Algardi were the most widely followed. Coysevox's bust of Louis XIV, in Versailles, shows quite clearly that despite its classical elements the sculptor had Bernini's archetype in mind. Evidence of the influence of the Italian type of portrait can also be found in Michelangelo Slodtz's bust of Stanislas Leczinski, Duke of Lorraine (1750, Nancy, Town Hall) and Jean Louis Lemoyne's bust of the Regent Philippe d'Orléans (*c.* 1715, Versailles, Château) and bust of Mansart (Paris, Louvre).

The equestrian monument found a good interpreter in Francesco Mochi, with his monuments to Ranuccio and Alessandro Farnese (1612–1620 and 1620–1625, Piacenza, Piazza dei Cavalli). Bernini's contribution to this type of monument includes the statue of Constantine on the Scala Regia in the Vatican. Mochi's influence is evident in Andreas Schlüter's monument of Frederick William of Brandenburg, father of Frederick I (1701, Berlin) and Pietro Tacca's Philip IV (1634–1640, Madrid).

We should also mention the *retablos*, a favourite element of Spanish and Portuguese sculpture; these were large frames enclosing painted or carved panels and placed above the back of an altar. This type of altarpiece, which had been established in the sixteenth century, flourished during the Baroque era, for it was an excellent instrument of psychological persuasion in the climate of the Counterreformation. The *retablos*, as a type of decoration, was exported by the Spaniards and the Portuguese to their Latin American dominions.

SCULPTURE AND NATURE: GARDENS

One of the most decisive aspects of the close link between sculpture and architecture in the seventeenth century was the Italian garden, first established during the Renaissance as a proof of the power exercised by man on nature. Thus plants, fountains, statues, and buildings all became elements of that peculiar manifestation of Italian art, the villa. Vegetation therefore became architecture because it defined space, but also sculpture, because of being "in the round"; for example in the Italian garden of Montalto Pavese, in Lombardy, its purpose was decorative. The statue, too, was no longer limited to a purely sculptural role but, rather, became, within the context of the villa, yet another architectural element. The villa, in the seventeenth century, continued to flourish as in the preceding century. To this was added the French version of a royal villa—Versailles. The Baroque spirit favoured rhetorical figures such as metaphors and allegories, preferably expressed through mythological subjects, and tending to add dynamic energy to the form. In these terms, pieces of sculpture, vegetation, fountains all became invested with theatrical effect.

In Rome one of the most important villas was the Villa Pamphili, designed by Alessandro Algardi, who also designed the Italian garden with statues on the terrace in front of the Casino dei Quattro Venti.

The Borromeo Villa, on Isola Bella in Lake Maggiore, was begun in 1622 and finished in 1671. Here sculpture has a decisively decorative role, with statues formally placed on high pedestals; in the *Pyramid* (the Water Theater) the sculp-

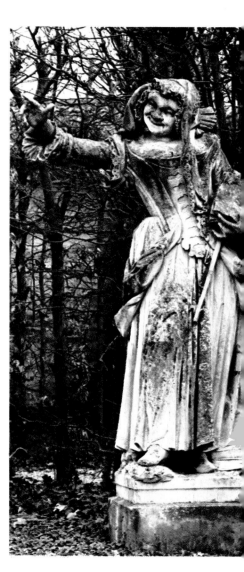

Antonio Bonazza, The Guessing Game, c. *1742. Garden of the Villa Widmann at Bagnoli, near Padua. Goldoni, who was a guest at the villa, wrote, "Not only villagers come here, but many Ladies and Gentlemen, Prelates and Citizens, and cultured people of all kinds."*

182

tures contribute to a typically Baroque effect of exotic "machinery."

In the Villa Barbarigo at Valsanzibio (Padua), the statues on the rustic fountain serve as a background to the rectangular pond. An interesting example of the interaction of vegetation and sculpture can be found in the Villa Marlia, in Lucca, where the statues in the little theater define the setting.

In the eighteenth century French taste in garden decoration becomes important. The favourite subject matters in sculpture are still mythological scenes, with a special predilection for the figures of Venus, Diana, and Apollo, who represented characters or events in daily life.

At Trescore Balneario (Bergamo), on the terrace of the Villa Terzi, the statues are placed on the banisters in rigid symmetry, and as stairway posts, thereby fulfilling an architectural rather than a sculptural role. One should also mention in Lombardy the Villa Prinetti Castelletti, north of Merate, and the Villa Belgioioso at Merate. The Villa Farnese at Colorno (Parma) was in French taste. In the Veneto, mention should be made of the Villa Trissino, in which the statues are placed in a vast context and not in a garden in the Italian manner, and the Villa Widmann at Bagnoli, near Padua, which Goldoni wrote about.

At Caserta, in the park of the royal palace, the sculptures representing mythological scenes are imbued with both the great classical Italian tradition and the gracefulness of Rococo. The sculptors employed at Caserta included Gaetano Salomone, Andrea Violani, Angelo Brunelli, and Paolo Persico. The favourite type of decoration was a group of statues arranged in and around water as on a stage set, and taking advantage of all the possibilities—in terms of colours and dynamic force—offered by the presence of water. There is evidence at Caserta of an echo of Versailles, and the groups of Diana and the Nymphs

and Diana with Actaeon are strongly reminiscent of Girardon's groups in the French palace.

In Sicily mention should be made of the Villa Palagonia at Bagheria (Palermo), which was started by Tommaso Maria Napoli and finished by Agostino Daidone. Here a taste for the bizarre borders on the grotesque, and the sculptures are placed on the walls surrounding the property in such a way as to be seen from outside. Although Rococo in taste they are a departure from the usual garden decoration, for they represent serpents, dragons, and monstrous horses.

We conclude this short survey of garden sculpture in Italy with the Villa Pisani at Strà, near Venice, where the statues by the fish pond and the groups in the meadow around it, though sculpted in the Rococo manner, are placed according to an eye for symmetry and proportion which already belongs to neoclassicism.

In France Jacques Boyceau de la Barauderie wrote in 1638 his *Traité du Jardinage selon la raison de la nature et de l'art*, an important work for the decorative art of gardens, and André Le Nôtre asserted that the vegetal element of gardens should prevail over the sculptural decoration.

Work on the château of Vaux-le-Vicomte started in 1656; here the sculptures placed in the wide terraces were treated as focal points, a fact which is particularly evident in the statue of Hercules. But it was Versailles, on which some of the best sculptors of the time were working (among them Lehongre, Regnaudin, Legros the Elder), which was to be the cradle of what has been described as "grandiloquent classicism." Here the decoration was elaborated around the myth of Apollo, the Sun God on his chariot, symbolizing the power of Louis XIV. The park at Versailles is full of mythological scenes, including Gaspard (1625?–1681) and Balthazar (1628–1674) Marsy's group

of *Lathona and her Children*, Jean Baptiste Tuby's (1635–1700) *Chariot of Apollo*, Girardon's bas-relief with the *Nymphs Bathing*, *Winter*, the *Abduction of Proserpina*, and *Apollo and the Nymphs*, and Lambert Sigisbert Adam's *Neptune and Amphitrite*. After 1674, Le Brun (1619–1690) and his colleagues placed marble statues on the terrace and on the *Tapis Vert*, bearing in mind, in their choice of allegorical subjects, Cesare Ripa's *Iconologia*. In this mythological and allegorical context we may also include Coysevox's *Flora* and *Hamadryad with Putto*, in the Tuileries, and Lambert Sigisbert Adam's group of the Seine and the Marne in the park of the château of Saint-Cloud. (There is an example of an everyday subject matter used sculpturally in the very same sculptor's *Return from the Hunt*, in the park of the castle of Sans-Souci at Potsdam). The château at Marly marks the passage of the Louis XIV era in art to the eighteenth-century vogue for rockery. The artist who was perhaps most sensitive to this change was Coysevox, who expressed it in his works *The Seine*, *the Marne*, *Neptune*, *Amphitrite*, *Fame and Mercury*, the *Hamadryad*, *Flora*, and the *Shepherd Playing His Flute*. The sculptor's choice of subject matter continued in the same vein, and in 1710 he sculpted for the park of the Duc d'Antin Marie-Adélaide of Savoy, the Duchess of Burgundy, as *Diana the Huntress*.

In Spain, at Aranjuez, Italian sculpture was in evidence, with Algardi and Guidi's *Fountain of Neptune*. In the Granja at Segovia the decorative sculptures taken from mythology (*Apollo and Daphne*, *Diana Bathing*, *Lathona*, *Nymphs*, *Muses*, the *Three Graces*, etc.) blend in perfectly with the fountains carved by Frémin, Thierry, Demandre, and Pitué; among these should be mentioned the *Carrera de Caballos*.

For the German-speaking countries special mention should be made of the park at Herrenhausen (Hanover), where

the sculptures placed in the parterre mingle with the star-shaped flower beds in a very sophisticated design. In the second half of the eighteenth century Adam Ferdinand Dietz (1708–1777) made his *Parnassus* for the garden of Veitshöchheim; the work is designed to emerge from the water in an emphatic contrast to the colours of the bright green of the vegetation behind it.

SCULPTURE AND THE THEATER: THE ART OF STAGE DECORATION

In the seventeenth century sculpture was one of the most important elements of stagelike decoration. In fact a large number of works of sculpture were extremely theatrical: Bernini's decoration for the Cornaro Chapel, for instance, or his *Ecstasy of St. Theresa*; the main altarpiece in the church of the Pilgrimage at Gössweinstein; Asam's *Assumption of the Virgin Mary* in the Augustinerkirche in Rohr. Life in a Baroque city was a constantly renewed theatrical show, and the stage set was provided by the association of architecture and sculpture. In the case of feast "machinery," which was usually destroyed when the celebration was over, sculpture was ephemeral in the same way that a stage spectacle is. These feasts and celebrations sometimes took place in church and sometimes in the city itself. A good example of "stage" sculpture was Rainaldi's ephemeral decoration of the façade of St. Peter's for the canonization of Carlo Borromeo in 1610.

At the end of the sixteenth century Domenico Fontana and Giacomo Della Porta had designed ephemeral commemorative catafalques, but it was not until the seventeenth century really that ephemeral "machinery" triumphed. In 1621 Orazio Torriani made a catafalque for Philip III on which were placed forty-eight plaster statues by a sculptor whose name has been lost. In 1622, in commemoration of Paul V's death, another catafalque was erected, on which were placed sixteen statues of virtues made by a young sculptor of twenty-four, Giovanni Lorenzo Bernini. In the 1627 catafalque for Pietro Della Valle's wife, the sculptural element was, conceptually and structurally, the most important part of the machinery. In 1658 Bernini designed and made a carnival cart for Don Agostino Chigi and, in 1661, the "stage" decoration for the funeral of Cardinal Mazarin. In 1662, on the occasion of the dauphin's birth, Giovanni Andrea Carlone designed the machinery for the fireworks. In 1667, Elpidio Benedetti and Giovanni Francesco Grimaldi designed the catafalque for Anne of Austria. In the early eighteenth century, Filippo and Francesco Bizzaccheri designed the machinery for a holy procession.

Let us now have a look at sculpture in the theater. There was, for instance, the stage decoration of the Farnese theater in Parma, designed by Aleotti in 1618–1619, with its statues placed in niches after the sixteenth-century manner. After this, however, emphasis in stage decoration was put on the mobile rather than built-in stage.

In 1650, in Paris, Giacomo Torelli (1608–1678) designed the stage sets for Corneille's *Andromède*; in 1677 he made four decorative statues for the proscenium of the Teatro della Fortuna at Fano.

Ludovico Ottavio Burnacini (1636–1707) designed fantastic sceneries in the exotic manner, such as the *Reggia di Plutone* (*Realm of Pluto*) and the *Golden Apple*, in which his favourite sculptural element was a monstrous and terrifying caryatid. A project of his for the imperial theater in Vienna included a series of statues placed on architectural elements on either side of the stage.

Other famous stage designers included the Galliari brothers (Bernardino and Francesco), Giuseppe Mitelli (1634–1718), the Bibiena family (Ferdinando, Francesco, Giuseppe, Alessandro, Antonio, Giovanni Maria, Carlo), who worked all over Europe; the Mauro family (Domenico, Gaspare, and Pietro), active in Parma, Turin, and Milan.

In his *Reggia Magnifica*, Pietro Righini (1683–1742) achieved the unity of sculpture and architecture; here the sculptures, apart from their decorative function, fulfilled also a tectonic function, and the whole thing was a masterpiece of Rococo grace.

In France Jean Bérain (1637–1711) favoured the more decorative aspects of stage design; in his decoration for *Atys*, the sculptures represent *putti*, allegorical figures, and caryatids.

In the theater of the Jesuit College in Rennes the statues, placed in niches, in corners, and on the banisters evoke the setting of an eighteenth-century villa.

In Spain stage designing was limited to the chariots in the *Autos sacramentales*, used in processions.

The Italian tradition as expressed by Bernini, the Bibienas, and the Mauros percolated through to central Europe. In this connection mention should be made of Joseph Furttembach (1591–1667), and Johann Oswald Harms (1643–1708).

MONUMENTAL ENSEMBLES

Before listing a few important monuments in which a certain unity was achieved between architecture and sculpture, we should point out that sculpture, apart from the role it played in architecture, has an important role to play in urban design. Good examples of this are Bernini's *Fountain of the Rivers* in the Piazza Navona in Rome and the Pestsäule (on which Rauchmiller, Fischer von Erlach, Burnacini, Bendl, and Strudel all worked) in Vienna. Also the so-called *Sacri Monti* in Lombardy and Piedmont, a series of chapels decorated with sequences of the lives of Christ, St. Francis, etc., which constitute a real open theater where the decoration, consisting of frescoes and statues (there are four hundred at Orta, six hundred at Varallo) achieves a remarkable unity.

CASERTA: The Reggia (Royal Palace). Mario Gioffredo's design made in 1742 was subsequently executed by Luigi Vanvitelli, who was influenced by the grandiose model of Versailles. In 1774 his son Carlo took over and continued the work. Vanvitelli himself designed the huge park, which is decorated with statues by Andrea Violani, Angelo Brunelli, Paolo Persico, Gaetano Salomone, and Pietro Solari.

COBURG: Church of the Fourteen Saints. Built between 1743 and 1763, it is an excellent example of the association between architecture and sculpture in the eighteenth century in Franconia. On the façade the group of *Christ between Faith and Charity* stands out; the interior has stucco decorations and the fourteen statues of saints.

NAPLES: Sansevero di Sangro Chapel. Built for Giovanni Francesco Sangro (1590), renovated under Francesco Sangro (1608–1613), and further decorated for Raimondo Sangro (1749–1766). The interior is typically Rococo, with frescoes by Francesco Maria Russo and statues by Francesco Celebrano, Paolo Persico, Francesco Queirolo, Antonio Corradini, and Giuseppe Sammartino.

ROHR: Augustinerkirche (1718–1723). It contains Egid Quirin Asam's famous altarpiece with the *Assumption of the Virgin Mary*. Every possible device and colour effect have been used in the stucco decoration, with its profusion of gold, in order to achieve the theatrical-cum-mystical effect dear to German Baroque.

ROME: St. Peter's. The reconstruction of the basilica (which dates from the fourth century A.D.) started in 1452 with Bernardo Rossellino and ended in 1614 with Carlo Maderno, who elongated the nave with respect to Michelangelo's plans. In the mid-seventeenth century, Bernini built the colonnade. The interior is decorated with statues and monuments by Della Valle, Bracci, Maini, Rusconi, Slodtz, Cornacchini, Bolgi, Mochi, Duquesnoy, Algardi, and Bernini.

San Giovanni in Laterano: important above all for the study of late Roman Baroque, the great statues and the decoration of the central nave by Ottoni, Rusconi, Mazzuoli, Legros, Monnot, De Rossi, and Moratti. Also for the eighteenth-century decoration of the Corsini Chapel, on which Maini, Monaldi, Della Valle, Cornacchini, Lironi, Rusconi, and Montauti all worked.

VERSAILLES: Residence of the King of France. The ensemble, which Jules Hardouin Mansart enlarged in 1679, is a perfect expression of the taste and splendour of the French court in the seventeenth century. Within the château itself, one of the most important features is the Hall of Mirrors. The park, designed by Le Nôtre between 1661 and

Top: Girolamo Rainaldi,
Ephemeral Façade for St. Peter's,
1610, for the canonization of St. Carlo Borromeo. Below: Ludovico Ottavio Burnacini, Theater of the Glory of Austria, *scene from the* Golden Apple, *1666.*

1668, contains a large number of statues by the best French sculptors of the time (among them Coysevox and Girardon) and the Grand and the Petit Trianon. Versailles was used as a model for some of the German palaces, particularly Nymphenburg, Potsdam, and Schönbrunn.

WÜRZBURG: Residence of the German bishop prince. Started by Balthasar Neumann for Johann Philipp Franz von Greiffenclau, then for his brother Friedrich Carl. Dientzenhofer, von Welsch, and von Hildebrandt collaborated with Neumann on this project. The building is a masterpiece of Baroque monumentality and Rococo grace. The chief stuccoworker was the Swiss Antonio Bossi, who collaborated with the sculptor Johann Wolfgang Van der Auvera and with Giovanni Battista Tiepolo, who painted the frescoes between 1750 and 1752.

MUSEUMS

FLORENCE

Museo degli Argenti: Set up in 1919 on the ground floor of the Pitti Palace; contains objects from the Medici collections. The bulk of the collection of ivory carvings, silver, and amber was provided by Cosimo II, Cardinal Leopoldo, and the Prince of Lorraine. There are also precious pieces of furniture. After the Medici family became extinct in 1743, the house of Lorraine added to the collection with objects brought from Salzburg and Würzburg. Important for works by Permoser, Foggini, and Soldani Benzi.

Museo del Bargello: Set up in the Palazzo del Bargello in 1874, with a group of sculptures from the Medici collections. There are examples of sculpture from the fifteenth century on, and a few significant pieces of Baroque sculpture, most of them bronzes by Fortini, Montauti, Piamontini, Selvi, Soldani Benzi, Della Valle, and Weber.

LONDON

Victoria and Albert Museum: Founded after the World Exposition of 1851, with the intention of assembling a collection illustrating the techniques and materials used in art and crafts. The director, Robinson, enriched the museum greatly by means of various acquisitions to which were added the Gherardini, Soulages and Gigli Campana collections. In 1857 the museum was transferred from Malborough House to a new building in South Kensington. It contains, among many other things, works by Algardi, Bernini, Dietz, Veyrier, Agostinelli, and a remarkable collection of seventeenth- and eighteenth-century bronzes and of Rococo ceramics.

MUNICH

Bayerisches Nationalmuseum: Founded by Maximilian II in 1853, mostly to illustrate the history of Bavaria and of

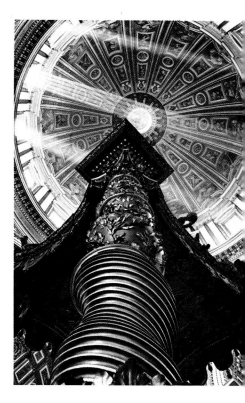

Giovanni Lorenzo Bernini, The Baldachin of St. Peter (detail), 1624–1633.

his own family. It contains an important collection of porcelains by Bustelli.

MURCIA

Museo Salzillo: Dedicated to the works of the sculptor Francisco Salzillo (1707–1783).

PARIS

Musée du Louvre: In 1791 the Constituent Assembly decided to collect all the royal works of art in the palace of the Louvre. In the nineteenth century Louis XVIII had the statues placed in the Galerie d'Angoulême. Works by Pigalle, Caffieri, Lemoyne, Puget, Coysevox, Costou, Adam and Bernini.

ROME

Galleria Borghese: Founded by Cardinal Scipione Borghese, nephew of Paul V, in the Villa Borghese, built by Giovanni Vasanzio. Apart from the original group of sculptures, the gallery was enriched by the addition of other important objects at the end of the seventeenth century when the Borghese family inherited the fortune of Cardinal Ippolito d'Este and Lucrezia d'Este, Duchess of Urbino, after the marriage of Paolo Borghese with Olimpia Aldobrandini. Between the end of the eighteenth century and the beginning of the nineteenth, many objects were taken to France. The Gallery is particularly important for Bernini's works, but it also contains interesting examples of Algardi's and Duquesnoy's work.

Galleria Doria Pamphili: Housed in the Palazzo Doria Pamphili. Founded by Camillo Pamphili, nephew of Innocent X. The collection grew considerably after the marriage of Giambattista Pamphili and Anna Doria; there were, in addition, several works that came from the Aldobrandini collection. Important for a group of sculptures by Algardi.

Museo di Palazzo Venezia: This palace was formerly the residence of the Venetian ambassadors. Important for small bronzes and terra–cotta studies by Bernini, Algardi, and Duquesnoy and for a collection of Meissen and Fontainebleau porcelain.

SÈVRES

Musée National de Céramique: Founded in 1812, it contains ceramics from various manufactures in Europe (Sèvres, Meissen, Berlin, etc.) and is particularly important for its Rococo collection.

VALLADOLID

Museo Nacional de Esculturas: Contains the best examples of Spanish polychrome sculpture, such as works by Gregorio Hernández (seventeenth century) and Pedro de Mena (seventeenth century).

VIENNA

Österreichische Galerie, Barockmuseum: Housed in the Belvedere Palace, residence of Prince Eugene of Savoy, built by Johann Lucas von Hildebrandt from 1713 on. From 1952 the collection of Baroque art has been housed in the Lower Belvedere Palace, which was finished in 1716. It is a very important collection from the point of view of German Baroque. Works by Permoser, Messerschmidt, Giuliani, and Donner.

WASHINGTON, D.C.

National Gallery of Art: Founded in 1937 with the Mellon, Widener, and Kress collections. It contains an important collection of Baroque sculpture, with works by Bernini and French sculptors of the seventeenth and eighteenth centuries.

BIBLIOGRAPHY

Angyal, A., *Die slawische Barockwell*, Leipzig, 1961.

Asche, S., *B. Permoser und die Barockskulptur des Dresdner Zwingers*, Frankfurt, 1966.

Battisti, E., *Rinascimento e Barocco*, Turin, 1960.

Bazin, G., *Classique, Baroque et Rococo*, Paris, 1965.

Bauer, H., *Rocaille, Zur Herkunft und zum Wesen eines Ornaments-Motivs*, Berlin, 1962.

Bianconi, P., *Francesco Borromini. Vita Opere Fortuna*, Bellinzona, 1967.

Birchler, L., *L'Art Baroque en Suisse*, Geneva, 1949.

Blunt, A., *Art and Architecture in France 1500 to 1700*, Melbourne, London, and Baltimore, 1953; second edition 1957.
Sicilian Baroque, London, 1968.

Brinckmann, A. E., *Barock-Bozzetti*, Frankfurt, 1923–1925, 4 vols.

Busch, H., and Lohse, B., *Barock-Plastik in Europa*, Frankfurt, 1964.

Carandente, G., *Giacomo Serpotta*, Milan, 1966.

Castedo, L., *The Baroque Prevalence in Brazilian Art*, New York, 1964.

Fagiolo dell'Arco, M. and M., *Bernini, una introduzione al gran teatro del barocco*, Rome, 1967.

Fagiolo dell'Arco, M., and Carandini, S., *L'effimero barocco: strutture della festa nella Roma del '600* (Vol. 1 catalogue, Vol. II texts), Rome, 1977.

Faldi, I., *La scultura barocca in Italia*, Milan, 1958.

Fokker, T. H., *Roman Baroque Art. The History of a Style*, Oxford, 1938, 2 vols.

Francastel, P., *Girardon*, Paris, 1929.
La sculpture de Versailles, Paris, 1929.

Gantner, J., and Reinle, A., *Die Kunst der Renaissance, des Barock und des Klassizismus* (*Kunstgeschichte der Schweiz*, III), Frauenfeld-Leipzig, 1956.

Gomez-Moreno, M. E., *Juan Martínez Montañés*, Barcelona, 1942.
Escultura del siglo XVII (*Ars Hispaniae*, XVI), Madrid, 1963.

Griseri, A., *Le metamorfosi del barocco*, Turin, 1967.

Hempel, E., *Baroque Art and Architecture in Central Europe, Germany, Austria, Switzerland, Hungary, Czechoslovakia, Poland* (Harmondsworth-Baltimore), 1965 (The Pelican History of Art).

Hitchcock, H.-R., *Rococo Architecture in Southern Germany*, London and New York, 1968.

Kelemen, P., *Baroque and Rococo in Latin America*, New York, 1951.
Art of the Americas, Ancient and Hispanic, with a comparative chapter on the Philippines, New York, 1969.

Kimball, F., *The Creation of Rococo*, Philadelphia, 1943.
Le style Louis XV, origine et évolution du Rococo, Paris, 1949.

Kubler, G., and Soria, M., *Art and Architecture in Spain and Portugal and Their American Dominions, 1500 to 1800* (Harmondsworth), 1959 (The Pelican History of Art).

Labò, M., Nava Cellini, A., Causa, R., and editors, *Barocco*, in *Enciclopedia Universale dell' Arte*, II, Venice and Rome, 1958, col. 345–468.

Lasarew, M. N., and Ilijn, M. A., *Der Barock*, Berlin, 1954.

Lees-Milne, J., *Baroque in Italy*, London, 1959.
Baroque in Spain and Portugal, London, 1960.

Lieb, N., *Barockkirchen zwischen Donau und Alpen*, Munich, 1953.

Manierismo, Barocco, Rococò: Concetti e termini, Convegno internazionale (Rome, 1960), Rome, 1962.

Martinelli, V., *Dal Manierismo al Rococò*, Milan, 1968 (Scultura italiana, IV).

Pope-Hennessy, J., *Italian High Renaissance and Baroque Sculpture*, London, 1963.

Portoghesi, P., *Borromini nella cultura europea*, Rome, 1964.
Borromini. Architettura come linguaggio, Rome, 1967.
Roma Barocca. Storia di una civiltà architettonica, Rome, 1967.

Réau, L., *Les sculpteurs français en Italie*, Paris, 1945.
Houdon, Paris 1964, 2 vols.

Redslob, E., *Barock und Rokoko in den Schlössern von Berlin und Potsdam*, Berlin, 1954.

Retorica e Barocco, Atti del III Congresso Internazionale di Studi Umanistici (Venice, 1954), Rome, 1955.

Sánchez Cantón, F. J., *Escultura y pintura del siglo XVIII* (Ars Hispaniae, XVII), Madrid, 1965.

Schönberger, A., *Ignaz Günther*, Munich, 1954.

Sedlmayr, H., and Bauer, H., *Rococò*, in *Enciclopedia Universale dell' Arte*, XI, 1963, col. 623–670.

Seicento europeo. Realismo, classicismo, barocco (catalogue of the exhibition, Rome, 1956–1957), Rome, 1956.

Sitwell, S., and Pevsner, N., *German Baroque Sculpture*, London, 1938.

Souchal, F., *Les Slodtz, sculpteurs et décorateurs du roi (1685–1764)*, Paris, 1967.

Studies in Renaissance and Baroque Art, presented to Anthony Blunt, London, 1968.

Tintelnot, H., *Barocktheater und barocke Kunst, Die Entwicklungsgeschichte der Fest und Theater-Dekoration in ihrem Verhältnis zur barocken Kunst*, Berlin, 1939.

Weihrauch, H. R., *Europäische Bronzestatuetten 15.-18. Jahrhundert*, Braunschweig, 1967.

Wethey, H. E., *Colonial Architecture and Sculpture in Peru*, Cambridge Mass., 1949.

Weise, G., *Die Plastik der Renaissance und des Frühbarock in nördlichen Spanien. I, Erste Hälfte des 16. Jahrhunderts. II, Die Romanisten*, Tübingen, 1957–1959, 2 vols.

Whinney, M., *Sculpture in Britain 1530 to 1830* (Harmondsworth), 1964 (The Pelican History of Art).

Wittkower, R., *Gian Lorenzo Bernini: The Sculptor of the Roman Baroque*, London, 1955.
Art and Architecture in Italy, 1600 to 1750 (Harmondsworth), 1958 (The Pelican History of Art).
Studies in the Italian Baroque, London, 1975.

Wölfflin, H., *Renaissance und Barock*, Munich, 1888.

Fundamental for historical research are a number of articles on individual sculptors or periods, published in specialized periodicals by the following scholars: C. D'Onofrio, I. Faldi, I. Lavin, V. Martinelli, J. Montagu, and A. Nava Cellini.

INDEX

PHOTOGRAPHIC SOURCES

The abreviations t, b, r, l refer to the position of the illustration on the page (top, bottom, right, left)

Photoatelier Jörg P. Anders, Berlin
153

Maurice Babey, Basel
59

Robert Braun Müller, Munich
53

J. E. Bulloz, Paris
134

Cameraphoto, Venice
82

Mario Carrieri, Milan
126

Cineleica Giordani, Padua
182

Civico Archivio Fotografico, Milan
65

By kind permission of the Courtauld Institute of Art, London
144

Gianni Croce, Piacenza
95, 96

Mario De Biasi, Milan
39

Deutsche Fotothek Dresden, Dresden
156

© ERI Edizioni Rai Radiotelevisione Italiana, Turin (*Giacomo Serpotta* by G. Carandente):
Photo Giovanni Trimboli
147

Fratelli Fabbri Editori, Milan
40, 42, 43, 45, 46, 47, 51, 54, 55, 57, 60, 61, 63, 78, 84, 97, 130, 136, 137, 138, 139, 146, 150, 151, 154, 158, 160, 162, 166, 168, 169, 170, 171, 172, 173

Farabola-Alinari, Milan
94

Marcel Gautherot, Rio De Janeiro
174

Photographie Giraudon, Paris
135, 143

Foto Gundermann, Würzburg
4

© Editorial Herrero, Mexico (*Cuarenta siglos de plastica mexicana*):

Hirmer Fotoarchiv, Hirmer Verlag, Munich
156, 161, 164

Istituto Centrale per il Catalogo e la Documentazione, Rome
88, 89, 105

Landesbildstelle Berlin, Berlin
152

Bildarchiv Foto Marburg, Marburg
155

Archivo MAS, Barcelona
58, 167

Leonard von Matt, Buochs
6, 178t, 180, 181, 186

Walter Mori, Milan
104

T. Okamura, Rome
2, 35, 36, 37, 38, 49, 80–81, 83, 86, 87, 90, 91, 92, 93, 98, 99, 101, 106, 107, 108, 109, 110, 111, 112, 113, 114, 115, 116, 117, 120, 121, 124, 125, 129, 148–149

Fotostudio Otto, Vienna
163

Friedrich Reinhard, Berlin
131

Photo Walter Reuter
64

François René Roland, Paris
33, 34, 66, 85, 128, 132, 133, 140

Oscar Savio, Rome
41, 119, 122, 123

Scala, Florence
48, 50, 52, 62, 141, 142

Helga Schmidt-Glassner, Stuttgart
165

Toni Schneiders, Lindau
157

Service de Documentation Photographique de la Réunion des Musées Nationaux, Paris
127

Photographie Hildegard Steinmetz, Gräfelfing-Munich
56

Victoria and Albert Museum, London
103, 178b

Warburg Institute, London
Photo Helmut Gernsheim
145

Mondadori Archives, Milan
30, 44, 100, 102, 118

With the kind cooperation of P. Zioli

We should like to express our thanks to Prof. Paolo Portoghesi, Rome (123), Prof. Maurizio Fagiolo dell'Arco, Rome (185t) Dott. Clelia Alberici (185b), Civica Raccolta Stampe A. Bertarelli, Milan